THE PHOTO ARK
VANISHING

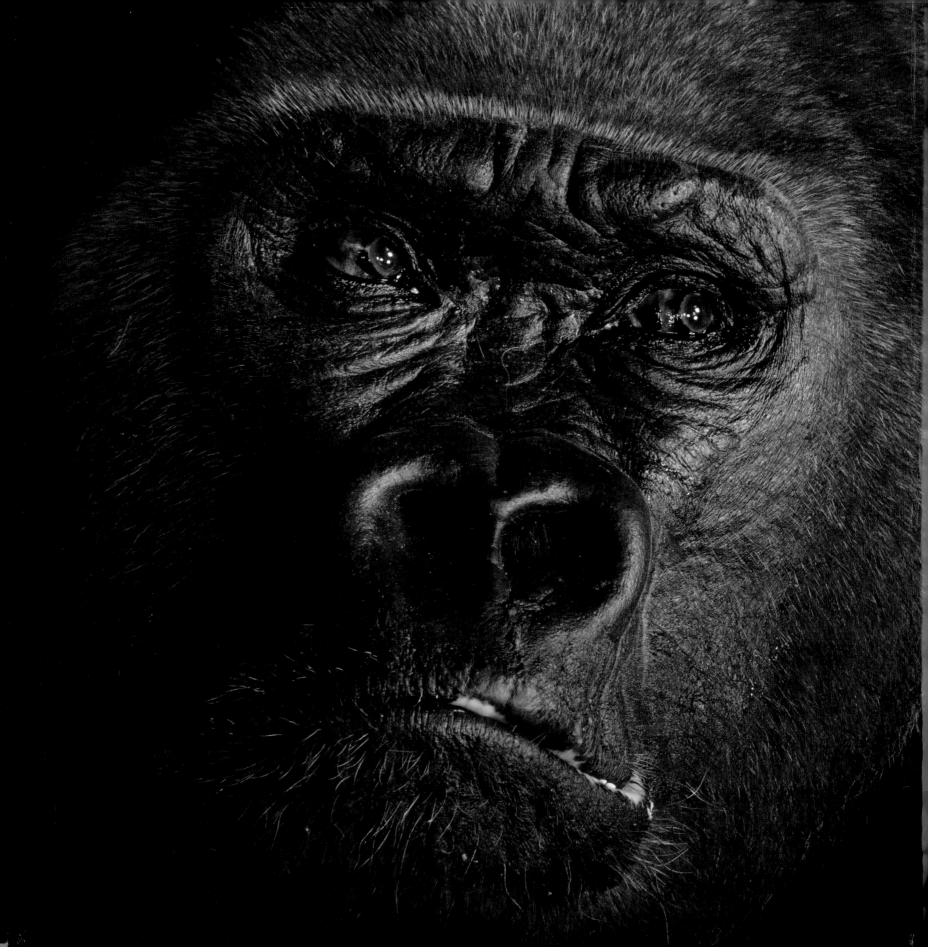

THE PHOTO ARK
VANISHING

THE WORLD'S MOST VULNERABLE ANIMALS

JOEL SARTORE

FOREWORD BY ELIZABETH KOLBERT

NATIONAL GEOGRAPHIC

WASHINGTON, D.C.

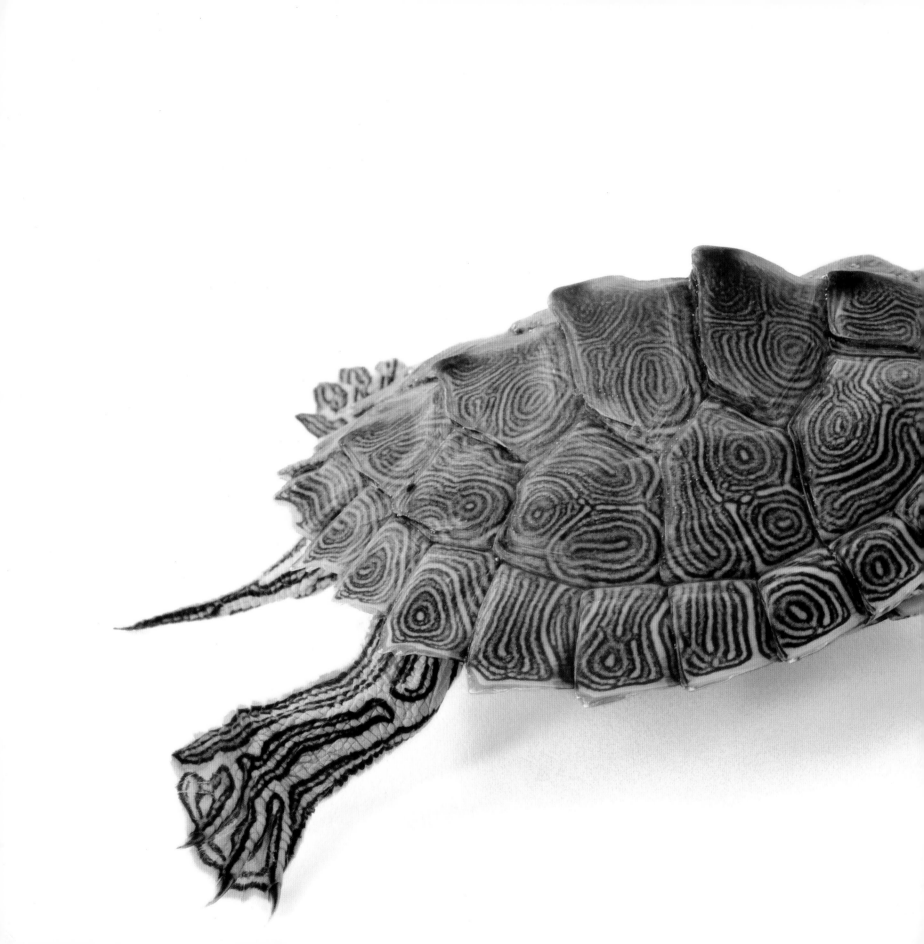

| CONTENTS |

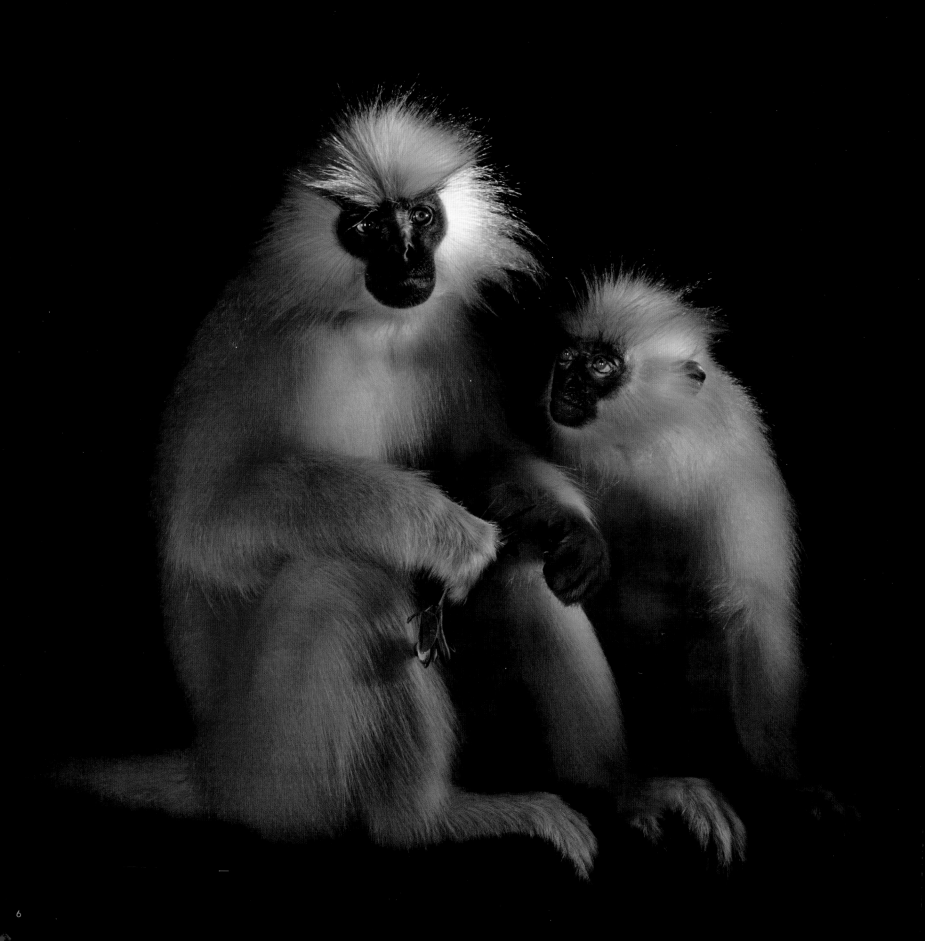

FOREWORD | ELIZABETH KOLBERT

If we lived in an ordinary time—time here being understood in the long, unhurried sense of a geologic epoch—it would be nearly impossible to watch a species vanish. Such an event would occur too infrequently for a person to witness. What's known as the background extinction rate is calculated by looking at the fossil record for a particular group of animals. In the case of the best-studied group, which is mammals, the background rate is so low that over the course of a millennium, a single species should disappear.

But, of course, we don't live in an ordinary time. Everywhere we look, species are winking out. Just in the past decade, three species of mammals have been declared extinct: the Saudi gazelle, a bat known as the Christmas Island pipistrelle, and a rat called the Bramble Cay melomys. Meanwhile, the International Union for Conservation of Nature (IUCN) lists more than 200 mammal species and subspecies as "critically endangered." In some cases, like the Sumatran rhino or the vaquita—a porpoise native to the Gulf of California—there are fewer than a hundred individuals left. In others, like the baiji (also known as the Yangtze River dol-phin), the species, though not yet officially declared extinct, has probably, in fact, already died out.

And what goes for mammals goes, unfortunately, for just about every other group you can think of: reptiles, amphibians, fish, even insects. Extinction rates today are hundreds—perhaps thousands—of times higher than the background rate, so high that scientists say we are on the brink of a "mass extinction." The last mass extinction, which did in the dinosaurs some 66 million years ago, followed an asteroid impact. Today the cause of extinction seems more diffuse. It's logging and poaching and introduced pathogens and climate change and overfishing and ocean acidification. But trace all these back and you find yourself face-to-face with the same culprit. The great naturalist E. O. Wilson has noted that humans are the "first species in the history of life to become a geophysical force." Many scientists argue that we have entered a new geologic epoch—the Anthropocene, or age of man. This time around, in other words, the asteroid is us.

What's lost when an animal goes extinct? One way to think of a species, be it of ape or of ant, is as an answer to a puzzle: how to live on planet Earth. In this sense, a species' genome is a sort of manual; when the species perishes, that manual is lost. We are, in this sense, plundering a library—the library of life. Instead of the Anthropocene, Wilson has

PAGE 1: Imperial amazon, *Amazona imperialis* (EN)
PAGES 2-3: Western lowland gorilla, *Gorilla gorilla gorilla* (CR)
PAGES 4-5: Cagle's map turtle, *Graptemys caglei* (EN)
OPPOSITE: Gee's golden langur, *Trachypithecus geei* (EN)

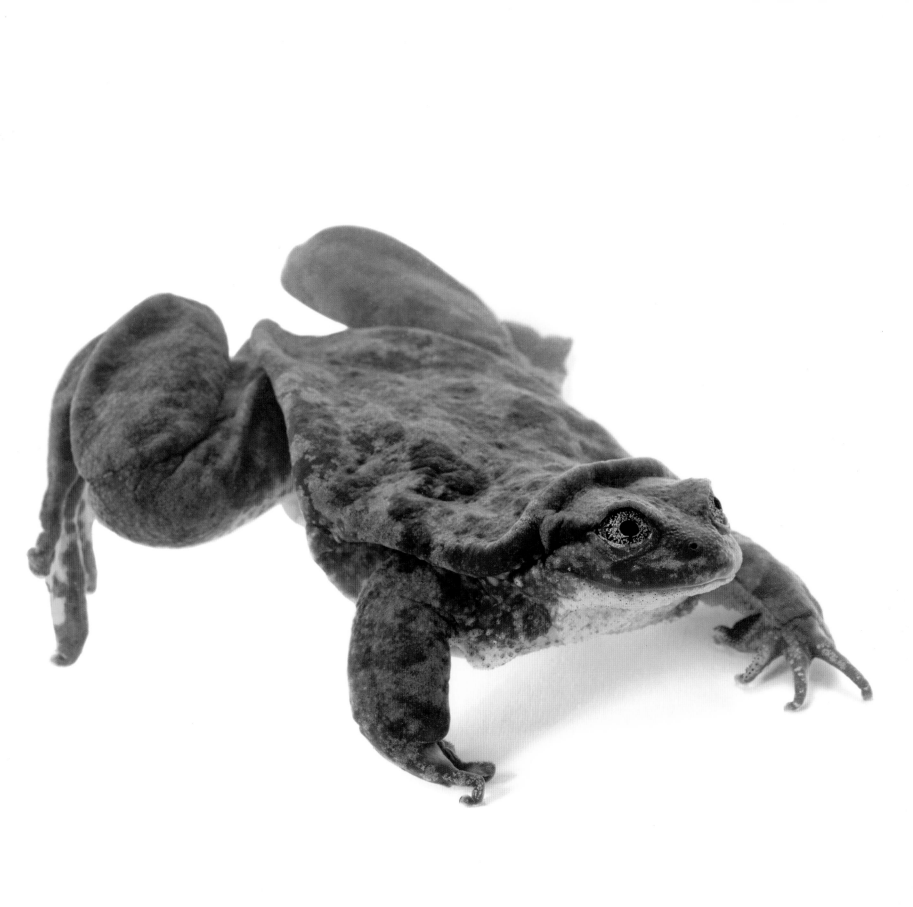

Sehuencas water frogs, *Telmatobius yuracare* (VU)

For more than 10 years, only one Sehuencas water frog, Romeo (left), was known to exist. During an expedition in late 2018 scientists discovered five individuals in the wild, offering hope for the future of the species. Romeo's mate, Juliet, is on the right.

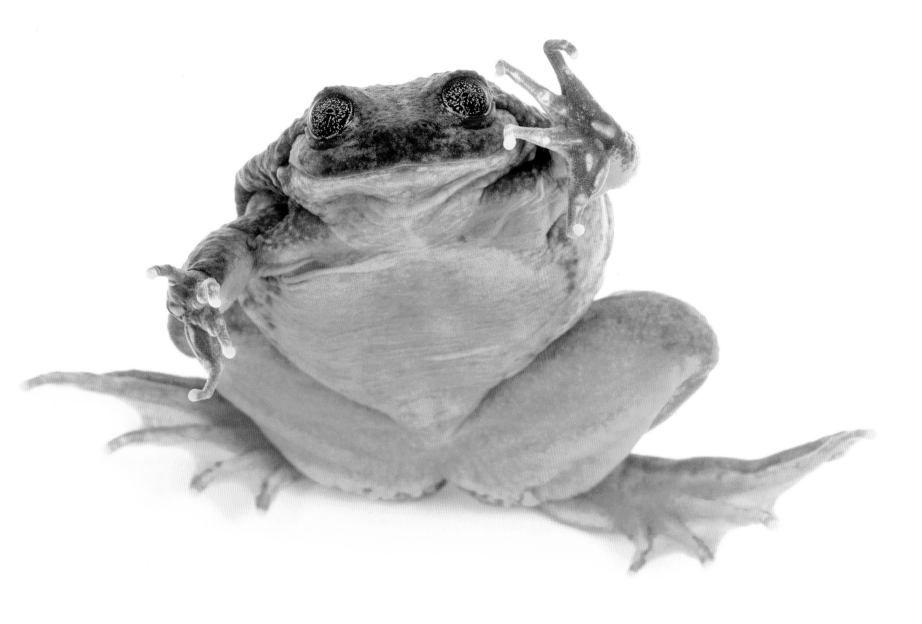

dubbed the era we are entering the Eremozoic—the age of loneliness.

Joel Sartore has been photographing animals in captivity for the past 15 years. In an ever growing number of cases, animals housed in zoos or special breeding facilities are among the last remaining members of their species. In some instances, they are the only members. Toughie, a Rabbs' fringe-limbed tree frog from central Panama, lived at the Atlanta Botanical Garden. He became the last known member of his species when a fungal disease swept through his native habitat and an attempt to establish a captive-breeding program failed. Toughie died in 2016, and it's likely the Rabbs' fringe-limbed tree frog is now extinct.

Romeo, a Sehuencas water frog who lives at the Cochabamba Natural History Museum in Bolivia, was likewise believed to be a sole survivor. Scientists there created an online dating profile for him. Romeo's profile linked to a donation page, and the $25,000 raised funded an expedition in the eastern Andes, where the species was once abundant. Amazingly, the search revealed five more, two males and three females. All were brought back to Cochabamba, and the one female mature enough to breed with Romeo has been given the name Juliet. Whether she will prove a worthy mate and perpetuate the species, no one knows. Even then, the species' survival will be tenuous.

Was the Rabbs' fringe-limbed tree frog beauti-ful? Not in the flashy way of, say, the Spix's macaw (which is believed to be extinct in the wild) or the Gee's golden langur (which is endangered). But, with its expressive black eyes and gangly limbs, it had its own kind of charm. Sartore treats all creatures—great and small, handsome and homely—with reverence. His photos capture what's singular and, I'd also like to say, soulful about every living thing. One of my favorite images in this book is of a Partula snail, laying down a trail of slime. There used to be dozens of species of Partula snails in the South Pacific, occupying different islands and different ecological niches. Much like Darwin's finches, these snails were the darlings of evolutionary biologists—living, slime-producing illustrations of the power of natural selection. The introduction of snails from Central America drove most of the Partula species extinct; a few survive thanks to a captive-breeding program.

Precisely because extinction takes place so frequently now, it's possible to become inured to it. And it is this desensitizing that makes Sartore's work so crucial. Through his images, we see just how remarkable each species is that's being lost. We live in an extraordinary time. Perhaps by recognizing this, we can begin to imagine creating a different one—one that preserves, as much as is still possible, the wonderful diversity of life. ■

OPPOSITE: African penguin, *Spheniscus demersus* (EN)

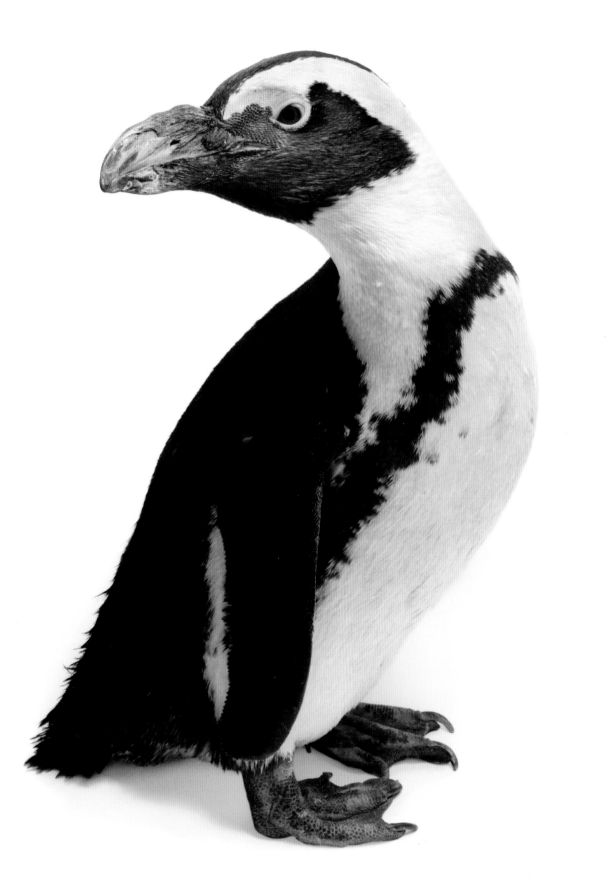

1940s

Barbary lion, *Panthera leo leo* (VU)

Lions were once common in North Africa, but they were hunted
so intensely that none remain in the wild in that region. The big
cats survive in sub-Saharan Africa but continue to be threat-
ened by hunting and habitat loss.

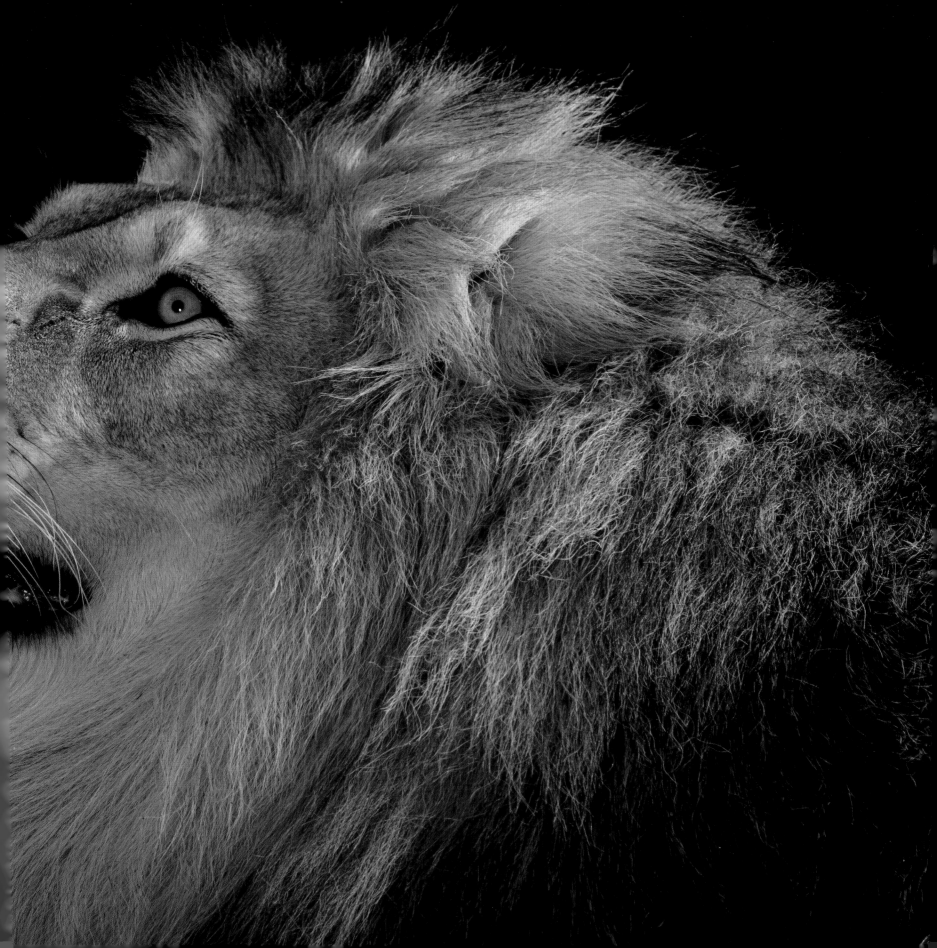

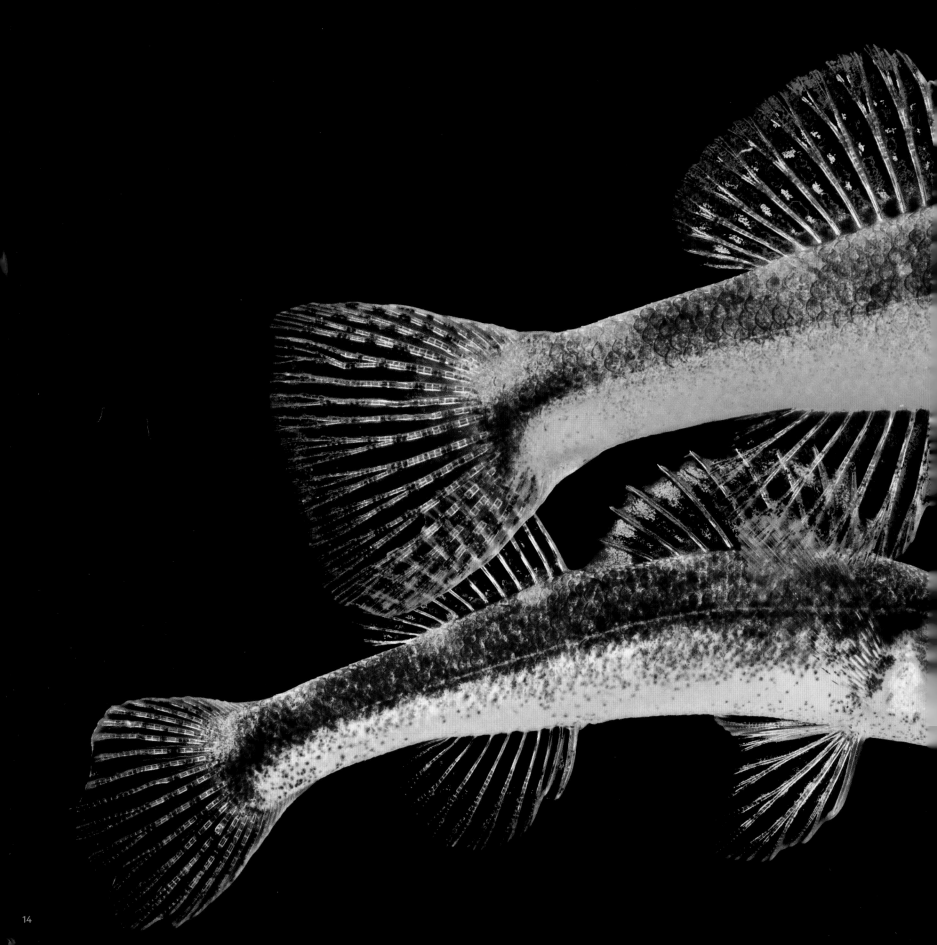

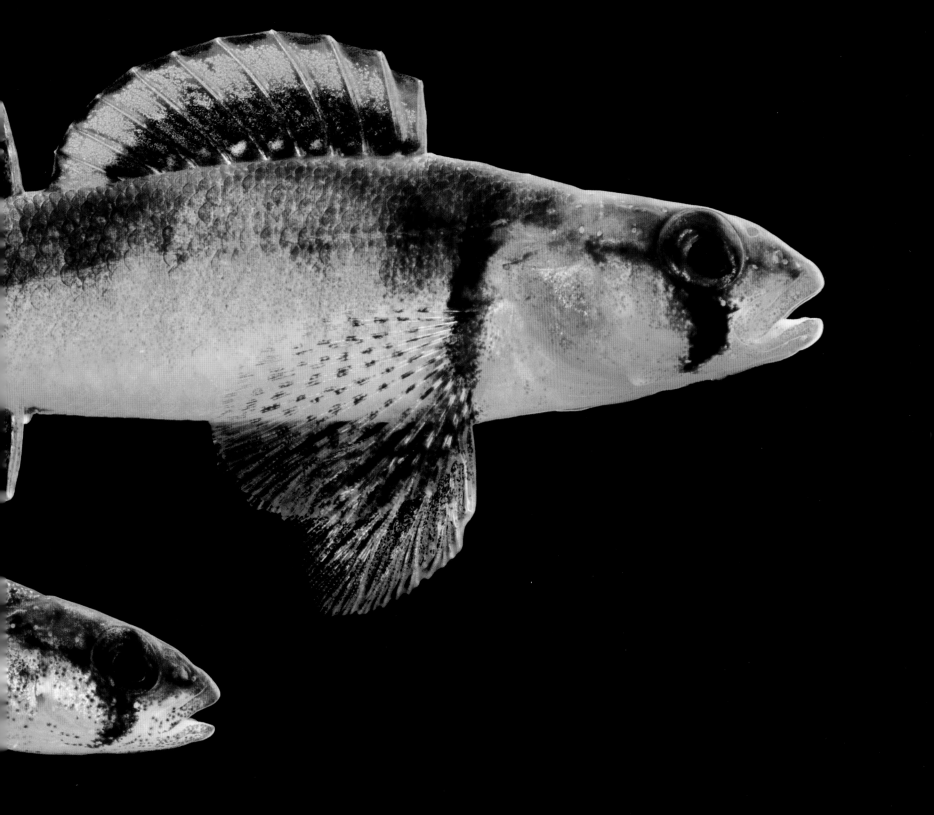

Slackwater darter, *Etheostoma boschungi* (EN)

This small fish is native to freshwater streams throughout
Tennessee and Alabama. Agriculture and development in
the region has led to many of these streams drying up or
becoming too polluted for the fish to survive.

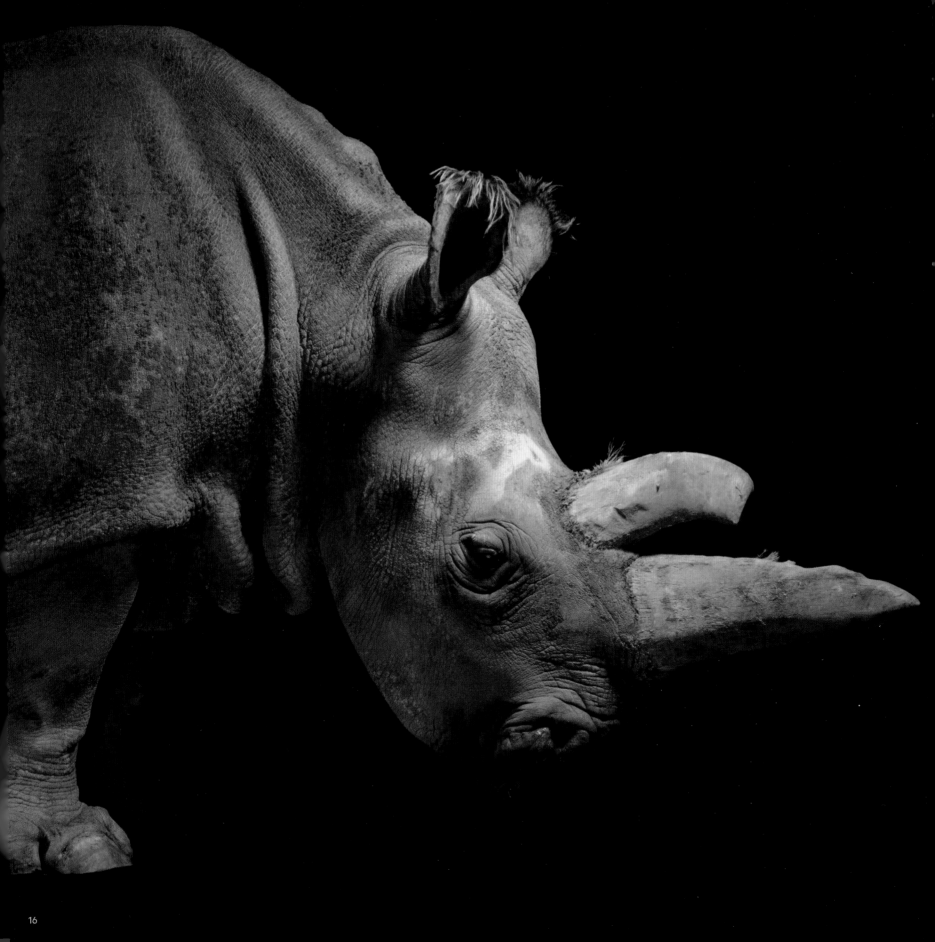

| INTRODUCTION | JOEL SARTORE |

Deep in the fall of 2018, I drove across the Czech Republic to the Dvůr Králové Zoo. The countryside looked to be from another time, tidy with stone villages and farms, every inch accounted for.

Gray clouds soaked the rolling countryside in sheets at times, requiring headlights the whole way. It seemed I was the only one on the road. In essence it was perfect weather for what I knew lay ahead; viewing the body of Nabire, one of the last northern white rhinos.

Three years before, I'd photographed her alive at the zoo, when there were just five of her kind left on Earth. Even then she was living on borrowed time. Too old for veterinarians to remove the large, fluid-filled cysts inside her, she was not expected to live much longer.

Encouraging her by offering the leafy greens she loved to eat, a keeper who had known Nabire since she was a baby led her into the photo stall we had set up at the zoo, lined with a black velvet curtain. She was sweet and patient during the photo shoot, and she let us touch her horn through the bars. She lay down and took a short nap afterward. A week later, one of the cysts inside her ruptured, and she passed away.

OPPOSITE: Northern white rhinoceros, *Ceratotherium simum cottoni* (CR)

I thought back on all that had happened as I approached the zoo's grand old museum that afternoon. It was getting dark, and there were no other visitors. I was dreading what I would see. I hadn't felt this way since seeing my mother in the mortuary.

Inside the museum, I rounded a corner and there she was—or at least there was her body, as a taxidermist had interpreted it. The wrinkles in her face were mostly smoothed out now, and her eyes were glass. A small chain to keep visitors from touching seemed to keep her in place. Ironically, she was surrounded by beautiful paintings depicting the evolution of life on Earth in all its glory.

I sat in an adjacent room where I could see her through a doorway, and my eyes welled up with tears.

For all the work and captive breeding and news stories and sleepless nights put in by those who care, this is how it all ends. This is what extinction truly looks like: a stuffed skin in a museum.

At the time of this writing, there are just two northern white rhinos left, a mother and daughter in a pen in Kenya, backed right up against the abyss. Two females, the last of their kind. How lucky we are to have known them at all.

Yet they're not alone. Over the years, I've met many animals for whom time is up or nearly so, from frogs to birds, primates to invertebrates. How hard must we be on our planet to cause even *insects* to vanish?

And doesn't that deserve at least a moment of reflection before we go on to the next shiny new thing? After all, our very lives depend on it.

Most folks on the street wouldn't know it, but nature doesn't need us. The globe will keep spinning no matter what. But *we* must have nature—desperately, in fact, for a million reasons. We need steady amounts of rain, in the right amounts at the right time, to grow our crops. We need ice at the poles to regulate temperature. We need healthy forests and oceans to generate the oxygen we breathe. We need pollinating insects to bring us fruits and vegetables. The solution is simple but not easy: We must save vast tracts of habitat *now* to stabilize the planet's life support systems.

But in a world consumed by celebrities and selfies, will we wake up in time to save ourselves? Or will we just smile into a smartphone all the way down? This is the greatest question of our time, and the one I deal with daily while building the Photo Ark.

Nabire's is one case among many. I see it every month when out shooting. Various caretakers know when a species' fate looks dire. Like a caring family doctor, they pull me aside and whisper, "I'm glad you got here in time."

When I look in the eyes of an animal deemed "the last one," I get a horrible, sinking feeling. It is epic in ways I don't yet understand, and it is irreversible. The loss of a tiger or the loss of a sparrow—they are equally tragic. But just how do we convince anyone that saving the least among us—say, a tiny frog and the mountain stream it lives in—is absolutely necessary and urgent now?

Human numbers are expanding exponentially, eventually to 10 or 11 billion people. As we and our grains and livestock spread ever outward, we convert jungles, marshes, tundra, prairies, and everything else to farms, ranches, factories, roadways, and cities. Of the mammal biomass on Earth today, less than 10 percent is wild. The rest is either us or the mammals we eat: cows, pigs, sheep, and goats.

Without their habitats, most wild animals can't survive. Oh, sure, we'll likely have coyotes and squirrels, crows and starlings—the generalists that can thrive by adapting to us. But for the specialists that have evolved to feed on a specific plant, or raise their young in a certain place at a specific time, life won't be easy as those special circumstances disappear.

And yet . . . This is actually the best time in human history to help save the planet. This is partly because there are so many species and places at risk, but it's also because of the connectivity of the internet. We can let the world know about the biggest threats to existence in real time, and where there's a need, humans love to fill it. This gives me great hope.

With every Photo Ark trip, I meet people who are true conservation heroes. They work all year, every year, to protect species and habitats, buying time until the rest of society realizes that the future of all life is intricately bound. They're doing all they can,

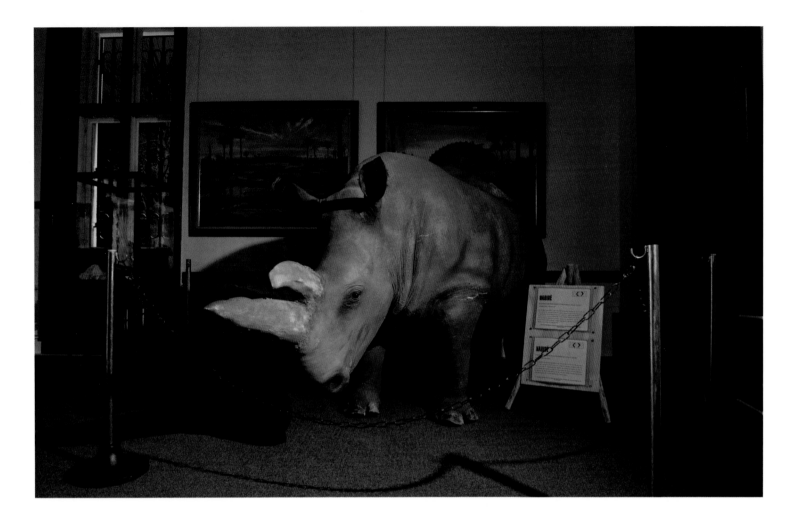

right this minute, to ensure biodiversity survives.

So let's talk about you for a minute.

Will you get off the bench? Will you step up and find a need in your community, and then actually do something about it? Start by thinking about what you love most, and what you would hate to lose. Perhaps you can get your city to grow native plants for pollinating insects in public parks and alongside roadways. Of course, no chemicals should be allowed there, not ever. Or maybe you realize that the house cats you love are efficient predators, and best kept inside to avoid killing songbirds.

ABOVE: Nabire today, mounted at Dvůr Králové Zoo's museum in the Czech Republic

Or you might start with your own home and then inspire your community to install special stickers on windows to save songbirds by avoiding collisions.

There are a thousand things you can do. Insulating your home, thus burning less fossil fuel to heat and cool it. Eating less meat, thus contributing in your small way to reducing the intensive use of carbon, chemicals, and water to raise livestock. Reducing, reusing, and recycling everything you buy.

The opportunities are endless.

With the Photo Ark, I'm doing all I can to turn things around, right this very minute.

Will you join me? ▪

Amazonian manatee, *Trichechus inunguis* (VU)

The world's only exclusively freshwater manatee, this South American marine mammal moves from flooded riverbeds in the wet season to deeper lakes in the dry season. Locals hunt them for their meat, and recent droughts have made them easier to find.

Sunda pangolin, *Manis javanica* (CR)

There are eight species of pangolins, and the Sunda subspecies is the most disrupted across Southeast Asia. The pangolin has up to 1,000 scales, falsely considered curative for a number of ailments in folk medicine.

BETWEEN 1975 AND 2011, ILLEGAL POACHING FOR FOLK

MEDICINE AND EXOTIC MEAT CONSUMPTION RESULTED

IN SUNDA PANGOLIN DEATHS OF APPROXIMATELY

500,000

THE IUCN RED LIST | BAROMETER OF LIFE

Nobody knows exactly how many species of plants and animals call our planet home. Scientists have given names to just under 2 million, but the actual number may be between 6 million and 2 billion. Biodiversity across the globe is rich, mysterious—and in peril.

Even as biologists discover new species, they race the clock to answer vital questions about the animals we've known for decades, or for centuries. Who are these creatures, and how do they live? What pressures threaten their existence? And how do we save the ones that are fading from our world?

The International Union for Conservation of Nature (IUCN) is the global authority on these questions. Since 1964, scientists have been working on a massive inventory of the world's living creatures by evaluating the risk of extinction for nearly 100,000 species. The Red List of Threatened Species, as this effort is collectively known, paints a global portrait of biodiversity and offers a baseline for measuring future changes to animals' population trends. Striking in its depth, the Red List reveals a disturbing truth: Roughly a quarter of all the assessed species—more than 26,000—are threatened with extinction.

The Red List is complex, but its framework is simple. Each species or subspecies falls into a category, listed opposite. Species that scientists can't formally assess because they know too little about them are classified as Data Deficient, and species that scientists have not yet assessed are classified Not Evaluated—a category that likely contains tens of thousands of species.

The Red List continues to grow and evolve as scientific research pushes on. Nearly all mammals, birds, and amphibians now have profiles. And scientists add new animals every year, like Durrell's night gecko, a vulnerable reptile that lives only on the island of Mauritius. They have reevaluated many others, occasionally finding bright spots, like the mountain gorilla, which was downlisted from critically endangered to endangered in 2018 thanks to collaborative conservation efforts. Their analyses yield sobering surprises, too, sometimes finding that entire species groups—such as groupers, a prized type of sea bass—are at much greater risk of extinction than previously estimated.

But the Red List is more than a deep well of scientific knowledge. It is also the common tongue across countries and continents for speaking about the conservation of species. Scientists, government officials, conservationists, journalists, and the private sector all turn to the Red List to

learn where animals live, how many are left, what type of habitat they need, and what sorts of conservation actions can slow their demise.

IUCN officials want the Red List to be a true barometer of life—a pressure gauge to help plan, prepare, and find solutions at a time when biodiversity is suffering from the human hand. But the Red List still has significant limitations. Tens of thousands of species have yet to be assessed. Marine animals, freshwater species, and invertebrates—the largest group in the animal kingdom—are all underrepresented. And lag times between scientific assessments are common.

For now, the work continues. The IUCN hopes to bring the total number of evaluated species to 160,000 by 2020. Then this barometer of life can come still closer to a complete reading of the health of our plants and animals. As it continues to grow and change, we can only imagine the insights it will reveal.

Throughout this book, we identify each animal's IUCN classifications, in some cases amplified or adjusted with current information from researchers who know these animals the best. Sometimes a subspecies will be experiencing greater threat than its parent species, and in those cases we indicate as such.

THE IUCN CLASSIFICATIONS

EX | EXTINCT There is no reasonable doubt that the last individual of a species has died.

EW | EXTINCT IN THE WILD Individuals of a species are known only to survive in captivity or as a naturalized population, well outside the former range.

CR | CRITICALLY ENDANGERED The best available evidence indicates that a species faces an extremely high risk of extinction in the wild.

EN | ENDANGERED The best available evidence indicates that a species faces a very high risk of extinction in the wild.

VU | VULNERABLE The best available evidence indicates that a species faces a high risk of extinction in the wild.

NT | NEAR THREATENED A species has been evaluated and does not currently qualify for one of the categories above, but is close to qualifying.

LC | LEAST CONCERN A species has been evaluated but does not qualify for any of the categories above.

DD | DATA DEFICIENT Not enough information is available to fully evaluate a species for its risk of extinction.

NE | NOT EVALUATED A species has not yet been evaluated for its risk of extinction.

GHOSTS

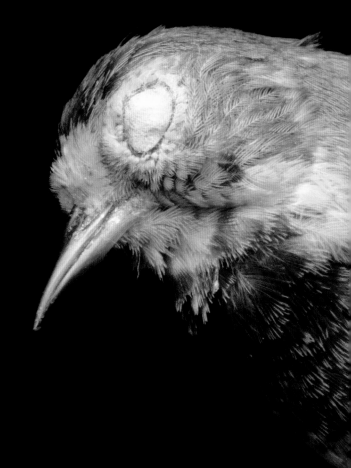

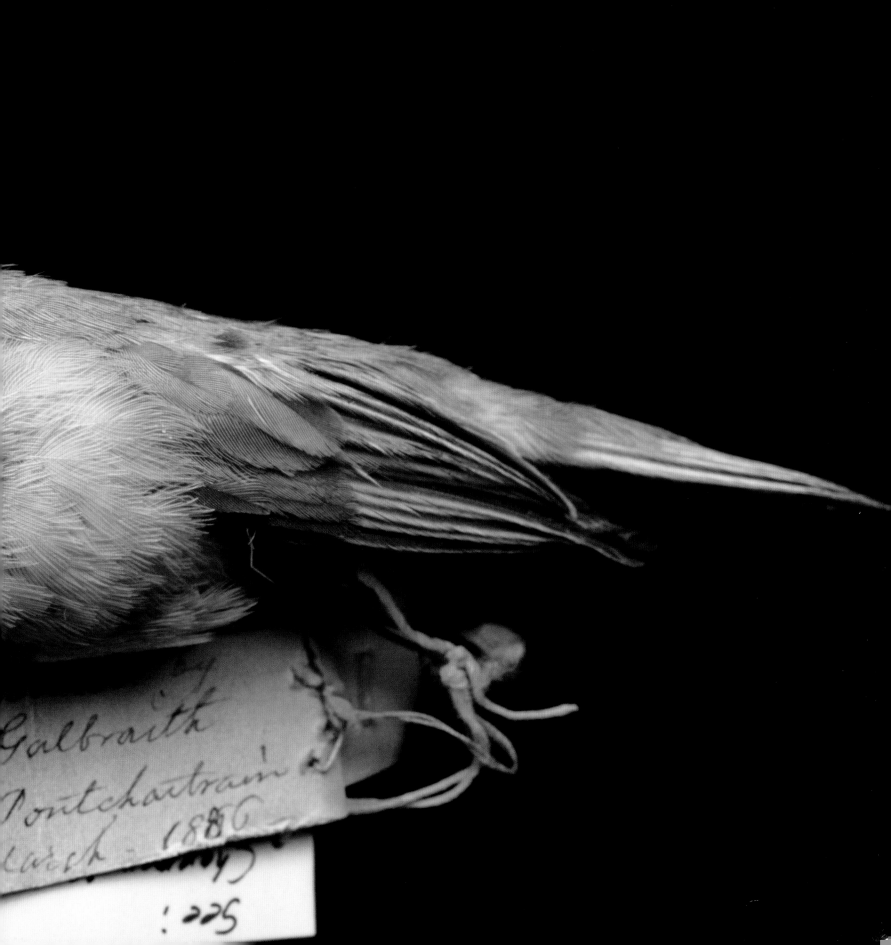

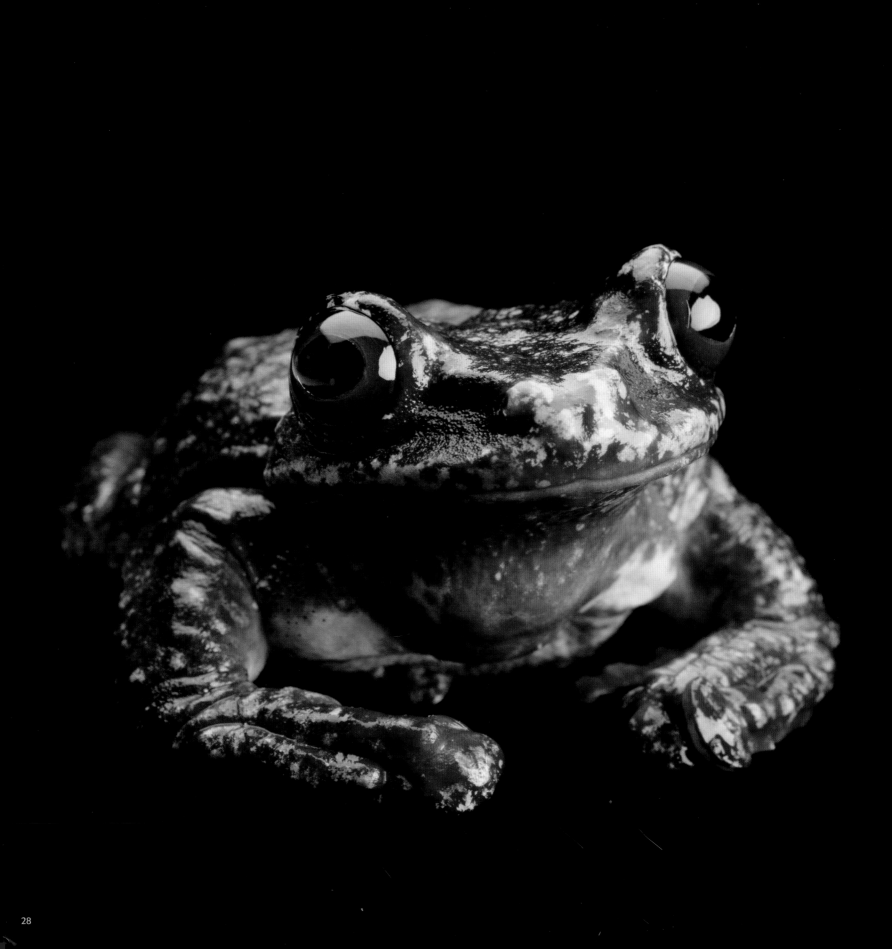

Hidden within the dense canopy of central Panama's cloud forests, the Rabbs' fringe-limbed tree frog was one of the rarest amphibians in the world. Webbing on its feet allowed the frog to leap between tree branches. Females laid eggs in water-filled tree holes, and males cared for tadpoles by allowing them to feed on flecks of skin.

But the Rabbs' fringe-limbed tree frog's final years were fraught with adversity. Disease ravaged its population, and human development sullied its habitat. The last time scientists heard the call of the Rabbs' fringe-limbed tree frog in the wild was in late 2007, but the species wasn't officially described to science until 2008. Just a year later the IUCN deemed it critically endangered. Captive-breeding efforts found no success, and the last known individual died in 2016 at the Atlanta Botanical Garden. Staff at the garden had nicknamed him Toughie.

Witnessing extinction can be disorienting. This creature can't truly be gone, we think. The Spix's macaw is too brilliantly blue, the South China tiger too fierce. Don't we still detect a presence? But eventually we accept the meaning of that last wild breath. This creature, once so alive, may now be a ghost.

If we're lucky, we find rare sparks that can bring species back from the brink. Some, like the Père David's deer, survive in captivity and, with good fortune and hard work, are reintroduced to the wild. Others, like the Columbia River Basin pygmy rabbit, persist in a new form—hybrids, but still here. But the grave truth is that for most animals, extinction is forever. That stark truth makes it all the more clear that we must save what we still have. ■

PREVIOUS: Bachman's warbler, *Vermivora bachmanii* (CR, possibly EX)
OPPOSITE: Rabbs' fringe-limbed tree frog, *Ecnomiohyla rabborum* (CR, possibly EX)
RIGHT: Guam rail, *Hypotaenidia owstoni* (EW)

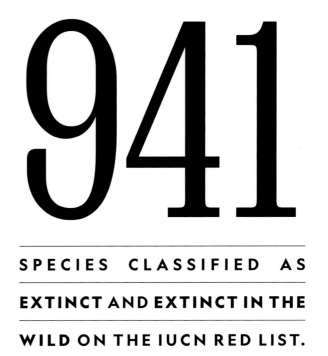

AS OF JAN. 2019, THERE ARE

941

SPECIES CLASSIFIED AS EXTINCT AND EXTINCT IN THE WILD ON THE IUCN RED LIST.

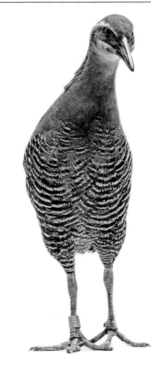

Butterfly splitfin, *Ameca splendens* (EW)

Once abundant in the Ameca River and its tributaries in western Mexico, this small fish is now more common in the aquarium trade. One small population of butterfly splitfin survives in a pond located in an amusement park.

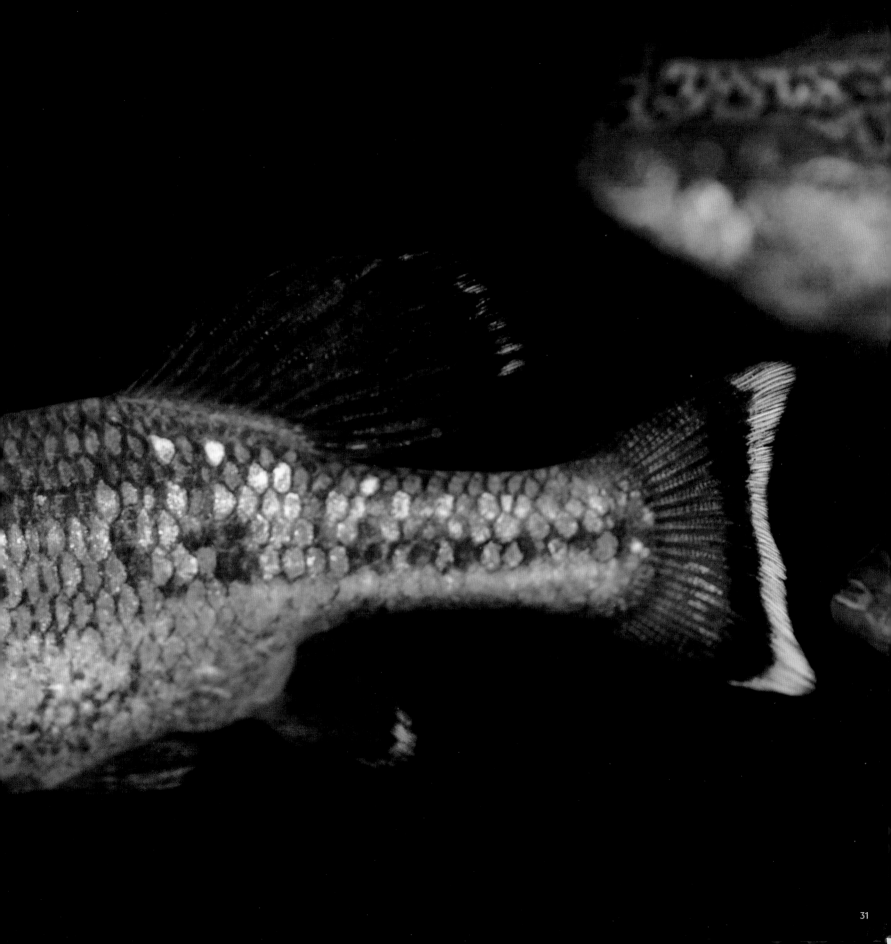

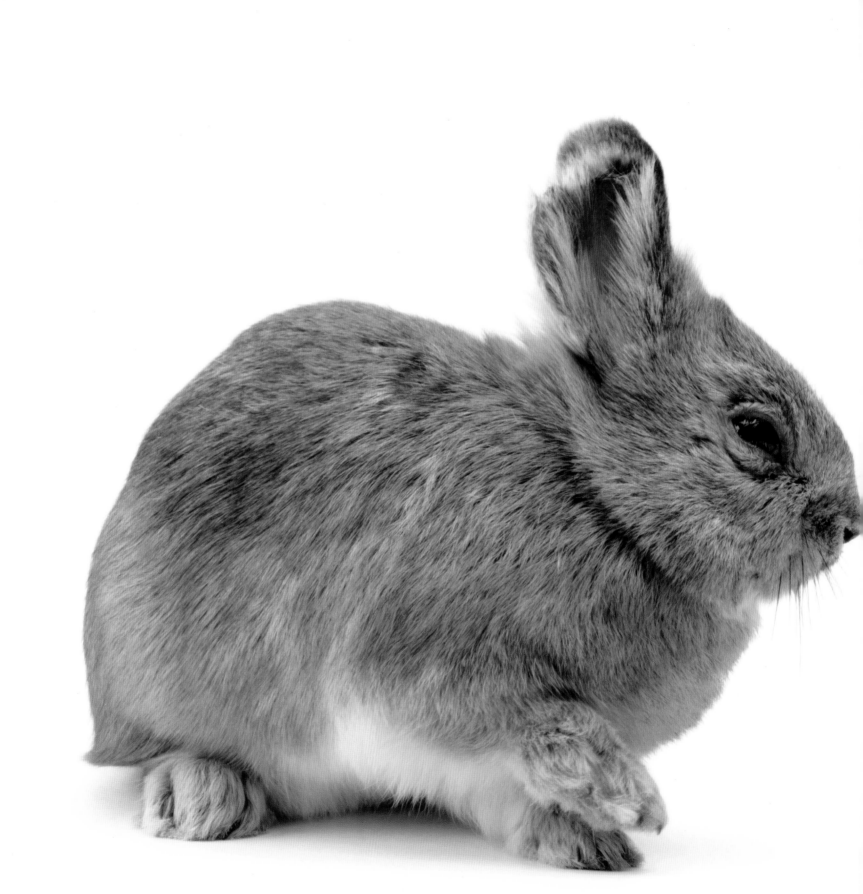

Columbia River Basin pygmy rabbit, *Brachylagus idahoensis* (LC)

Washington State was once home to a genetically unique subpopulation of pygmy rabbits. After habitat fragmentation and population decline, the Columbia River Basin pygmy rabbit was listed as endangered in 2001, and captive-breeding efforts found little success. Interbreeding may preserve some of the unique genetic traits of the subpopulation, but Bryn, pictured here, was the second to last known purebred Columbia River Basin pygmy rabbit.

THE LAST GENETICALLY DISTINCT
INDIVIDUAL IN THE WILD DIED IN
2008

Atossa fritillary, *Speyeria adiaste atossa* (NE, likely EX)

Fluttering on broad wings with delicate black markings, these butterflies used to be common in the mountains of Southern California. Like many butterflies, fritillary caterpillars have an extremely specialized diet. As the violet plants they fed on were cleared in favor of development, the Atossa fritillary faded—the last known individual of this species was collected in 1959.

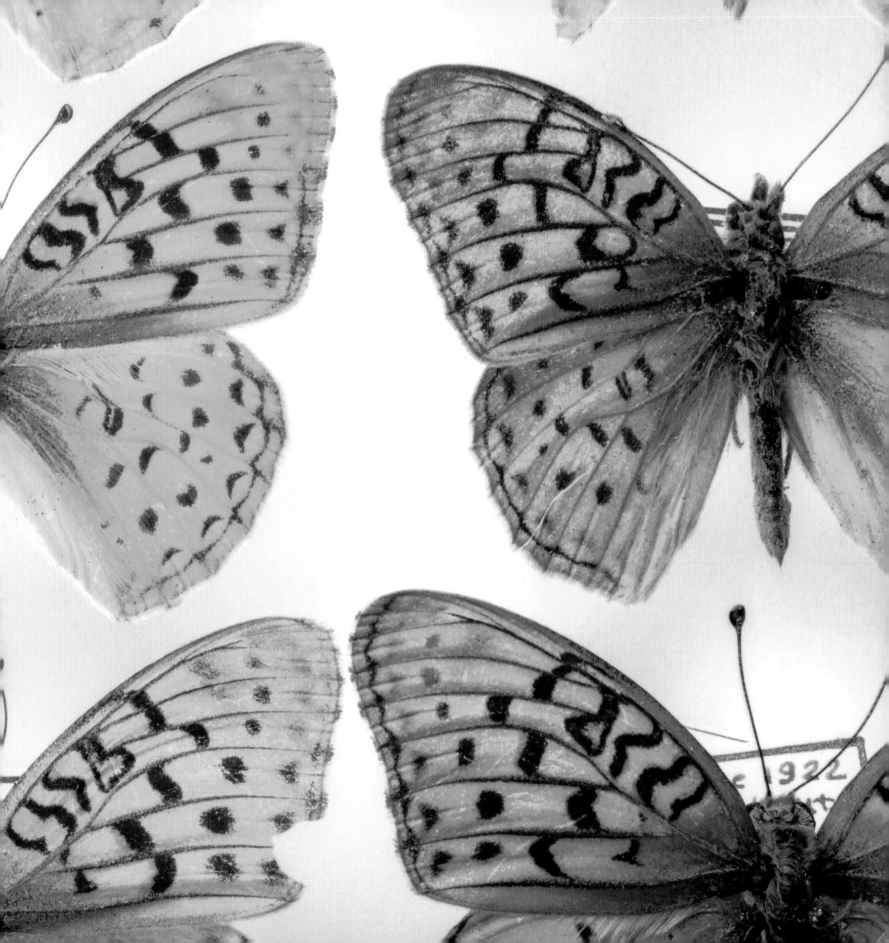

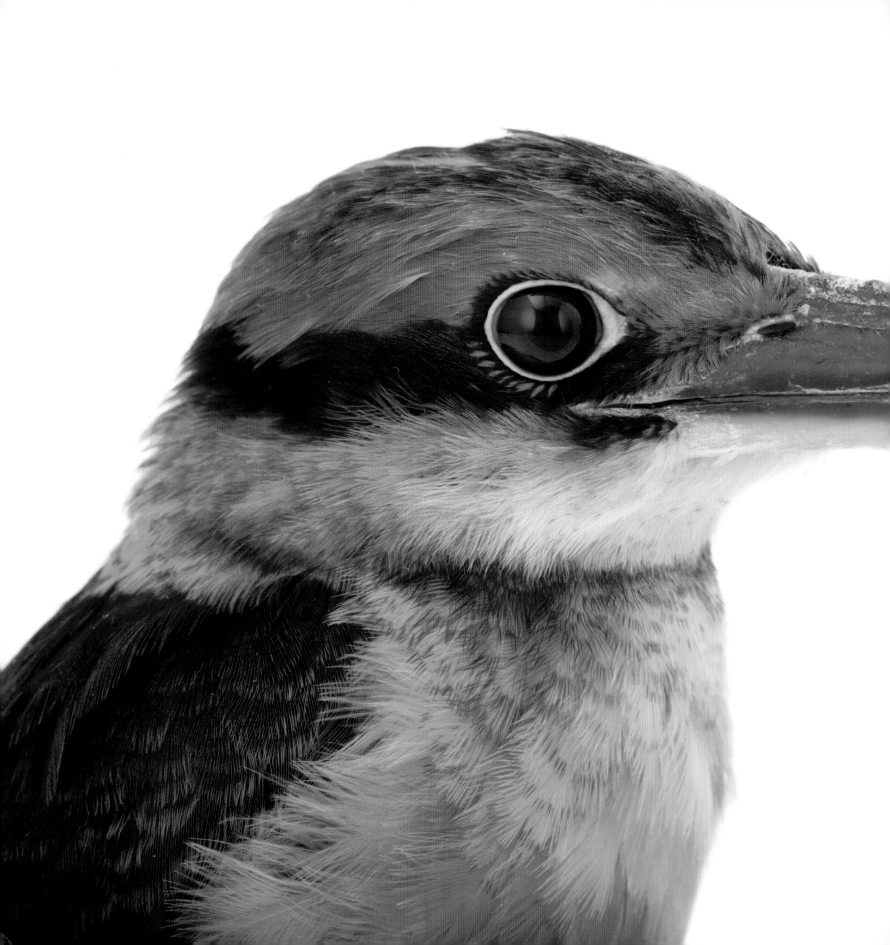

> ## " EVER SEEN A GHOST? YOU HAVE NOW. AMAZING BIRDS WITH A CALL THAT ONCE PIERCED THE FORESTS OF GUAM, THEY WOULD BE LONG GONE WITHOUT CAPTIVE BREEDING. TODAY THERE ARE FEWER THAN 200.

JOEL SARTORE

Guam kingfisher, *Todiramphus cinnamominus* (EW)

The accidental introduction of brown tree snakes on Guam upset a delicate balance in the island ecosystem. Many native lizard and bird species, including the Guam kingfisher, were extinguished from the island. In 1986, researchers brought the 29 known wild birds of this species under human care. Today there are fewer than 160 Guam kingfishers in the world, all living in captivity.

Scimitar-horned oryx, *Oryx dammah* (EW)

In the not-so-distant past, scimitar-horned oryx were abundant in the deserts of North Africa. They are uniquely adapted to their arid environments, pulling moisture from plants when drinking water was scarce. Loss of habitat and overhunting led to the species being declared extinct in the wild in 2000. Reintroduction efforts have begun in Tunisia, Morocco, and Senegal and are in the works in Chad and Niger.

Père David's deer, *Elaphurus davidianus* (EW)

In 1865, a small population of these deer living in a Beijing hunting garden were nearly the last of their kind. A French missionary brought a few to Europe, and that captive population grew as the native population in China declined. In 1985, Père David's deer were brought back to China, and hopes are they can return to the wild.

South China tiger, *Panthera tigris amoyensis* (CR, possibly EW)

In the early 1950s there were more than 4,000 South China tigers in the wild. They were seen as a pest and hunted to the brink of extinction until the Chinese government put protections for the species in place in the 1970s. It's estimated that fewer than 100 of these tigers exist today.

Ivory-billed woodpecker, *Campephilus principalis* (CR, possibly EX)

Ghost indeed: Ornithologists and avid birders hopefully foray into the greatly reduced territory of this bird, North America's largest woodpecker. Possible sightings were reported in Arkansas in 2004, but confirmation remains elusive. This stuffed individual resides at the University of Nebraska State Museum.

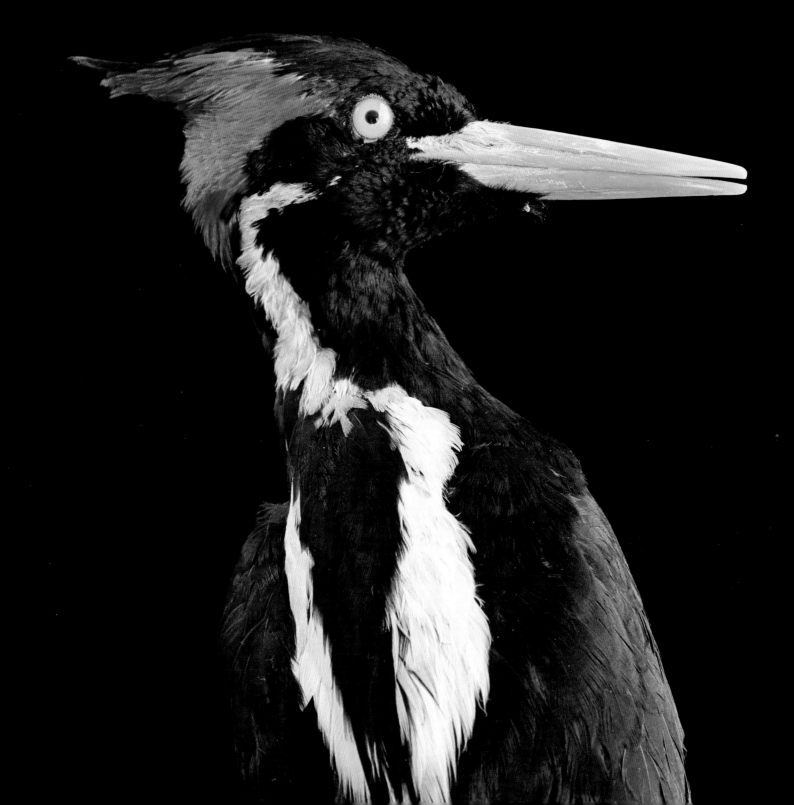

Dusky seaside sparrow,
Ammospiza maritima nigrescens (EX)

When the Kennedy Space Center was being built in Florida, the nearby marsh was flooded in an effort to reduce mosquitoes, devastating the dusky seaside sparrow's nesting grounds. A small population survived, but with no habitat protections in place, their numbers dwindled. The last known dusky seaside sparrow, pictured here, died on June 16, 1987, and the species was declared extinct in 1990.

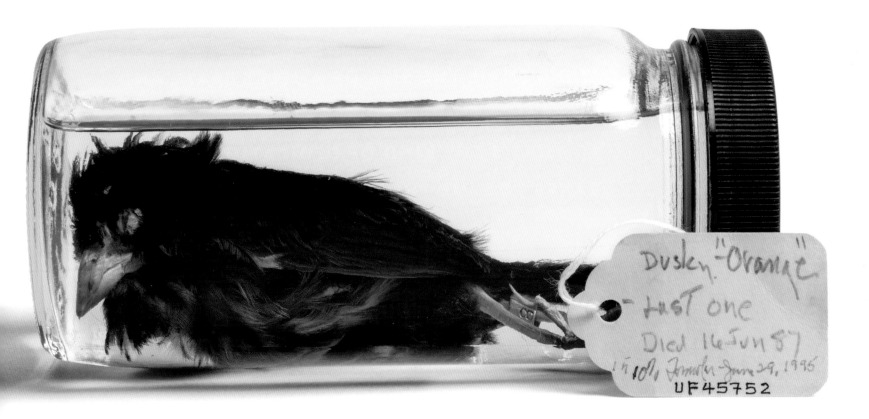


"IT'S A SNAIL THE SIZE OF A JELLY BEAN, AND THE SAINT LOUIS ZOO SPENT YEARS SAVING IT. THAT'S THE KIND OF DEDICATION IT TAKES TO SAVE THE WORLD.


JOEL SARTORE

Polynesian tree snail, *Partula nodosa* (EW)

These small terrestrial snails are native to the South Pacific island of Tahiti. In the late 1970s, the arrival of a predatory snail species meant to control a different invasive species led to massive population decline. Though the Partula snail had disappeared from Tahiti by the late 1980s, captive populations offered hope. Since 2015, snails bred at the Saint Louis Zoo have been reintroduced to their native range in Tahiti.

Wyoming toad, *Anaxyrus baxteri* (EW)

These small, unassuming brown toads were once common in the floodplains of Wyoming's Laramie River. An increase in pesticide use in the 1970s and '80s may have contributed to the devastation of their population, and all known wild toads were brought into captivity in the mid '90s. Their numbers have risen, but a disease called chytridiomycosis threatens toads—among many other amphibians.

Kihansi spray toad, *Nectophrynoides asperginis* (EW)

Kihansi Falls in eastern Tanzania was once home to around 17,000 of these small amphibians. When a new dam was built, cutting off most of the water to the waterfall, the toads suffered as their habitat dried out. In 2000 about 500 toads were collected and brought to the United States. Captive breeding was successful, and the population grew to more than 6,000 toads, some of which are now being reintroduced to their native habitat.

Spix's macaw, *Cyanopsitta spixii* (CR possibly EW)

These brilliant blue birds have most likely disappeared from the rainforests of Brazil. A lone wild sighting in 2016 sparked hope that the Spix's macaw might persist, but scientists believe that the sighting was a captive bird that had escaped. About 60-80 of these parrots continue to live in captivity.

DISAPPEARING

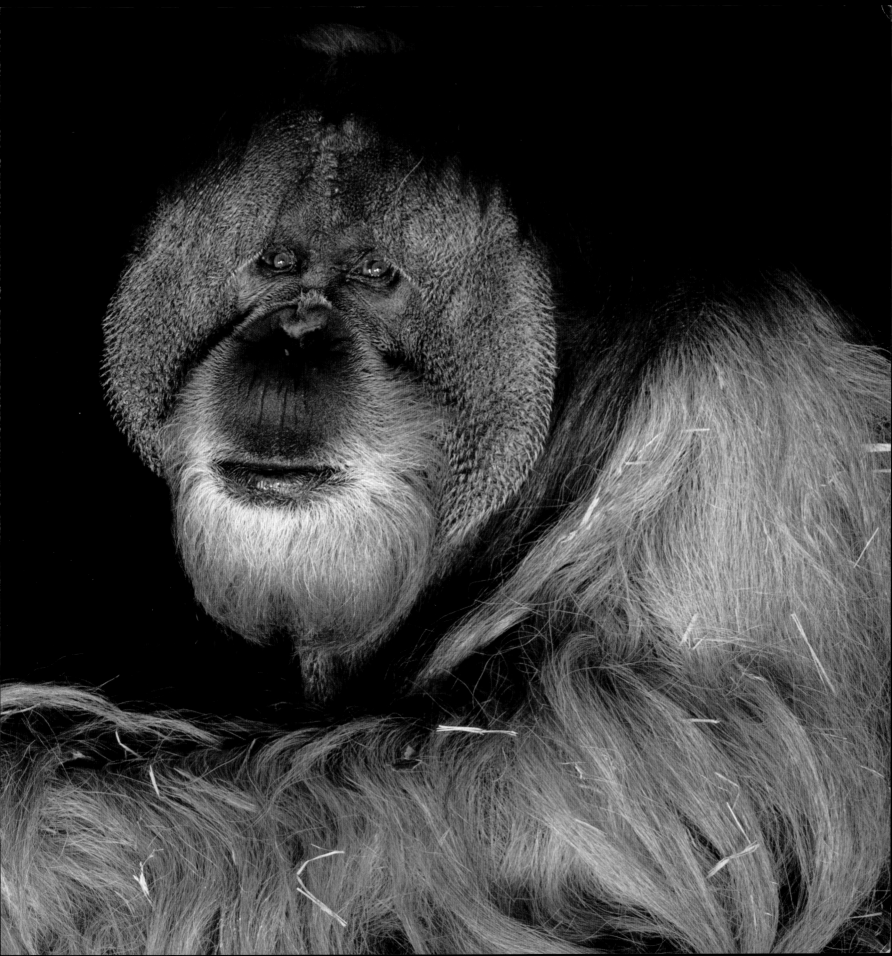

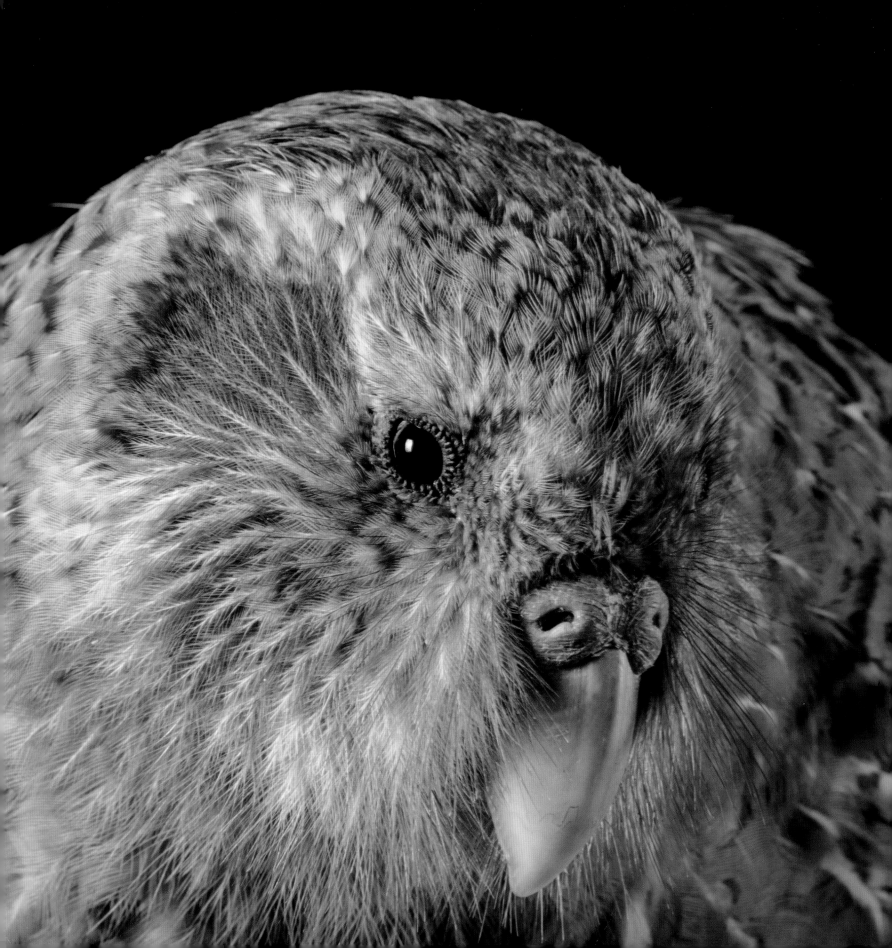

For millions of years the kakapo, like most animals, has lived a simple life. Stay under cover by day. Forage by night. Mate when favorite trees produce their rich fruits and seeds. With a range that once covered New Zealand, this parrot has left a legacy in the ancient dirt, its bones proof of a natural history older than mankind.

Evolution created a flightless bird that was perfectly adapted for its island environment. But as with so many animals now hovering on the brink of extinction, the arrival of humans and the things that came with them, from domesticated animals to disease, spelled trouble. The kakapo soon faced a new set of mammalian predators it was not designed to dodge. Within centuries—a speck of time in the kakapo's long history—the birds nearly vanished. By the late 20th century only 62 survived. Today, even with intense conservation efforts, fewer than 150 kakapos remain.

In this chapter we meet animals who are disappearing before our eyes. A wildcat losing its wildness to hybridization with house cats. A fish-eagle whose fish are now scarce. A gangly insect known as a tree lobster, ravaged by invasive rats, and a slow-growing coral nearly wiped out by disease. And then, right on the brink: A long-lived turtle gone from its home range along one of the most polluted rivers in the world, its future utterly dependent on two aging individuals living in captivity. As dire as their situations may be, what the kakapo and these other creatures tell us—if we listen—is that their stories mustn't end here. Disappearing need not be the same as being gone. ◼

PREVIOUS: Sumatran orangutan, *Pongo abelii* (CR)
OPPOSITE: Kakapo, *Strigops habroptila* (CR)
RIGHT: Mongoose lemur, *Eulemur mongoz* (CR)

AS OF JAN. 2019, THERE ARE

5,826

CRITICALLY ENDANGERED

SPECIES ON THE IUCN RED LIST.

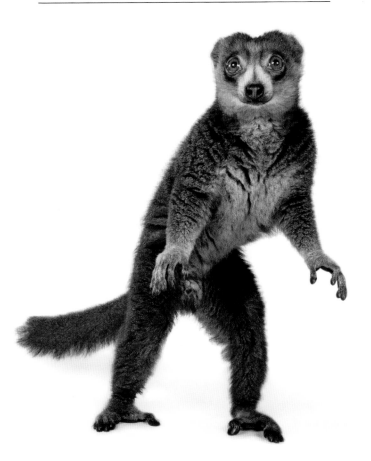

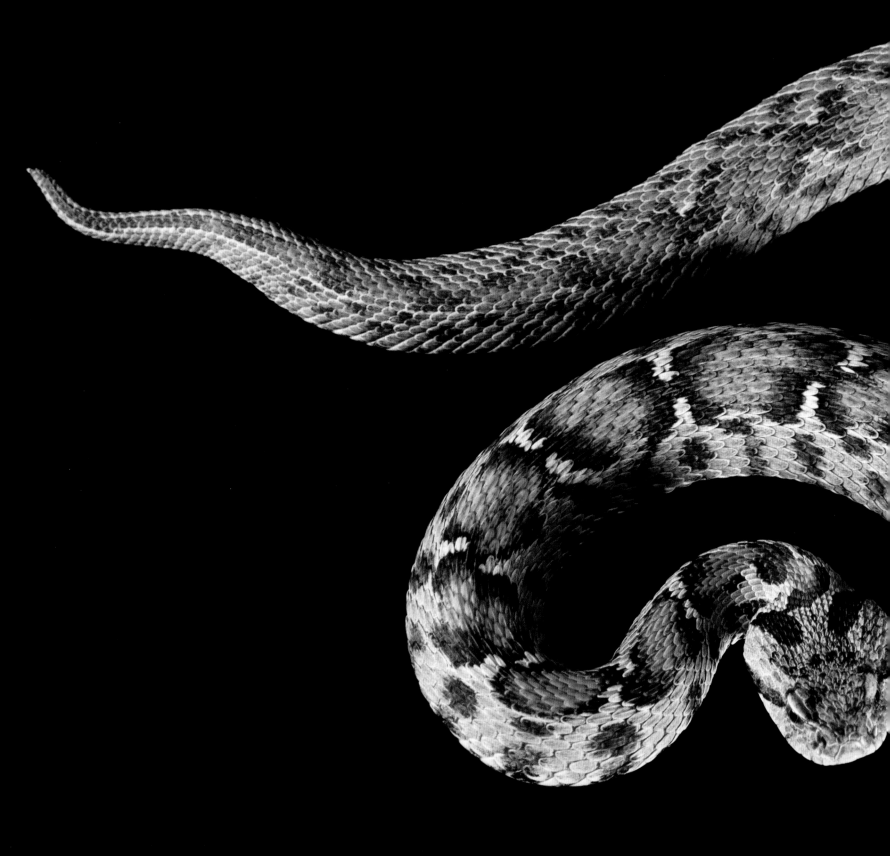

Wagner's viper, *Montivipera wagneri* (CR)

First discovered in Iran in 1846, the Wagner's viper wasn't seen for over 140 years and was considered extinct until the mid-1980s, when a number of snakes were found in Turkey.

Variegated spider monkey, *Ateles hybridus* (CR)

These South American monkeys play a vital role spreading seeds in their native forests—at least 148 species of plants and fruits rely on the critically endangered primates for dispersal.

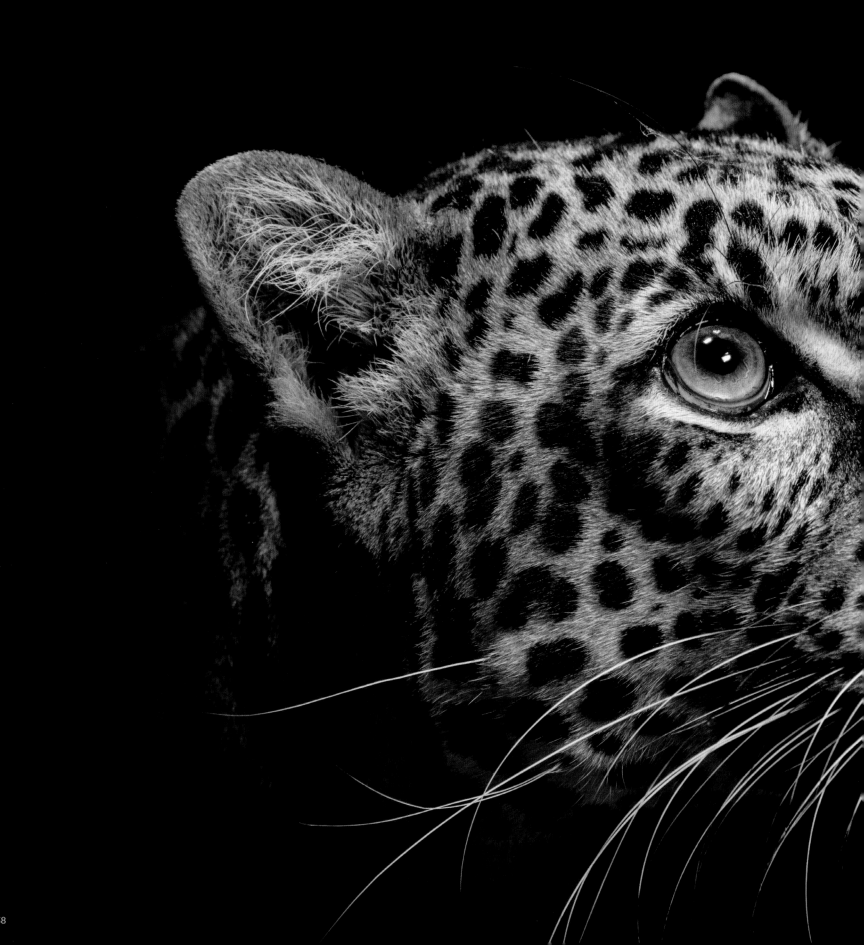

THE LAST LARGE CARNIVORE REMAINING ON ITS

CROWDED ISLAND HOME, THE JAVAN LEOPARD'S

NUMBERS MAY HAVE DROPPED UNDER

500

Javan leopard, *Panthera pardus melas* (CR)

The last big cat surviving on Java, the Javan leopard is believed
to have come to the Indonesian island 600,000 years ago via
an ice-age land bridge from mainland Asia. On neighboring
Sumatra, leopards were likely wiped out in a volcanic eruption
about 74,000 years ago.

Negros bleeding-heart, *Gallicolumba keayi* (CR)

Endemic to the Philippine islands of Negros and Panay, the Negros bleeding-heart is one of five bleeding-heart ground doves in the region, named for a distinct red patch on their throat and breast.

Regent honeyeater, *Anthochaera phrygia* (CR)

The songs of the regent honeyeater, which is found on the western slope of Australia's Great Dividing Range, have been known to change over time and even have regional dialects inside their range.

Pinstripe damba, *Paretroplus menarambo* (CR)

This small freshwater fish was thought to be extinct in the wild until 2008, when a small population was discovered in a lake in northwestern Madagascar.

Mhorr gazelle, *Nanger dama mhorr* (CR)

The world's largest gazelle, these desert dwellers (a sub-species of the Dama gazelle) were once widespread across Chad, Sudan, and Darfur. They can bounce with all four feet off the ground, an action known as stotting.

WITH SMALL, FRAGMENTED SUBPOPULATIONS,

THE TOTAL NUMBER OF DAMA GAZELLES LEFT

IN THE WORLD MAY BE FEWER THAN

250

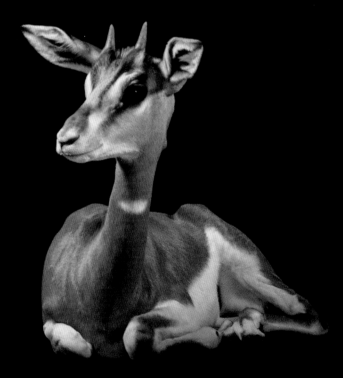

Lord Howe Island stick insect,
Dryococelus australis (CR)

Populations of these insects, colloquially known as
tree lobsters, were devastated by rats that swam
to Australia from a capsizing ship. The invasive
rodents overwhelmed the species, which was
thought extinct by 1920, but a small population
was confirmed in 2001.

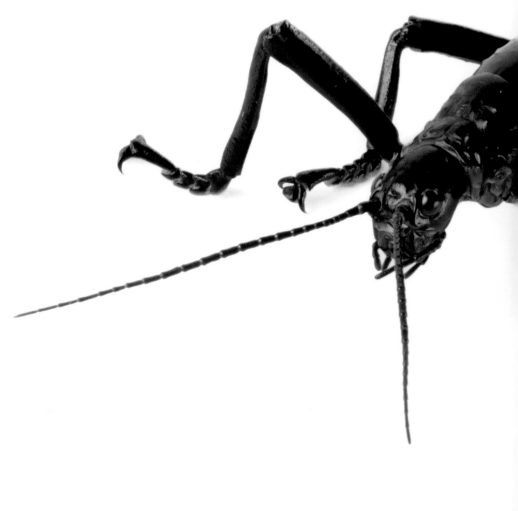

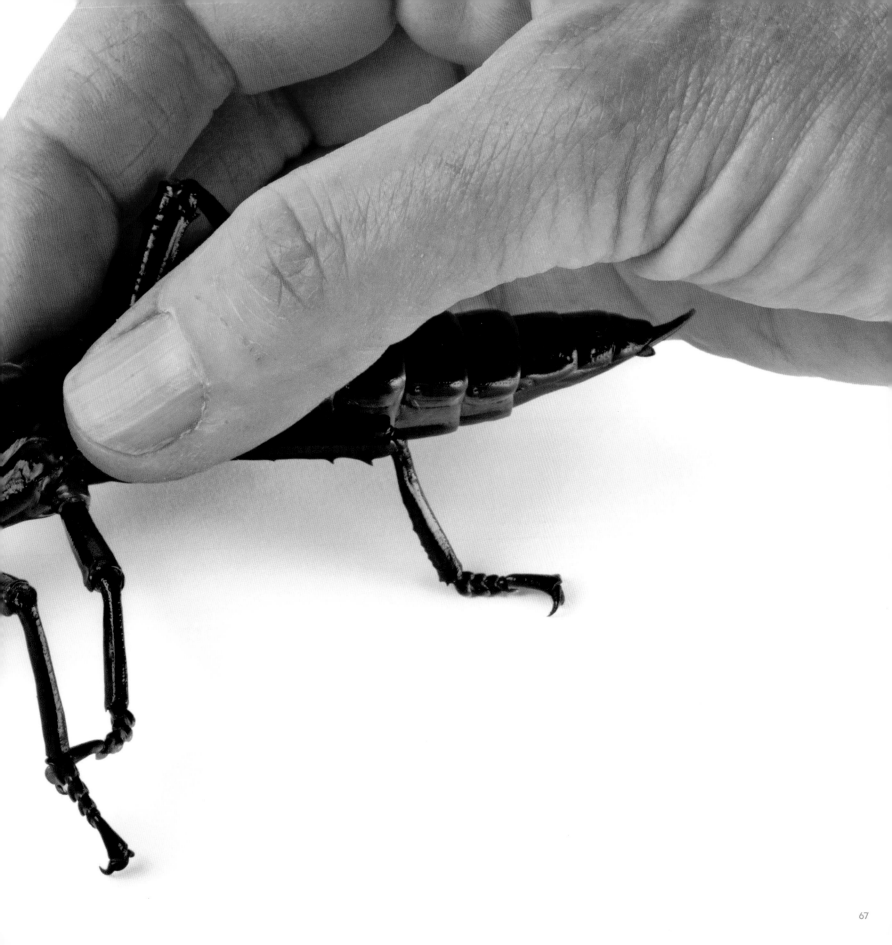

≈135

MATURE INDIVIDUALS

REMAIN IN THE WILD

LURKING IN RIVERS, creeks, and marshes, the Philippine crocodile captures prey of all sorts: dragonflies, fish, snakes, waterbirds, dogs, and even pigs. It would seem this reptile could prowl its territory unafraid. But humans are its only known predators, and our impact has been severe. Hunting, habitat loss, and entanglement in fishing nets have caused the reptile's range to shrink and its numbers to drop. Scientists believe the crocodile was once found across the Philippine islands. But today these reptiles are only known to inhabit three areas—northern Luzon, southwestern Mindanao islands, and Dalupiri Island—and the latest population estimates suggest a downward trend. Despite legal protection, decades of captive-breeding efforts, and on-site conservation, as of 2012, fewer than 200 crocodiles remain in the wild.

Philippine crocodile, *Crocodylus mindorensis* (CR)

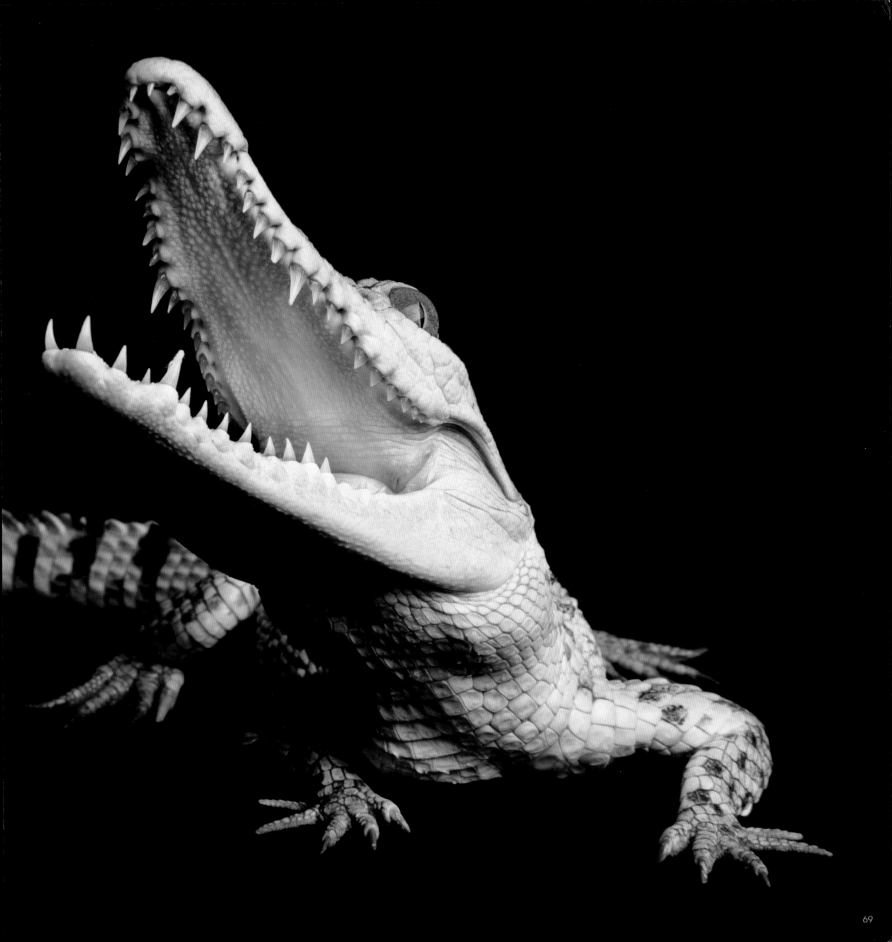

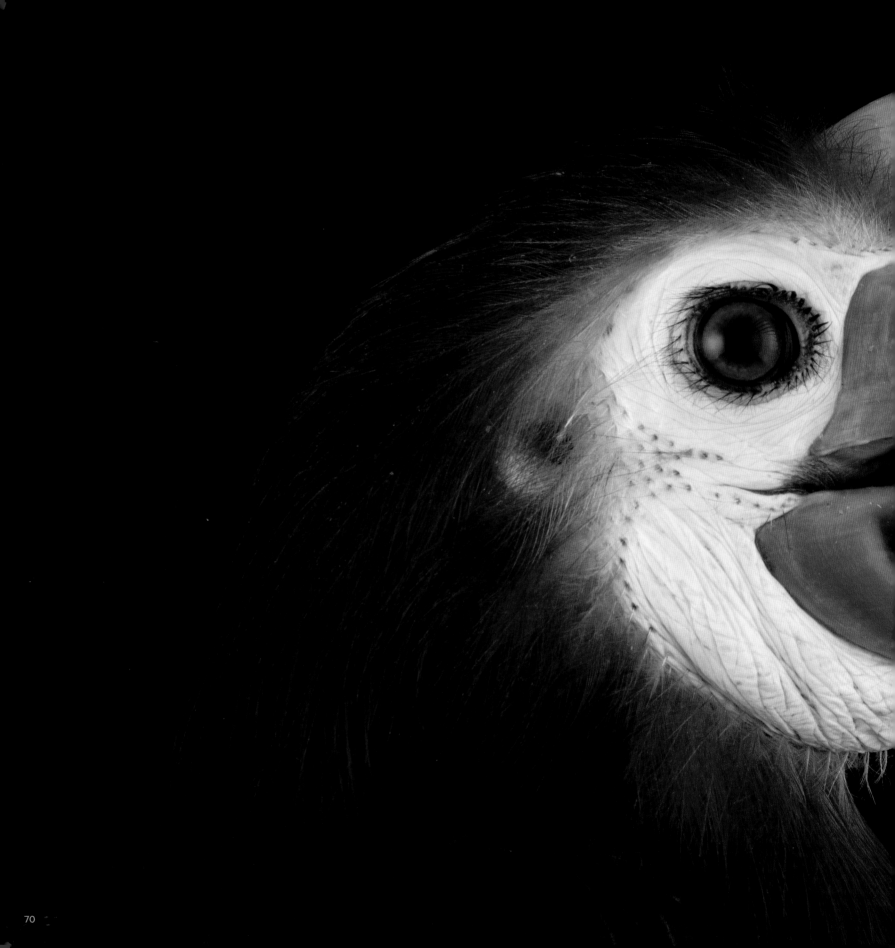

Rufous-headed hornbill,
Rhabdotorrhinus waldeni (CR)

Recent surveys estimate a population of between 1,500 and 4,000 surviving individuals. Massive deforestation in the Philippines has left the islands of Negros and Panay where this hornbill lives at about 3 percent and 6 percent, respectively, of their original forest cover.

Sumatran tigers, *Panthera tigris sumatrae* (CR)

The vast majority of Sumatran tiger deaths are from direct human slaughter. At least 40 of these critically endangered animals are killed by poachers every year.

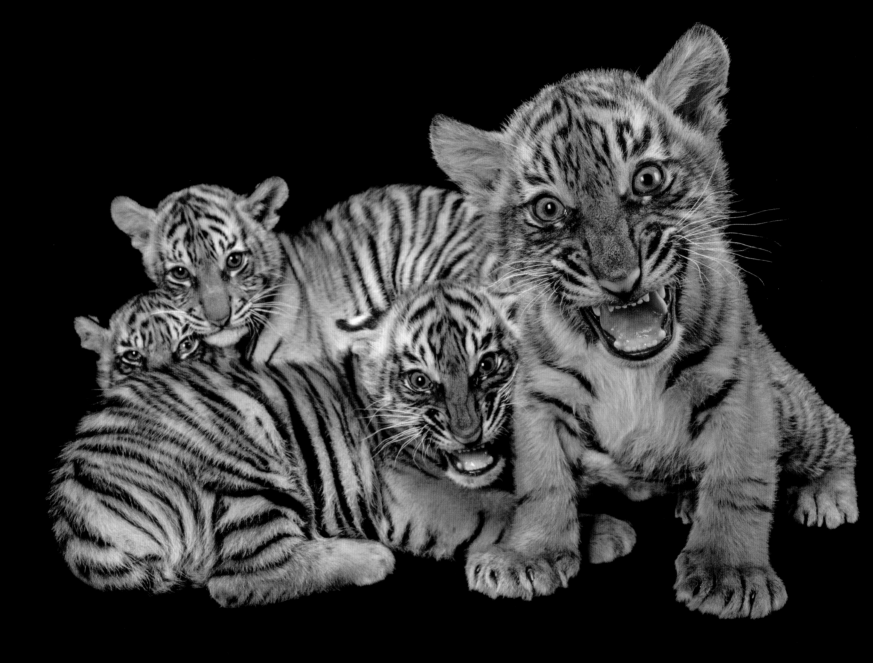

Visayan warty pig, *Sus cebifrons negrinus* (CR)

When threatened, Visayan warty pigs will raise the hairy mane of bristles on their back to seem larger, forming an impressive mohawk.

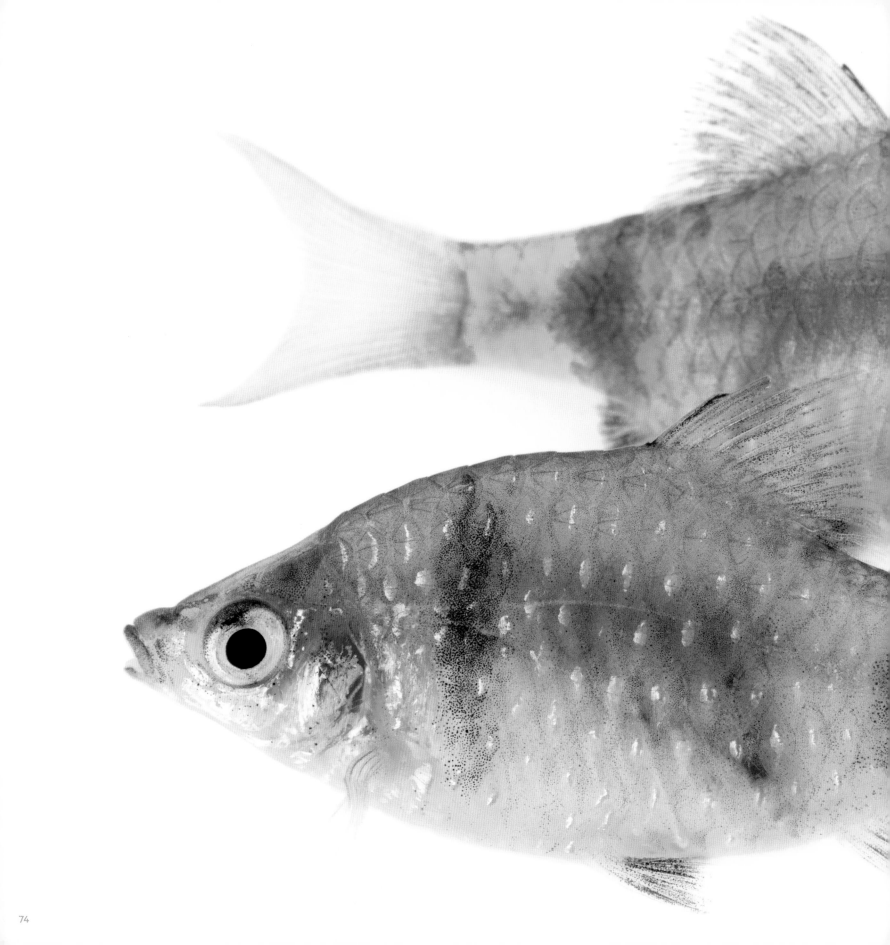

THE BANDULA BARB BROUGHT THE

NUMBER OF PHOTO ARK SPECIES TO

9,000

Bandula barb, *Pethia bandula* (CR)

This small freshwater fish can be found only in a small stream
in Galapitamada, Sri Lanka. Within a decade of its discovery,
the estimated population shrank from about 2,000
individuals to just 200-300.

Sumatran elephant, *Elephas maximus sumatranus* (CR)

The population of these small Asian elephants has been cut in half in just a single generation owing in large part to the widespread devastation of their forests for palm oil, rubber, and pulpwood production.

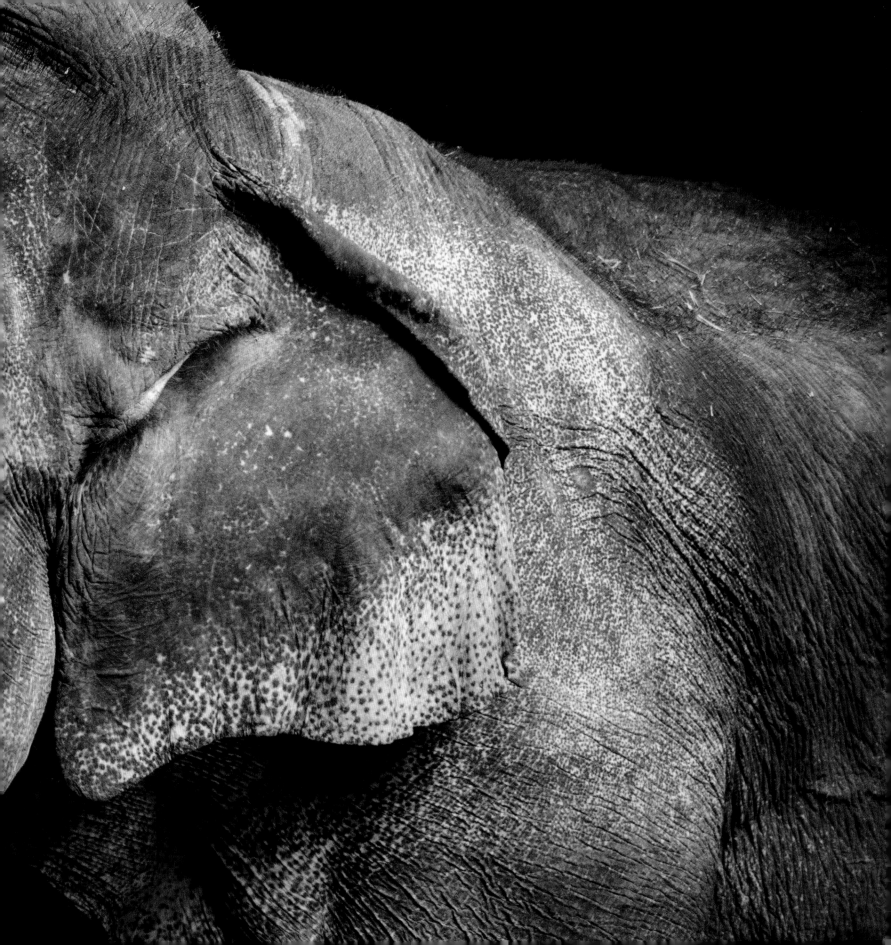

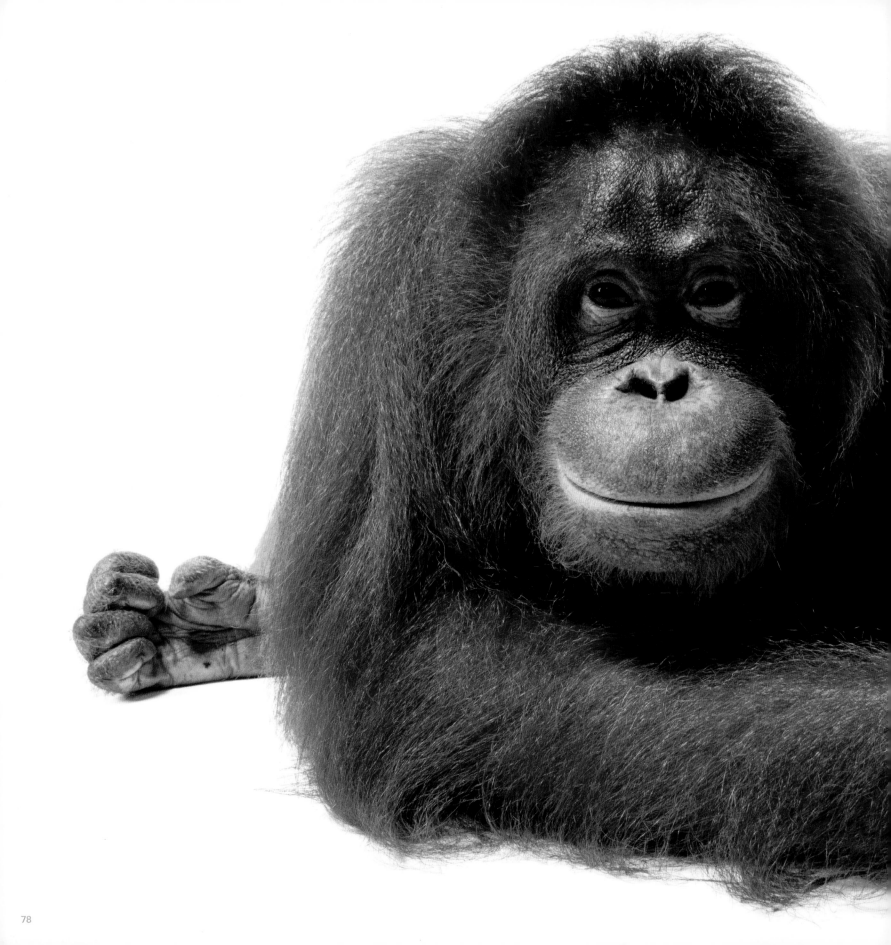

> "**TRUSTING, RELAXED, AND CURIOUS, ONCE TRIXIE THE ORANGUTAN UNDERSTOOD I WAS THERE TO TAKE HER PICTURE, SHE ACTUALLY LEANED IN.**"

JOEL SARTORE

Bornean orangutan, *Pongo pygmaeus wurmbii* (CR)

One of the only great apes in Asia, these orangutans tend to lead solitary lives and have only one offspring every six to eight years. Destruction of their forest habitat and illegal hunting are driving this unique species toward extinction.

Kurdistan newt, *Neurergus derjugini microspilotus* (CR)

Severe drought in the Zagros Mountains and the illegal pet trade threaten this stream-dwelling species. While it is legally protected in Iran, without enforcement the newt's numbers continue to dwindle.

American burying beetle,
Nicrophorus americanus (CR)

These beetles bury dead animals in order to feed their young.
When the larval beetles hatch, both parents stick around to
care for the brood, which can reach up to 30 young.

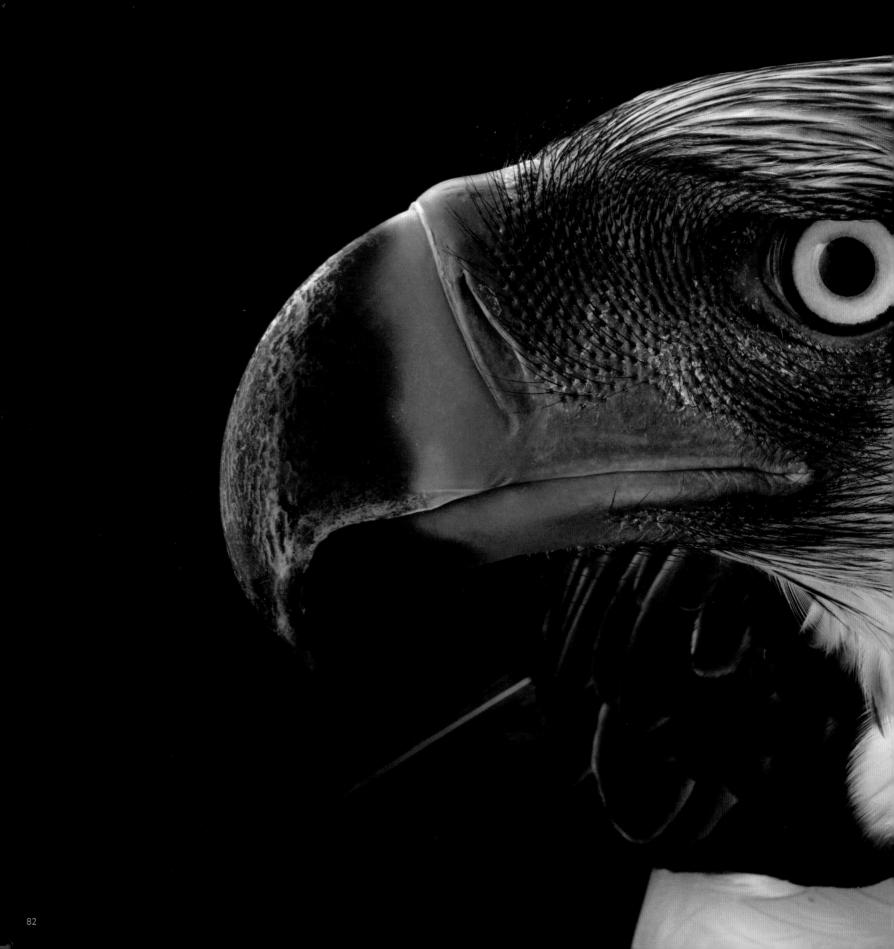

Philippine eagle, *Pithecophaga jefferyi* (CR)

These eagles, the national bird of the Philippines, are one of the largest on Earth, but they have developed shortened wingspans to maneuver between trees in their forest habitat.

RISING SEAS

PREDICTIONS THAT OCEAN LEVELS will rise 65 centimeters in the next 80 years suggest a bleak outlook for a low-lying archipelago. The Florida Keys' wetlands, mangrove forests, and pine rocklands just barely clear the high tide line, but they support a rich array of wildlife, including the endangered Stock Island tree snail and the Schaus swallowtail butterfly. The islands' unique landscapes are also home to many regional subspecies, like the Key deer, that occur only there and are already in decline. The silver lining is that conservationists, federal officials, and scientists all seem to agree on an urgent need to identify the long-term threats of sea-level rise on the Florida Keys—and establish systems and protections that will help its wildlife adapt to the changes ahead.

TOP ROW, LEFT TO RIGHT: Key Largo cotton mouse, *Peromyscus gossypinus allapaticola* (LC); Lower Keys marsh rabbit, *Sylvilagus palustris hefneri* (CR); Silver rice rat, *Oryzomys palustris natator* (LC) **BOTTOM ROW, LEFT TO RIGHT:** Stock Island tree snail, *Orthalicus reses reses* (EN); Key deer, *Odocoileus virginianus clavium* (LC); Key Largo wood rat, *Neotoma floridana smalli* (LC); Schaus swallowtail butterfly, *Papilio aristodemus* (NE)

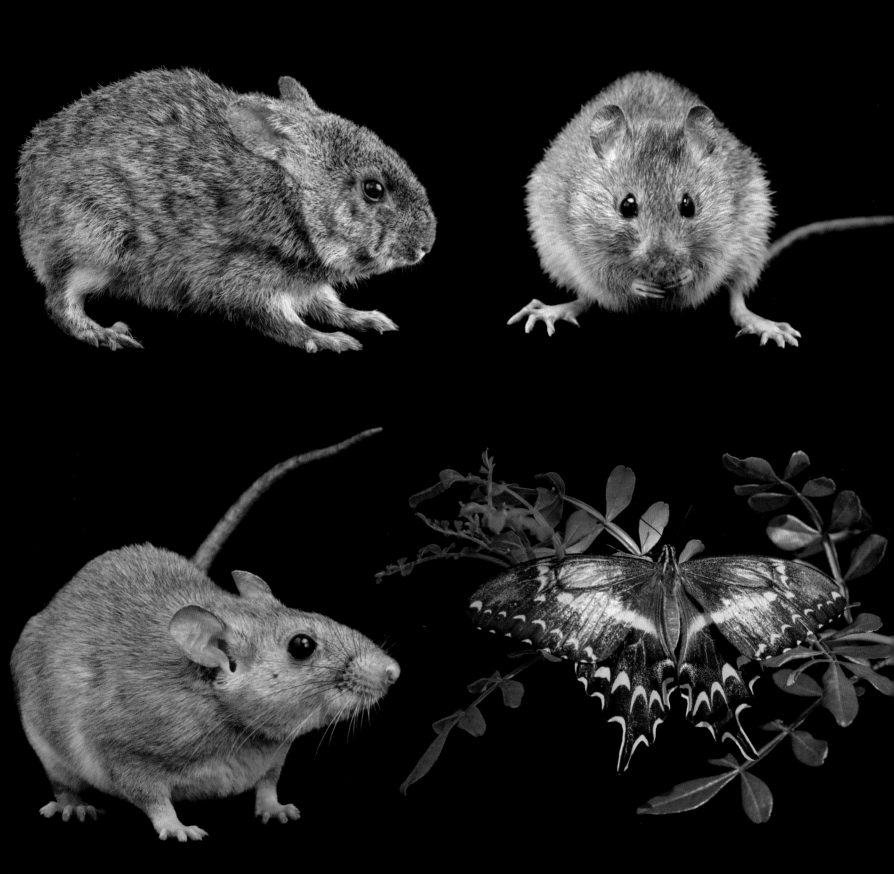

FACING THREATS FROM CLIMATE CHANGE, HABITAT LOSS, AND LIVESTOCK ENCROACHMENT, THE AFRICAN WILD ASS POPULATION NUMBERS ABOUT 70

Somali wild ass, *Equus africanus somaliensis* (CR)

DNA analysis has shown that the African wild ass—of which this Somali wild ass is a subspecies—is a forerunner to modern donkeys. Today inbreeding and competition with donkeys are among the animal's biggest threats.

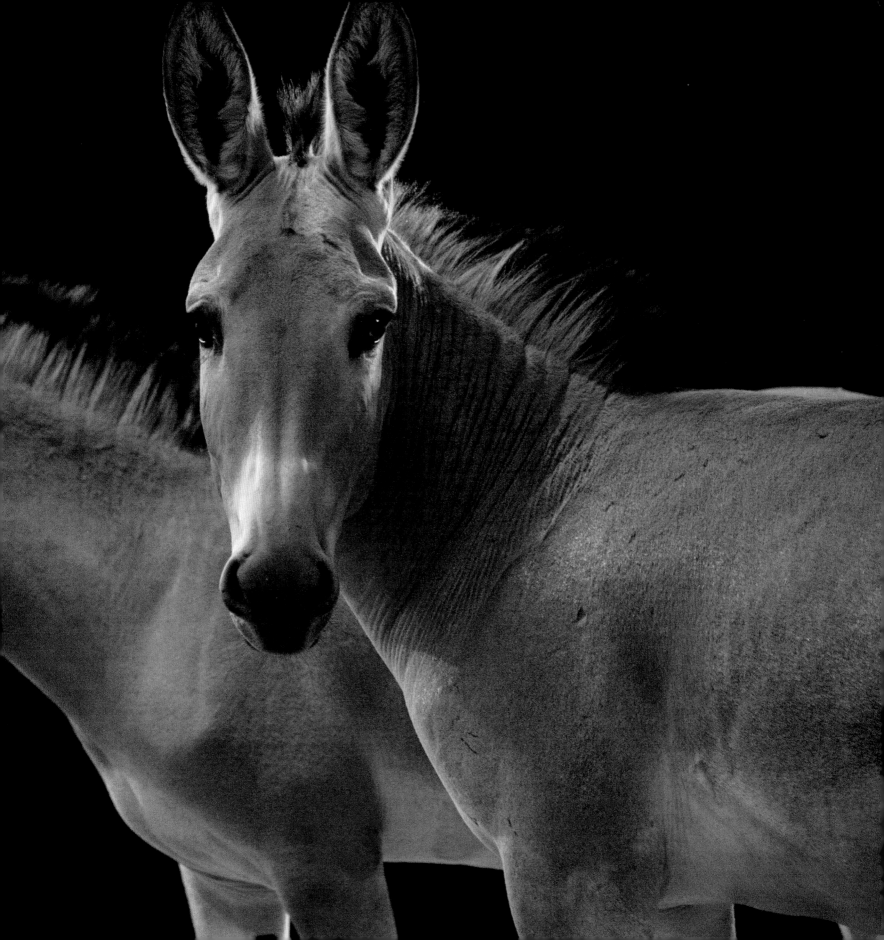

Peacock parachute spider, *Poecilotheria metallica* (CR)

This spider is so rare that in the wilds of India only two have been seen since 1899. But it is easily obtainable through the international pet market, which may offer a pathway to reintroduction.

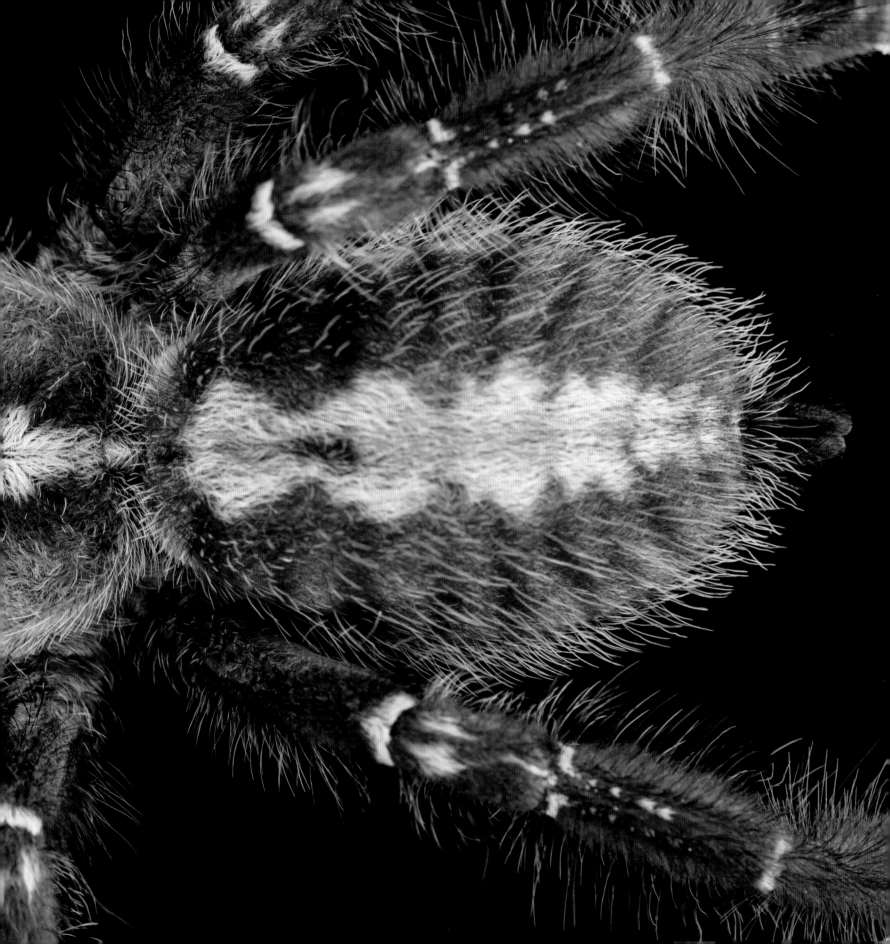

Pygmy hog, *Porcula salvania* (CR)

The smallest and rarest species of wild pig, the pygmy hog once roamed the grasslands of India. Today it is on the brink of extinction, with only a few hundred in the wild.

Cát Bá langur, *Trachypithecus poliocephalus* (CR)

These Asian monkeys spend their days swinging through woody forest, but nights with a troop in the limestone caves of Vietnam. Langurs will often rotate nights between different caves throughout their territory.

Diademed sifaka, *Propithecus diadema* (CR)

These Madagascan lemurs may only be fertile one day per year, which has limited their ability to rebuild a population severely damaged by slash-and-burn agriculture.

" LIVING UNDERWATER AT HIGH ALTITUDE MEANS LESS OXYGEN TO BREATHE THROUGH YOUR SKIN. THIS FROG SOLVED THE PROBLEM BY RAD-ICALLY INCREASING ITS SURFACE AREA WITH FLAPS RESEMBLING AN AQUATIC SHAR-PEI.

JOEL SARTORE

Titicaca water frog, *Telmatobius culeus* (CR)

In 2016, a mysterious event led to the death of approximately 10,000 Titicaca water frogs in Peru. Scientists guess that heavy pollution was the cause, but an official answer has yet to be announced.

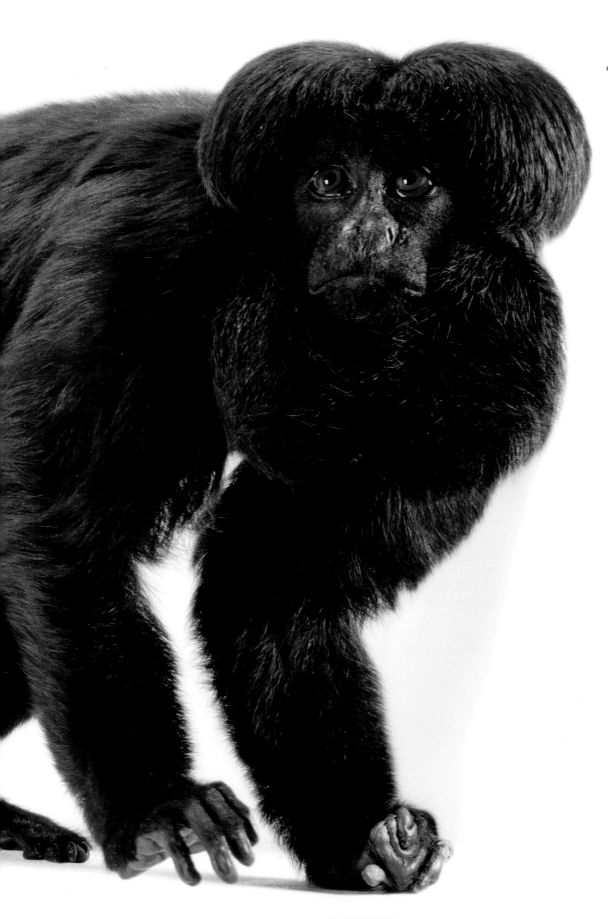

Black bearded saki, *Chiropotes satanas* (CR)

Native to eastern Brazil, this Amazonian monkey lives on fruit seeds, pulp, and flowers. Logging and farming have diminished its habitat, and bands of 4 to 39 have been discovered, surviving for years on their own on isolated islands.

≈240

MATURE INDIVIDUALS

REMAIN IN THE WILD

HIGH IN A TREE by the water's edge, a Madagascar fish-eagle waits and watches. She snatches her prey from the surface of the water with sharp talons. These birds have lived in this region for thousands of years, but their reliance on the sea is now one of the leading causes of their population decline. Despite its shaggy, powerful appearance, Madagascar's largest raptor competes with another hungry species to catch the fish it depends on to survive: humans. Roughly 240 fish-eagles remain in the wild, and conservationists have identified a long list of threats, including deforestation and water pollution, that could be perilous for such a small population. There's good news, though. In 2015, the Malagasy government granted protected status to two wetland areas near Antsalova and Tambohorano that are home to about a quarter of the bird's breeding population. Conservationists with the Peregrine Fund are working with local communities to make small changes that could have big returns, such as providing fishermen with fiberglass canoes in place of wooden ones to preserve trees for fish-eagle perches.

Madagascar fish-eagle, *Haliaeetus vociferoides* (CR)

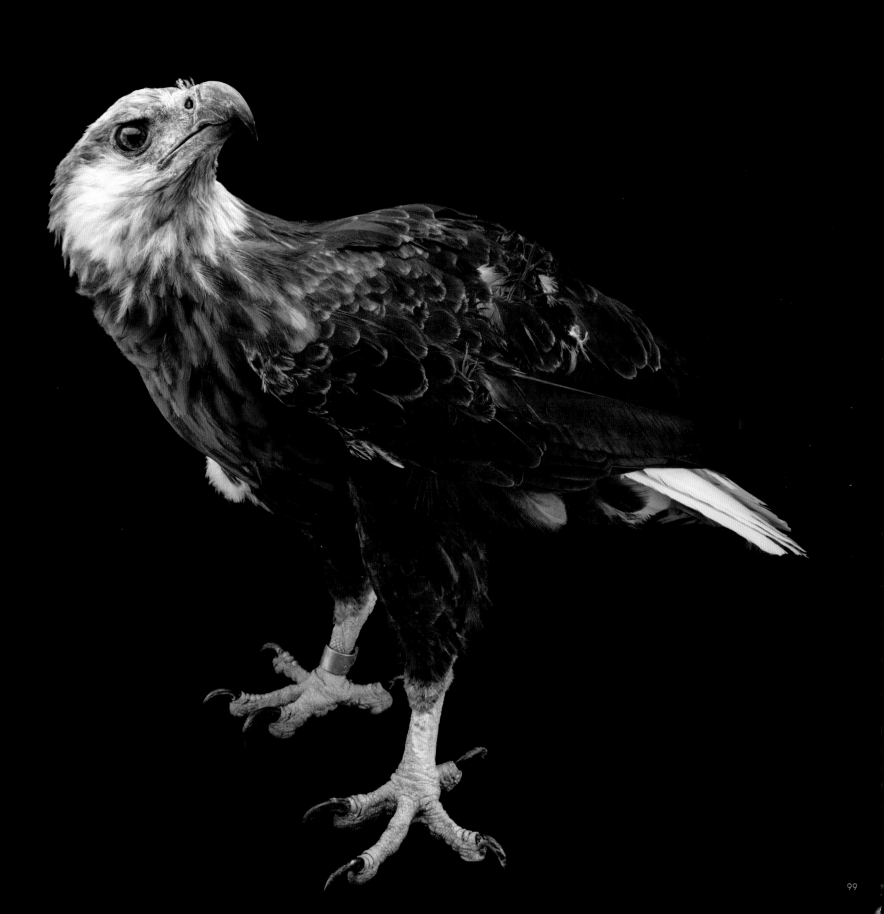

Pilalo tree frog, *Hyloscirtus ptychodactylus* (CR)

This critically endangered frog sticks its rear end in the air as a threat response to predators. Commercial development and logging are destroying its forest and wetland habitat in Ecuador, but Balsa de los Sapos, an amphibian breeding and study center in Quito, is working to keep the species alive.

Central American river turtle, *Dermatemys mawii* (CR)

This is the last remaining species of an early family of turtles. Fossils from this family have been found dating back to the Jurassic and Cretaceous periods, but today slow reproduction and overharvesting mean its survival is in doubt.

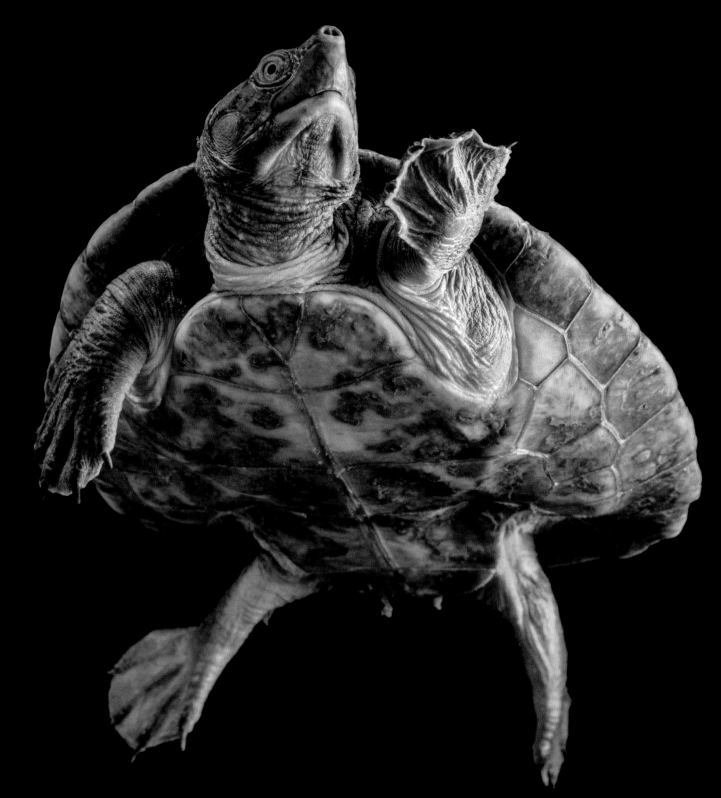

Javan slow loris, *Nycticebus javanicus* (CR)

This small primate can create a toxin that it wipes all over its body to protect itself from predators. But habitat loss is the bigger threat now, as the remaining populations are becoming increasingly fragmented.

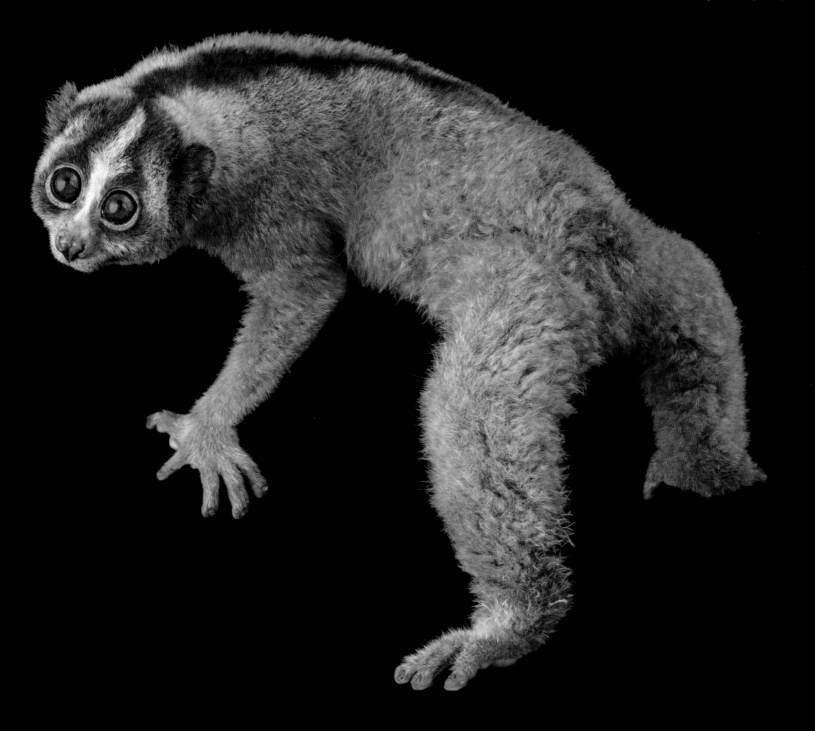

> "WE BELIEVE SUCCESS EQUALS ANIMALS THRIVING IN THE WILD. WITH SO MANY SPECIES TEETERING ON THE EDGE OF EXTINCTION, WE HAVE NO TIME LEFT TO WASTE. THIS IS WHAT DRIVES US.

JENNY GRAY, CHIEF EXECUTIVE OFFICER, ZOOS VICTORIA

Leadbeater's possum, *Gymnobelideus leadbeateri* (CR)

Smaller than a human hand, these Australian marsupials live in the hollows of trees. Worsening wildfires have devastated available habitat for the Leadbeater's possum.

Malayan tiger, *Panthera tigris jacksoni* (CR)

It's estimated that fewer than 250 adult Malayan tigers remain in the world, down from approximately 3,000 in the 1950s. In addition to a rapidly shrinking range, tigers and tiger parts are in high demand in the international wildlife trade.

SONGBIRD CRISIS

ONCE FILLED WITH SWEET BIRDSONG, many of Asia's rainforests are now falling silent. A cultural affinity in Southeast Asia for keeping these beautiful birds as pets has spurred massive trafficking of songbirds trapped in the wild—and has sent many rare species into a death spiral. Indonesia is a hub for this illegal global trade: Researchers conducting an inventory of Jakarta's bird markets in 2014 discovered 19,000 birds for sale over three days. Most illegally captured birds survive only a day or two in cages, earning them the grim moniker of "cut-flower birds"—they last no longer than a spray of flowers in a vase. Conservationists, zoos, nongovernmental organizations (NGOs), and academic institutions are collaborating to educate consumers on the songbird crisis and step up law enforcement and regulation of the pet trade.

TOP ROW, LEFT TO RIGHT: Javan black-winged starling, *Acridotheres melanopterus* (CR); Rufous-fronted laughingthrush, *Garrulax rufifrons rufifrons* (CR); Bali myna, *Leucopsar rothschildi* (CR) **BOTTOM ROW, LEFT TO RIGHT:** Greater green leafbird, *Chloropsis sonnerati* (VU); Ruby-throated bulbul, *Pycnonotus dispar* (VU); Javan green magpie, *Cissa thalassina* (CR); Sumatran laughingthrush, *Garrulax bicolor* (EN)

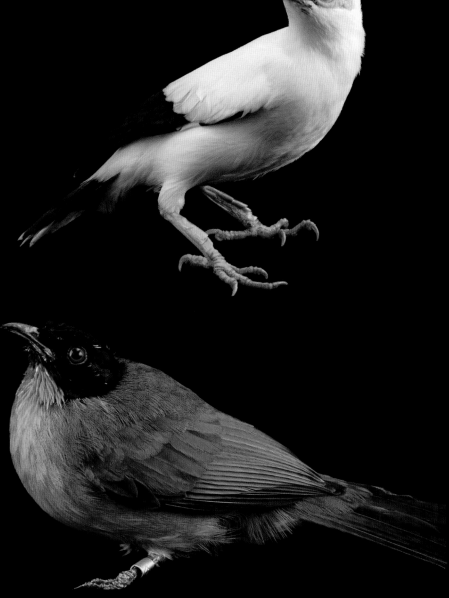

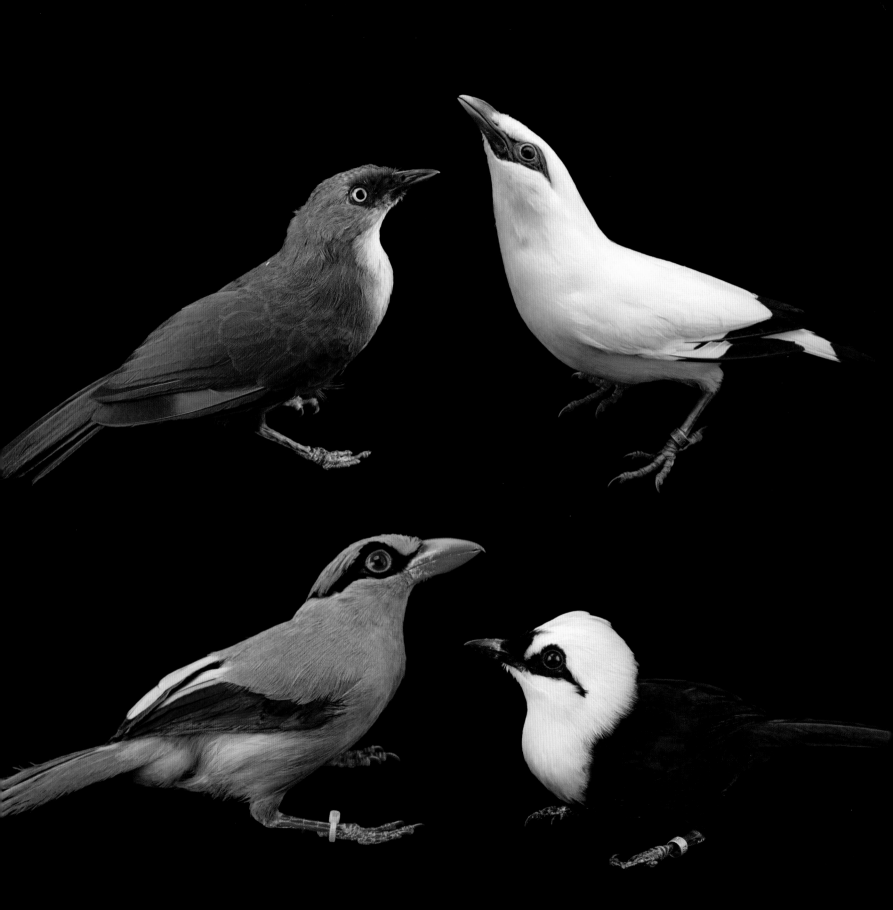

Celebes crested macaque, *Macaca nigra* (CR)

This species can primarily be found on two islands in Indonesia: Sulawesi, where it is native, and Pulau Bacan, where it was brought over by humans in 1867. The population on Pulau Bacan is thriving but at the risk of disrupting the balance of its non-native island.

Northern white-cheeked gibbon,
Nomascus leucogenys (CR)

With their long arms and flexible shoulders, gibbons are built to swing through the forest canopy. As deforestation from logging and agriculture break up the forest expanses, these uniquely adapted animals are disappearing from their native ranges in east Asia.

OVER THE PAST CENTURY, THE

LIVING RANGE OF THE ADDAX HAS

BEEN REDUCED BY UP TO

99%

Addax, *Addax nasomaculatus* (CR)

Once wide-ranging, these desert antelope have been devastated by uncontrolled hunting. Fewer than 100 are estimated to remain in the wild in a narrow region between Niger and Chad.

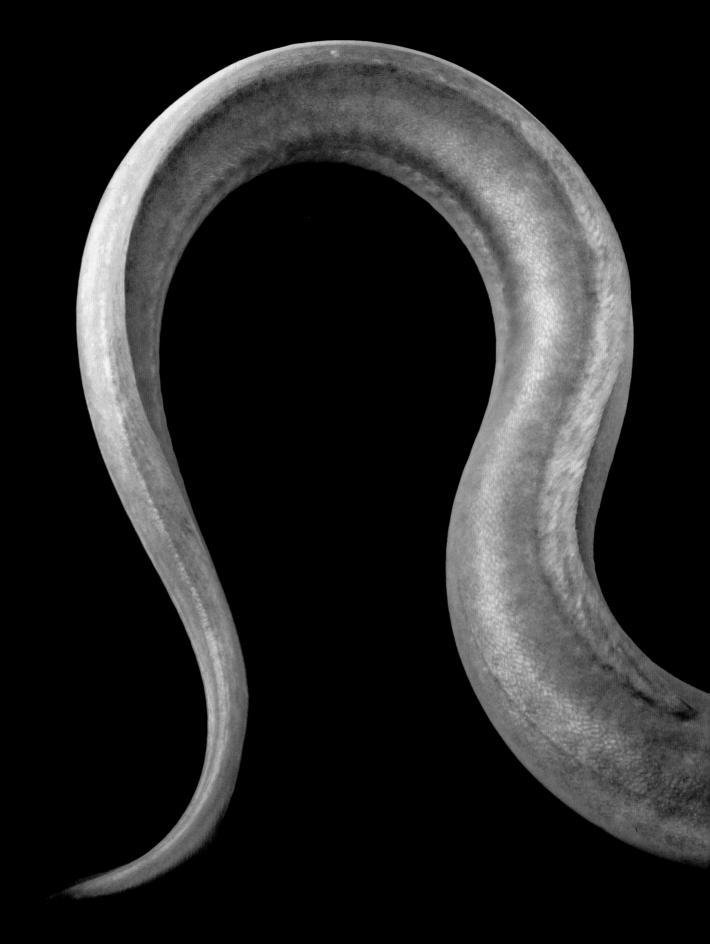

" **JUST HOW DO YOU FEEL ABOUT AN EEL? YOUR ANSWER DETERMINES WHETHER 'THE LEAST AMONG US' LIVES OR DIES.**

————

JOEL SARTORE

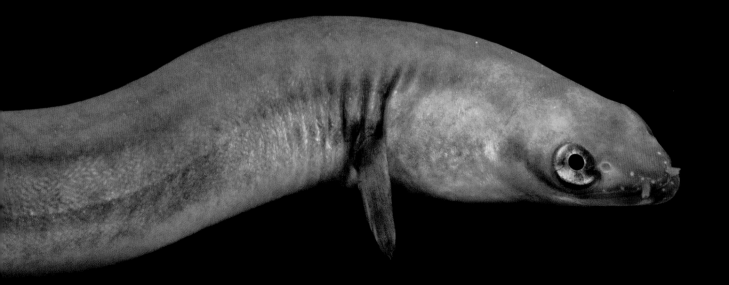

European mink, *Mustela lutreola* **(CR)**

The European mink's range has shrunk by more than 85 percent since the 1800s. Despite their losses, they are expanding into new ecosystems and adapting to new habitats in northeastern Spain, which poses conservation challenges of its own as they encroach on the resources of other ecosystems.

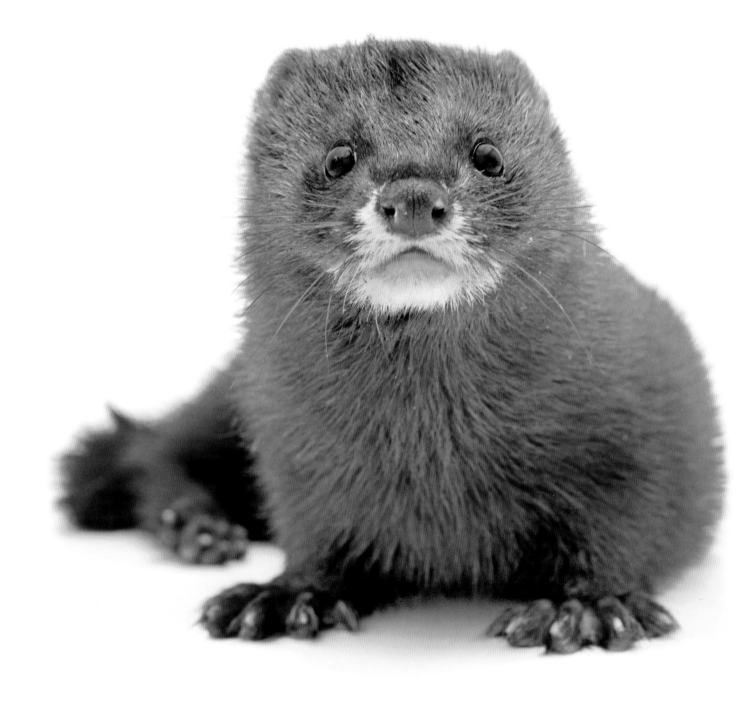

Puerto Rican crested toad, *Peltophryne lemur* (CR)

These toads once numbered fewer than 100 animals left in the wild. A captive-breeding program reintroduced tadpoles to their native area and the new toads are beginning to build new generations.

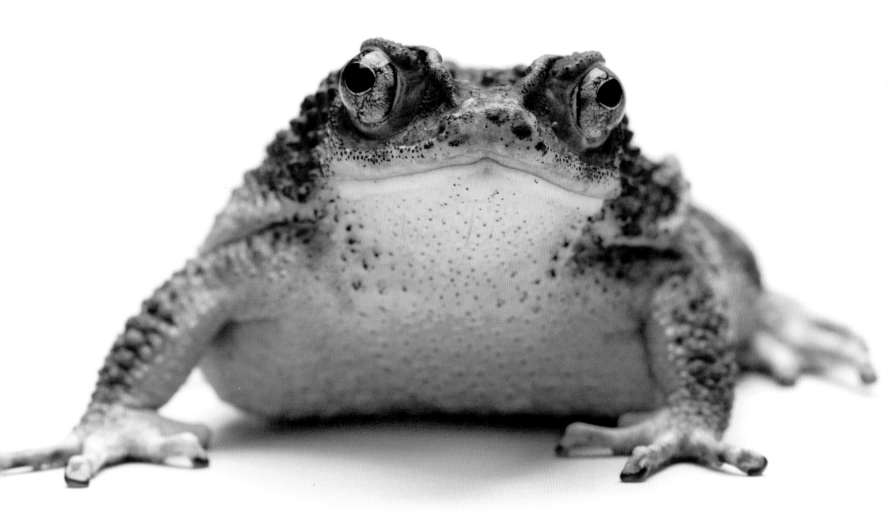

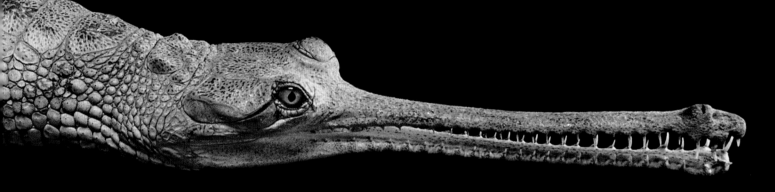

Gharial, *Gavialis gangeticus* (CR)

These narrow-nosed crocodiles face a range of threats, from trophy hunting to accidental capture in fishing nets. Gharial eggs are prized in some cultures, and nest raids make efforts to restore these populations even more challenging.

BETWEEN THE 1940S AND 1970S, THE

WORLDWIDE POPULATION OF WILD

GHARIAL WAS REDUCED BY ABOUT

96%

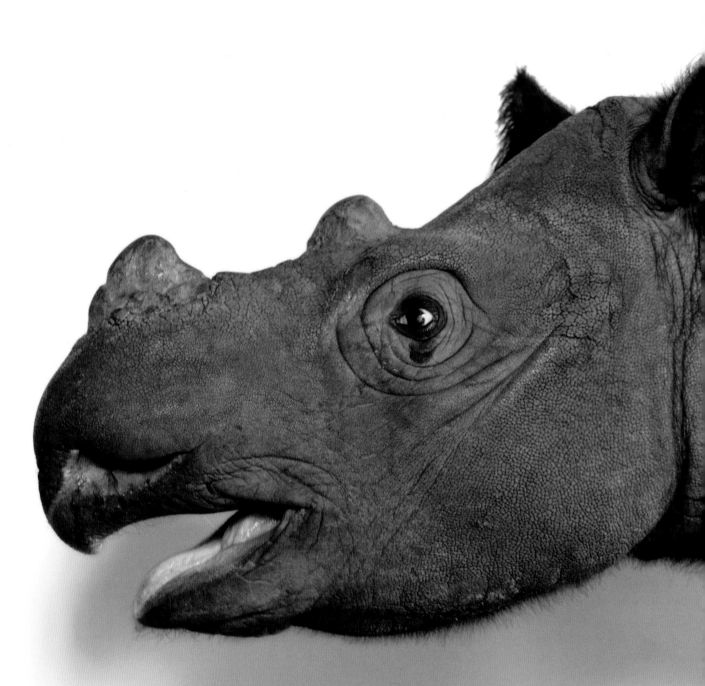

Sumatran rhinoceros, *Dicerorhinus sumatrensis sumatrensis* (CR)

About 170 to 230 individuals of this, the smallest rhinoceros species, are
known to exist today. Poaching is the primary cause of decline over the past
two decades, driven by demand for rhino horn and other body parts.

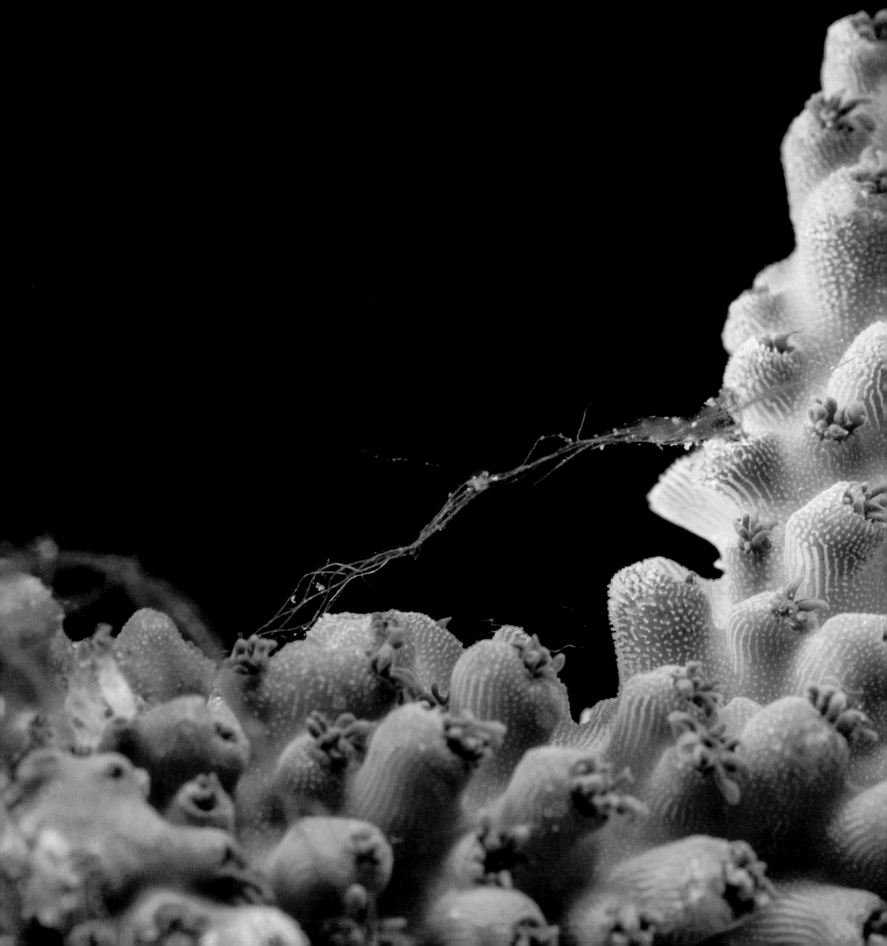

Staghorn coral, *Acropora cervicornis* (CR)

The dense underwater thickets formed by staghorn coral
are vital to the health of Caribbean coral reefs. In the 1980s,
a disease wiped out 97 percent of its population, from which
this slow-reproducing coral is still recovering.

≈48

PUREBRED INDIVIDUALS

REMAIN IN THE WILD

THE SCOTTISH WILDCAT knows every inch of its territory by sight, sound, and touch. Silent and alone, it rests by day and hunts by night, patrolling the remote reaches of the Highlands in search of rabbits. In Scotland, the wildcat is the last of its kind, a distinct subspecies that has outlasted wolves and lynx in Britain by centuries, and is the largest form of the more widespread European wildcat. A pure Scottish wildcat resembles a muscular tabby cat. But it has distinct physical characteristics, including a bushy, ringed tail with a blunt, black tip; a dark stripe along its back; and an extra-thick coat of fur. A flash of white on the chest, spotted fur, or a tapered tail signal the Scottish wildcat's gravest dilemma: the mingling of the domestic with the wild. These wild felines often crossbreed with domestic cats, and such widespread hybridization has put their future in peril.

Scottish wildcats, *Felis silvestris grampia* (NE)

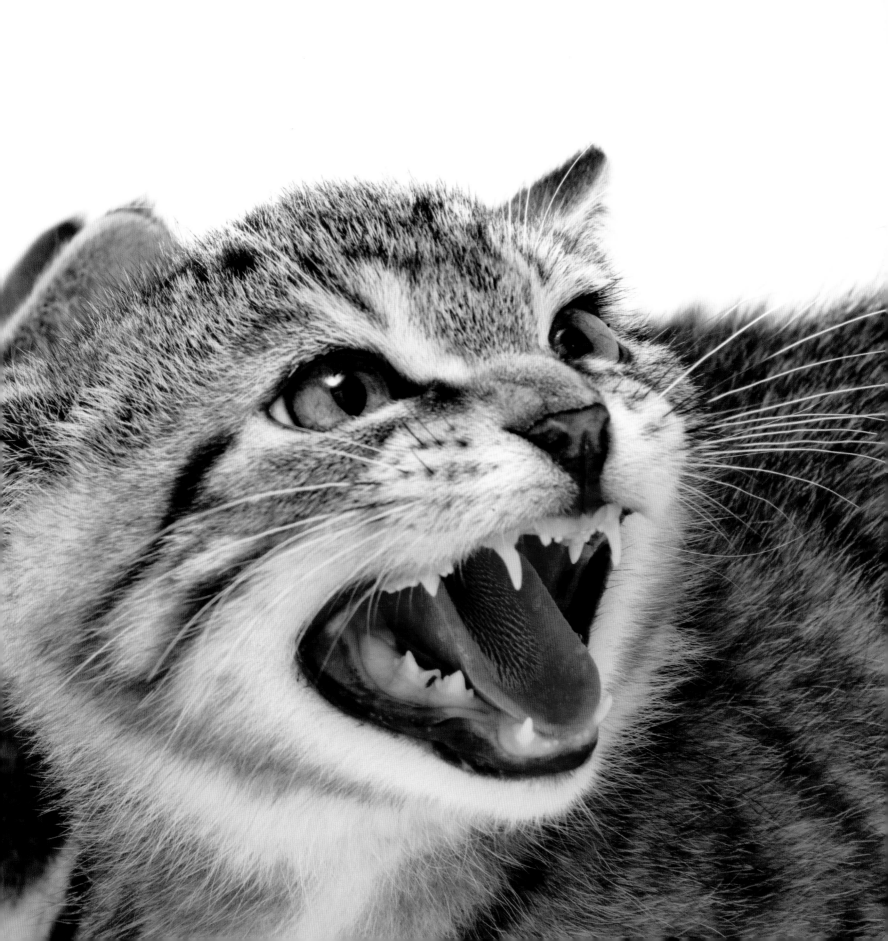

Cross River gorilla, *Gorilla gorilla diehli* (CR)

An estimated 200 to 300 of these gorillas exist in the wild today, scattered across Nigeria and Cameroon. Pictured here is Nyango, the only confirmed Cross River gorilla in captivity. She lived at the Limbe Wildlife Center in Cameroon for more than 20 years before her death in 2017.

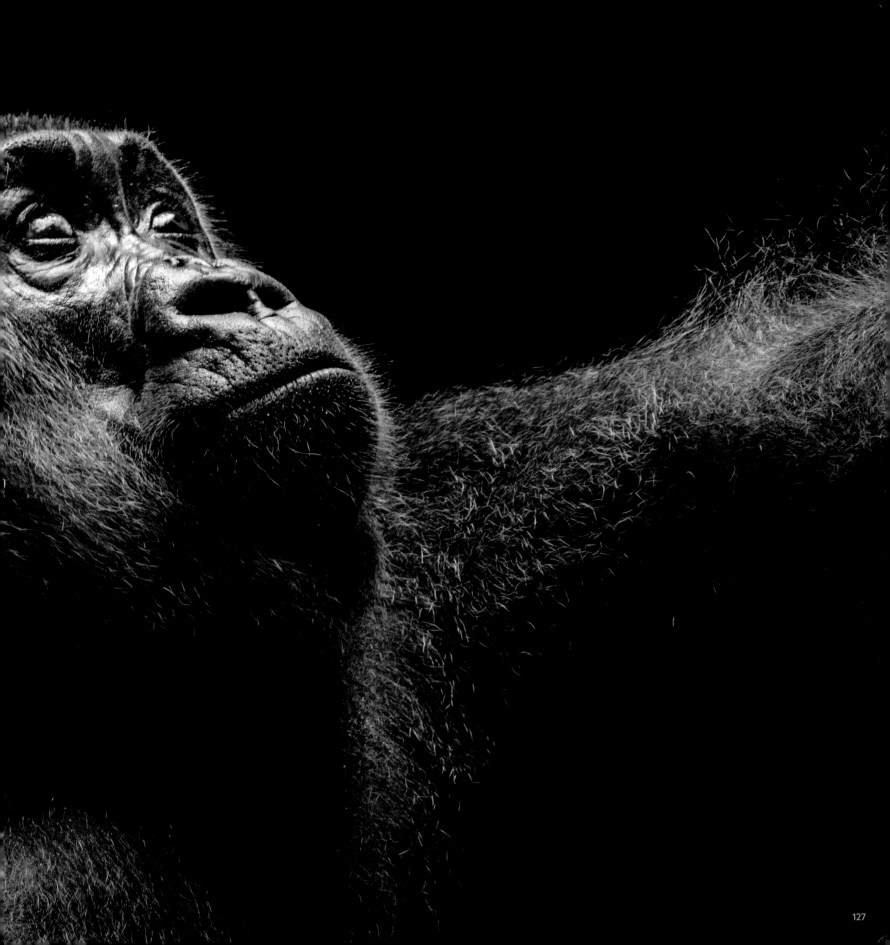

Siau Island tarsier, *Tarsius tumpara* (CR)

This small tarsier is harmed by overhunting and increased development, but its biggest threat may be its isolation. Its only populations live on the shores of a small freshwater pond and on a steep cliff by the ocean in Indonesia.

Talaud bear cuscus, *Ailurops melanotis* (CR)

Only known to exist on Indonesia's Salibabu Island—which measures less than 100 square kilometers—this elusive marsupial has proven difficult to study. Heavy hunting pressures threaten its small population.

Citron-crested cockatoo,
Cacatua sulphurea citrinocristata (CR)

Fewer than 3,000 birds remain of this brightly plumed species. Between rapid decline of their forest habitat and their popularity as pets, these cockatoos have suffered near-catastrophic losses.

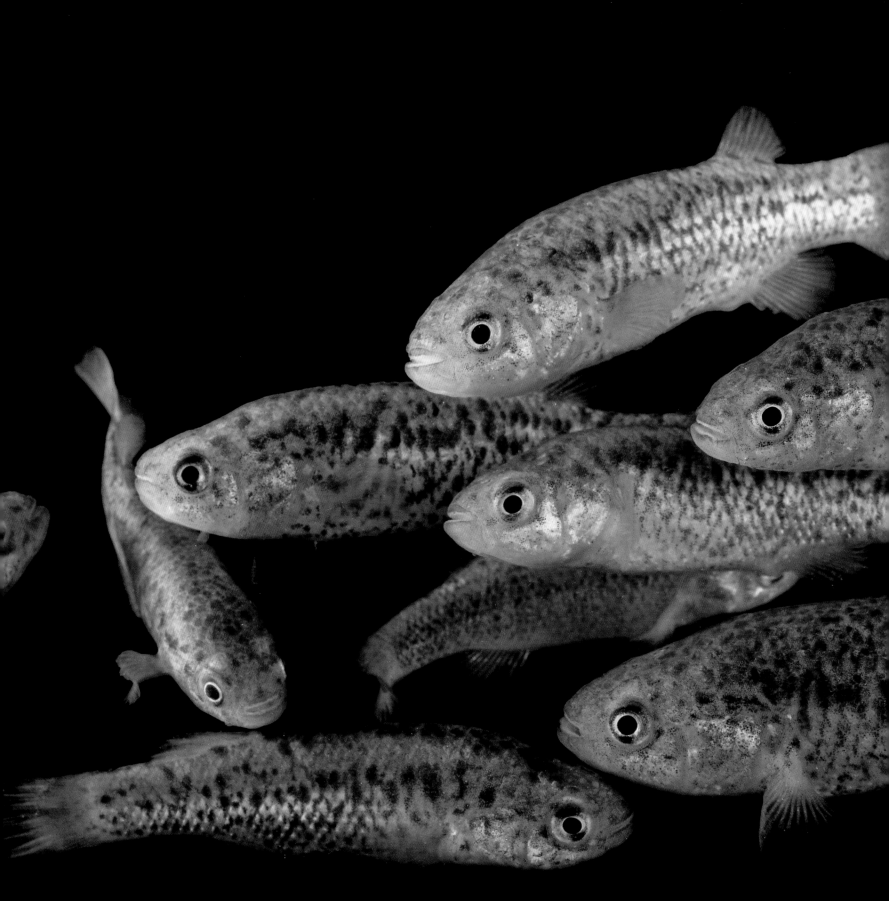

0

REMAIN IN THE SPECIES'
ORIGINAL NATIVE RANGE

ABOUT 100 KILOMETERS east of Death Valley is southern Nevada's Pahrump Valley. It's a dry place, yet its freshwater springs once supported their very own native species of fish: the Pahrump poolfish, a wide-mouthed speck of a specimen measuring just 50 millimeters long. The poolfish made its home in three shallow springs in the valley, where each spring supported a unique subspecies. But groundwater pumping in two of the springs caused them to dry up and spelled the end for the poolfish. By the 1970s, the species had been wiped out of its native range. Today the poolfish is long gone from Pahrump Valley, surviving only in a handful of springs where conservationists reintroduced it decades ago.

Pahrump poolfish, *Empetrichthys latos* (CR)

Blue-eyed black lemur, *Eulemur flavifrons* (CR)

Among the most endangered primates on the planet, blue-eyed black lemurs—black if male, brown if female— are threatened by hunting and deforestation across their native range in Madagascar. Captive-breeding efforts are under way in an attempt to rebuild their population.

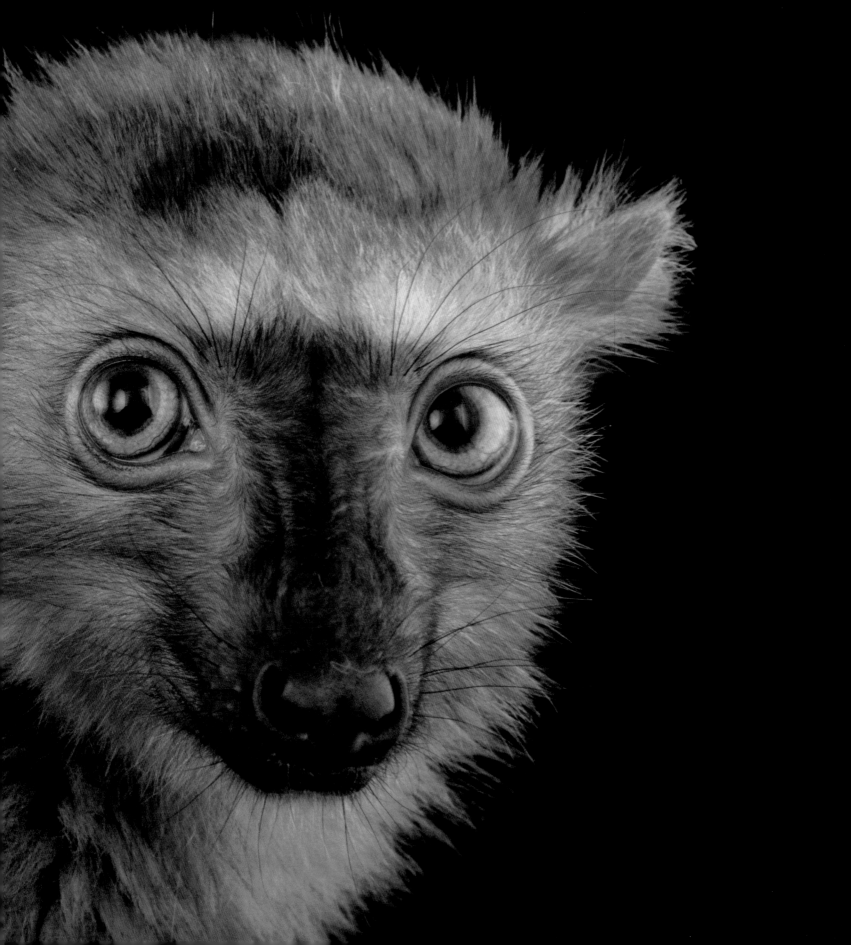

Three Forks springsnail, *Pyrgulopsis trivialis* (CR)

These small aquatic snails serve their ecosystems by eating algae and other detritus, keeping the water clean. Their isolation along with a wave of invasive crayfish threaten their survival.

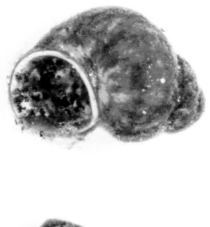

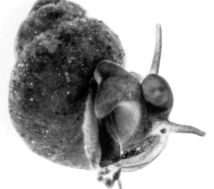
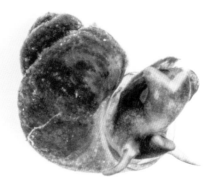

Fat threeridge, *Amblema neislerii* (CR)

This freshwater mussel is native to the Apalachicola, Flint, and Chipola Rivers of Florida and Georgia. Drought and river pollution have reduced the population so that only a few of 324 known sites still survive.

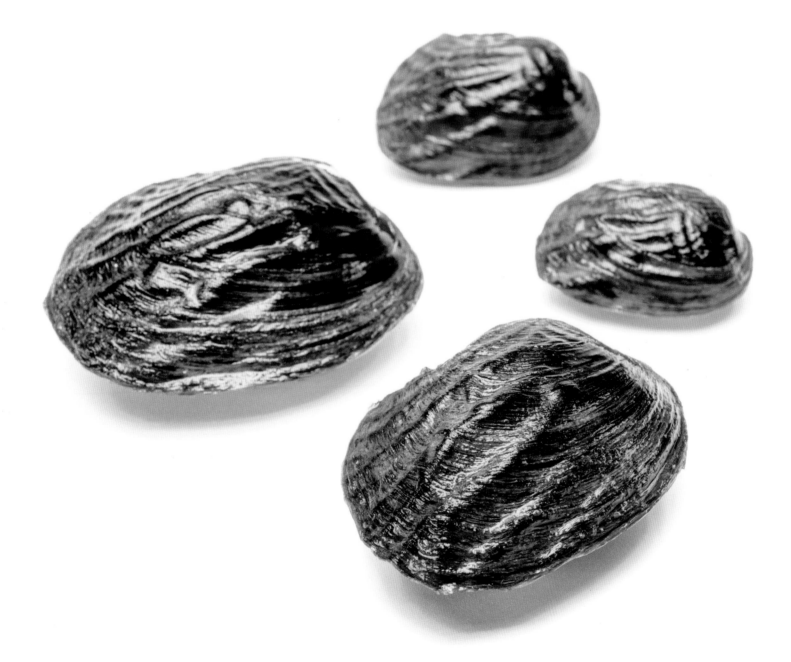

137

> **"I HATE TO THINK THAT A SPECIES GOES EXTINCT AND I COULD HAVE DONE SOMETHING ABOUT IT. I KNOW THAT WE MIGHT FAIL, BUT WE HAVE TO TRY, AND WE HAVE TO WORK HARD.**

MICHAEL MEYERHOFF, PROJECT MANAGER,
ANGKOR CENTRE FOR CONSERVATION OF BIODIVERSITY

White-shouldered ibis, *Pseudibis davisoni* (CR)

Now primarily found in Cambodia, these elegant waterbirds were once widespread across Southeast Asia. Now their population is small and fragmented—fewer than 700 adults are believed to exist in the wild.

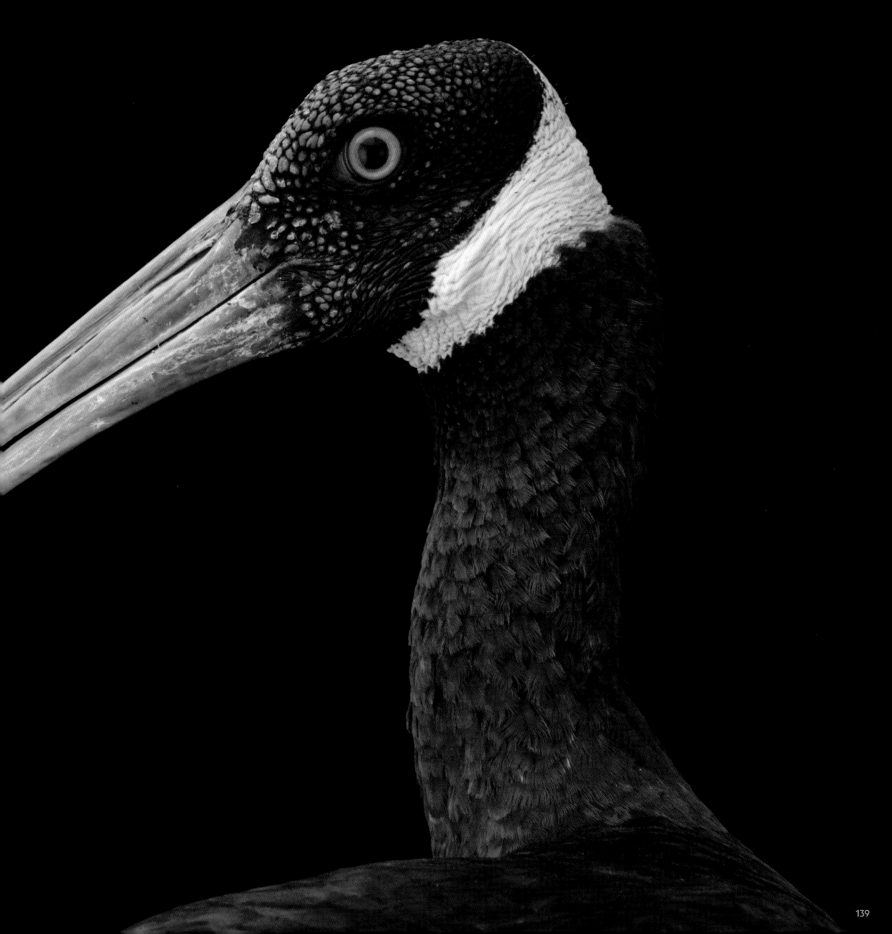

Red wolf, *Canis rufus* (CR)

After being declared extinct in the wild by 1980, red wolves had a modestly successful reintroduction in North Carolina, peaking at more than 150 wild wolves by the early 2000s. After pushback from landowners, the wild population was reduced to around 40, while more than 200 wolves live in captive-breeding facilities.

Grey-shanked douc langur, *Pygathrix cinerea* (CR)

In 2014, a team of scientists discovered a new, large population of grey-shanked doucs in Vietnam's Quang Nam province. Estimated at about 180 animals, it's only the second population known to have more than 100 doucs living together.

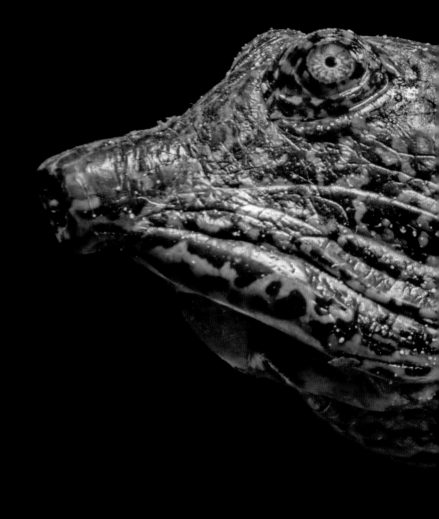

4

INDIVIDUALS REMAIN

SCIENTISTS FIRST DISCOVERED the Yangtze giant softshell turtle in 1873, but the last 146 years have revealed little more about this elusive species. What we do know is that it is the world's largest freshwater turtle—and the most endangered. Only four individuals are known to survive. Two live in China's Suzhou Zoo, where fervent attempts to breed the turtles by artificial insemination have failed. And two survive in the wild in lakes near Hanoi, Vietnam. These turtles stay submerged for long periods of time and rarely break the surface of the water. But despite this secretive behavior, hunting and pollution have caused its numbers to plummet. Efforts are ongoing to find more of these turtles living in the wild, while scientists continue captive breeding to attempt to raise population numbers. According to Rick Hudson, president of Turtle Survival Alliance, which has been involved in breeding efforts, "Never have the stakes been any higher."

Yangtze giant softshell turtle, *Rafetus swinhoei* (CR)

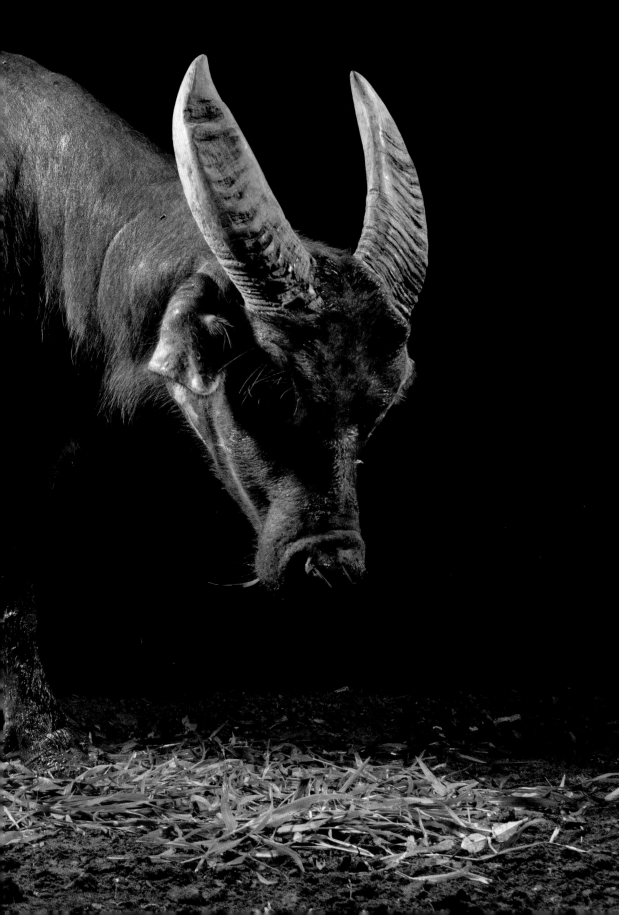

Tamaraw, *Bubalus mindorensis* (CR)

A small buffalo native to the Philippine island of Mindoro, the tamaraw's numbers have dwindled as humans have encroached on its habitat. Kalibasib, the tamaraw pictured here, was the only successful birth from a captive-breeding program that began in 1980 and is the only tamaraw in captivity.

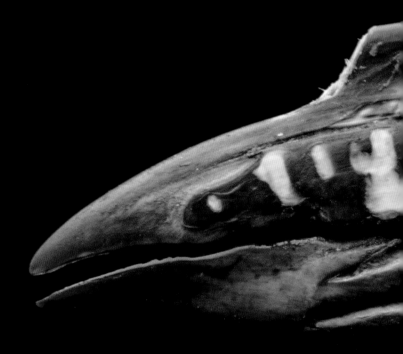

I CHAPTER TWO I

FADING

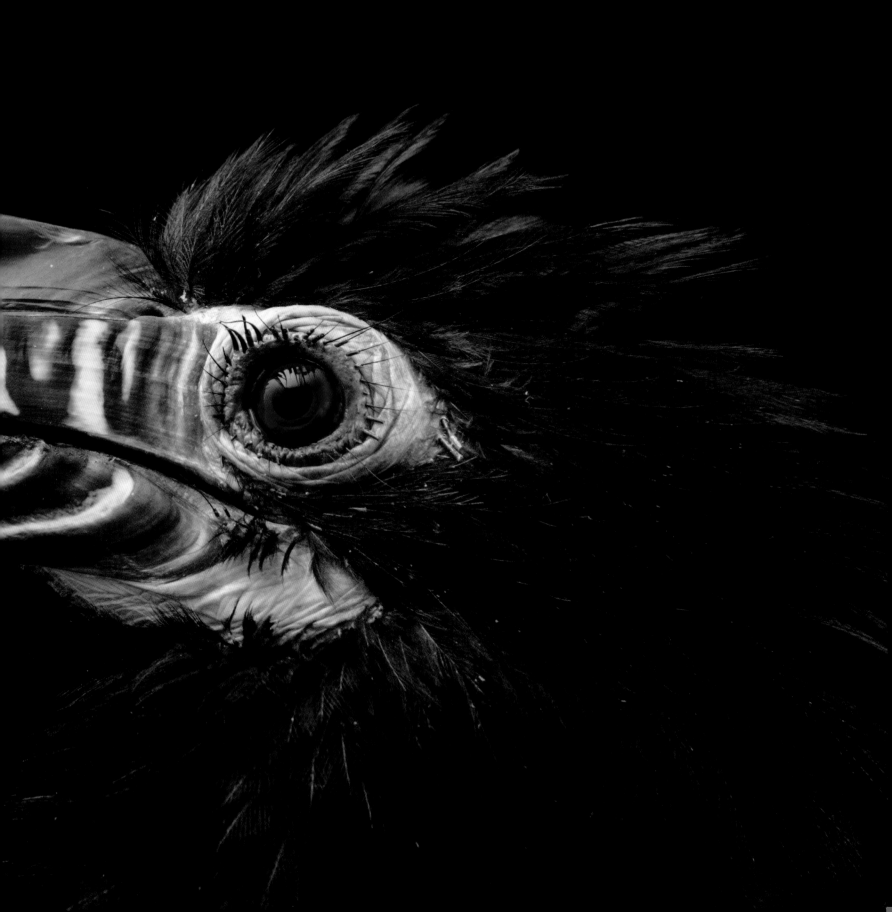

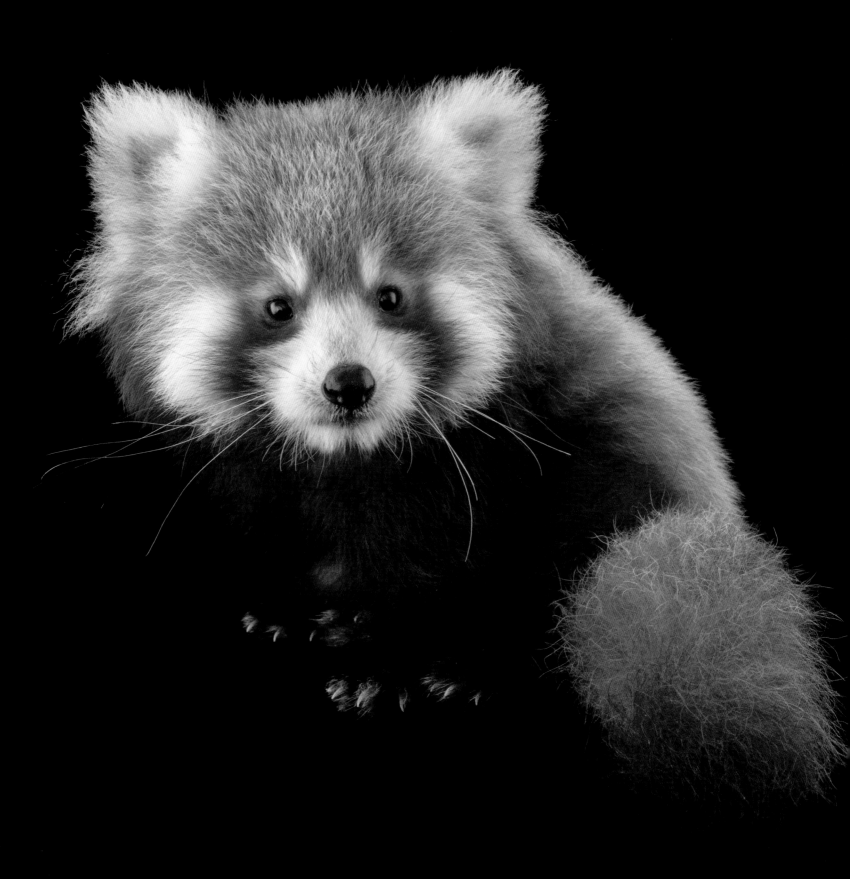

When Frédéric Cuvier penned the first formal description of the red panda in 1825, he declared it "quite the most handsome mammal in existence." Nonetheless, this bushy-tailed species with dark, knowing eyes has largely dodged the spotlight of scientific inquiry, curled up in the canopy of the Himalaya's high forests.

The panda's solitary ways and its remote home make studying the species challenging. In its taxonomic family, the red panda now stands alone—and on shaky ground. Its closest evolutionary relatives are all extinct, and the panda's wild population is shrinking. There are currently believed to be around 230 to 1,060 individuals, a number that is dropping as forests are cleared for human settlement, development, and agriculture. How can an animal that seems so familiar fade before us, faster than scientists can paint a full portrait of its life?

Charisma alone cannot shield an animal from the outsize impact of humans. We've learned this from ongoing efforts to save some of the world's best known creatures. Many of the animals we meet in this chapter are not famous. But it shouldn't matter. They tell us stories of resilience: a snail that lives only on a strip of beach in the Indian Ocean, nearly wiped out by rat poison; a chatty parrot, coveted by the illegal pet trade, that nests deep in the forests of Mexico; a Caribbean lizard that has flirted with extinction since scientists first identified it 80 years ago but still, somehow, survives. The imprints these animals leave on our planet may have grown faint, but they're still here. There's still time to make those marks brighter, stronger, clearer. ■

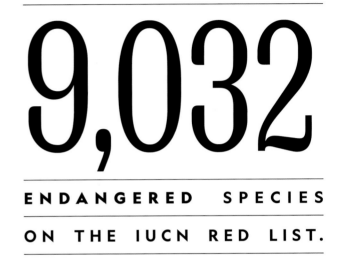

AS OF JAN. 2019, THERE ARE

9,032

ENDANGERED SPECIES ON THE IUCN RED LIST.

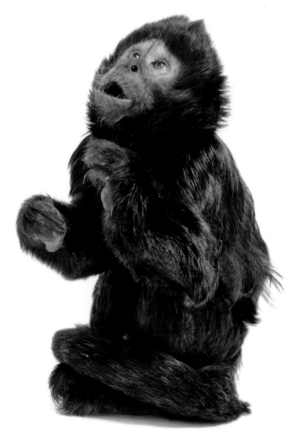

PREVIOUS: Visayan tarictic hornbill, *Penelopides panini panini* (EN)
OPPOSITE: Red panda, *Ailurus fulgens fulgens* (EN)
RIGHT: Crested capuchin, *Sapajus robustus* (EN)

" IS IT EXTINCT?
OR DO A FEW STILL REMAIN, HIDING
HIGH IN THE FOREST CANOPY?
NOBODY KNOWS.

———

JOEL SARTORE

This tiny tree frog measures just 20 millimeters wide and lives in the lower canopy of the Panamanian cloud forest. Like many amphibians, these tree frogs are at risk of contracting a fungal disease known as chytridiomycosis.

New Zealand kaka, *Nestor meridionalis* (EN)

The raucous social gatherings of this New Zealand parrot led the indigenous Maori to label them as chatterboxes and gossips. Today invasive species are outcompeting these parrots for food and other resources.

This desert-dwelling pig is known locally as a taguá. Its diet is mostly made up of spiny cacti. These pigs roll the plants on the ground to get rid of the spines, and their kidneys are specially adapted to break down the acid in the cactus flesh.

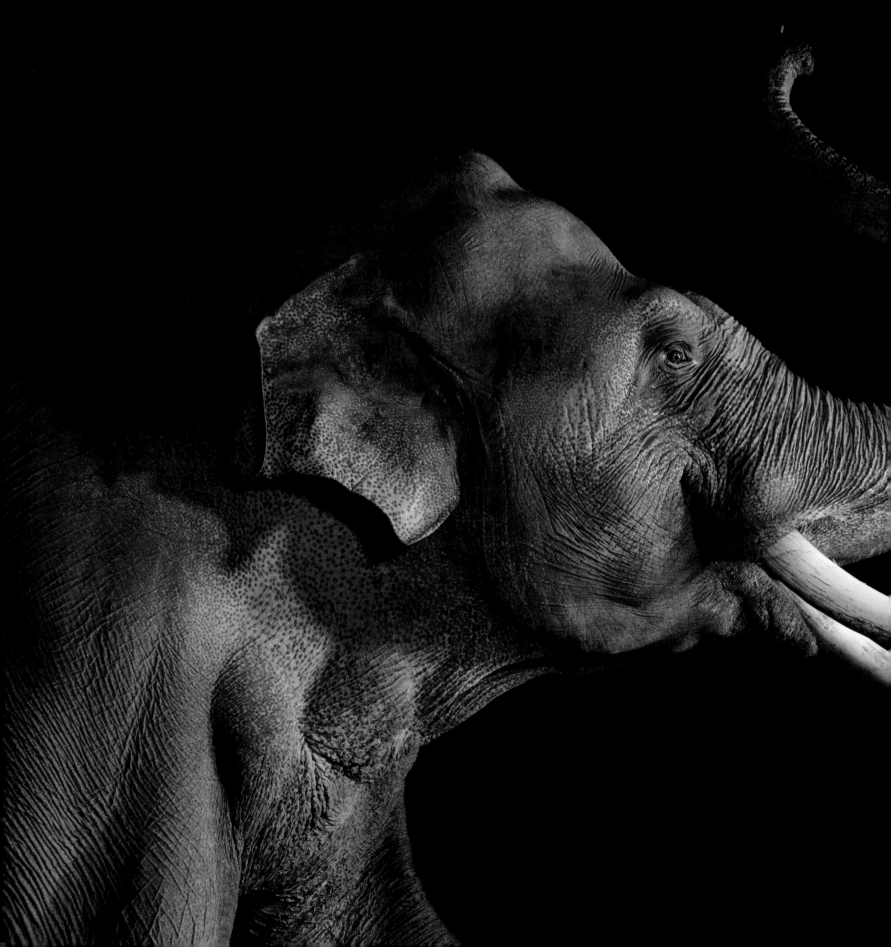

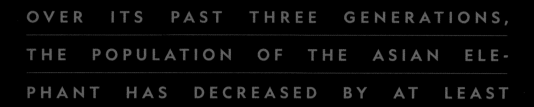

OVER ITS PAST THREE GENERATIONS,
THE POPULATION OF THE ASIAN ELE-
PHANT HAS DECREASED BY AT LEAST

50%

Asian elephant, *Elephas maximus* (EN)

Though slightly smaller than their African cousins, Asian
elephants can weigh as much as 5,400 kilograms. At the
beginning of the 20th century, nearly 100,000 of these
gentle giants roamed the Earth.

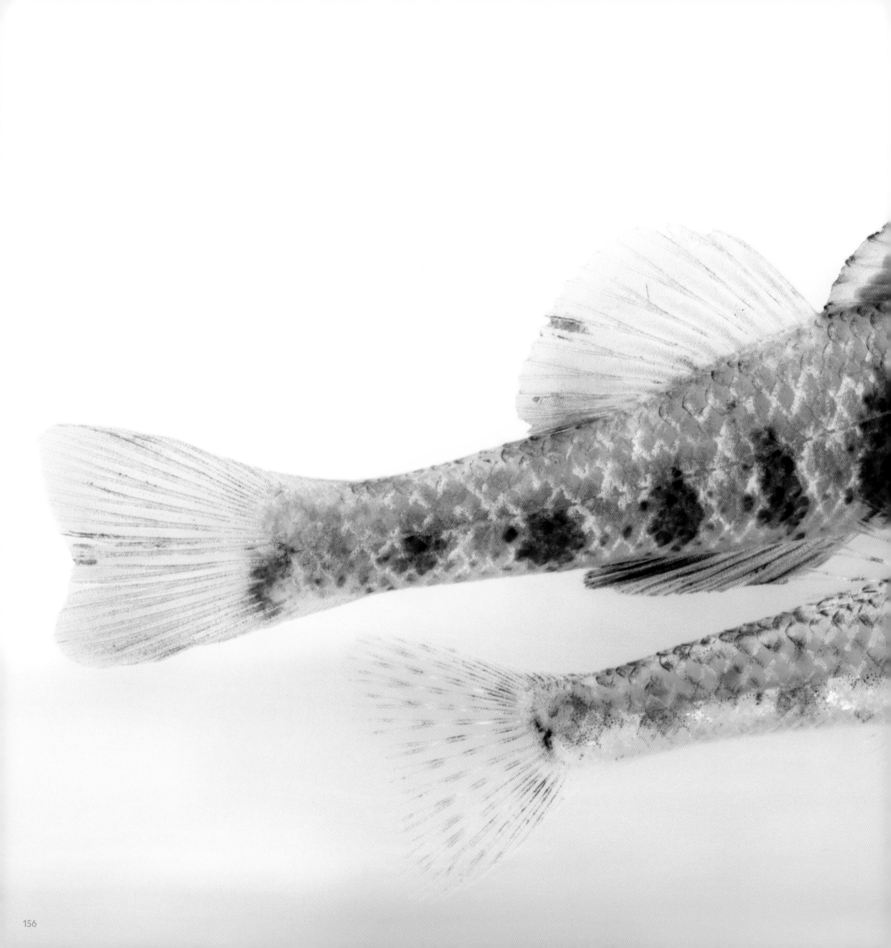

Bluemask darter, *Etheostoma akatulo* (EN)

These colorful fish can be found in the sand- and gravel-strewn beds of small creeks and tributaries of Tennessee's Cumberland River. Deteriorating water quality due to pesticide and mining runoff means their relatively small habitat is growing even smaller.

Lion-tailed macaque, *Macaca silenus* (EN)

In the hilly, evergreen forests of southwestern India you can find the striking lion-tailed macaque. Fewer than 4,000 individuals remain, scattered among a number of small, fragmented subpopulations.

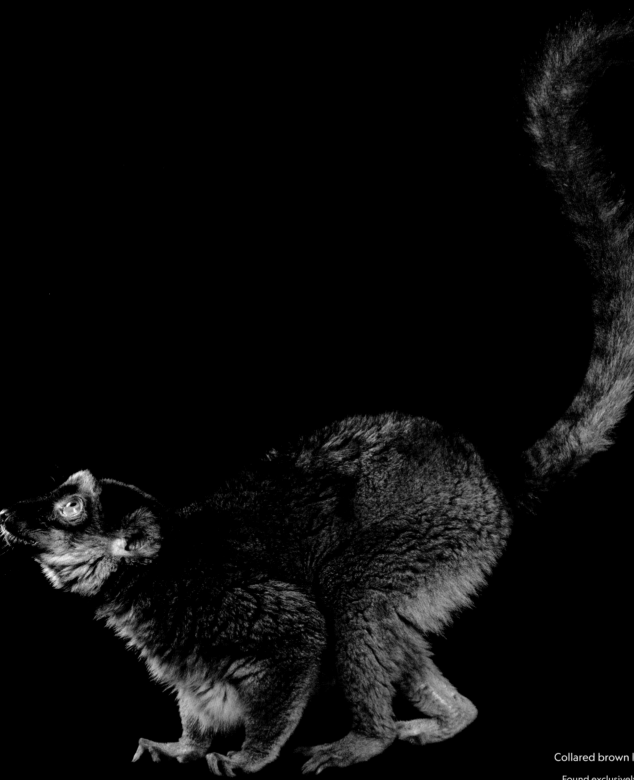

Collared brown lemur, *Eulemur collaris* (EN)

Found exclusively in the forests of southeastern
Madagascar, these lemurs share leadership equally
between males and females—unlike most lemurs,
which are strictly matriarchal.

≈2,500

MATURE INDIVIDUALS REMAIN IN THE WILD

AN ACROBATIC FLASH of green wings. A shrill, laughing call. A party of parrots preening one another in the forest. This is the thick-billed parrot, once a resident of Arizona and New Mexico now found only in the mountainous forests of Mexico's Sierra Madre Occidental. This social bird nests in tree cavities, with a preference for holes already excavated by woodpeckers. Flocks of parrots follow the availability of pinecones, clipping the cones and shredding their exteriors to pluck out the pine nuts within. But extensive deforestation across this part of Mexico, along with the illegal pet trade, has caused a sharp decline in the bird's numbers. The most recent estimates suggest fewer than 2,500 mature individuals survive in the wild.

Thick-billed parrot, *Rhynchopsitta pachyrhyncha* (EN)

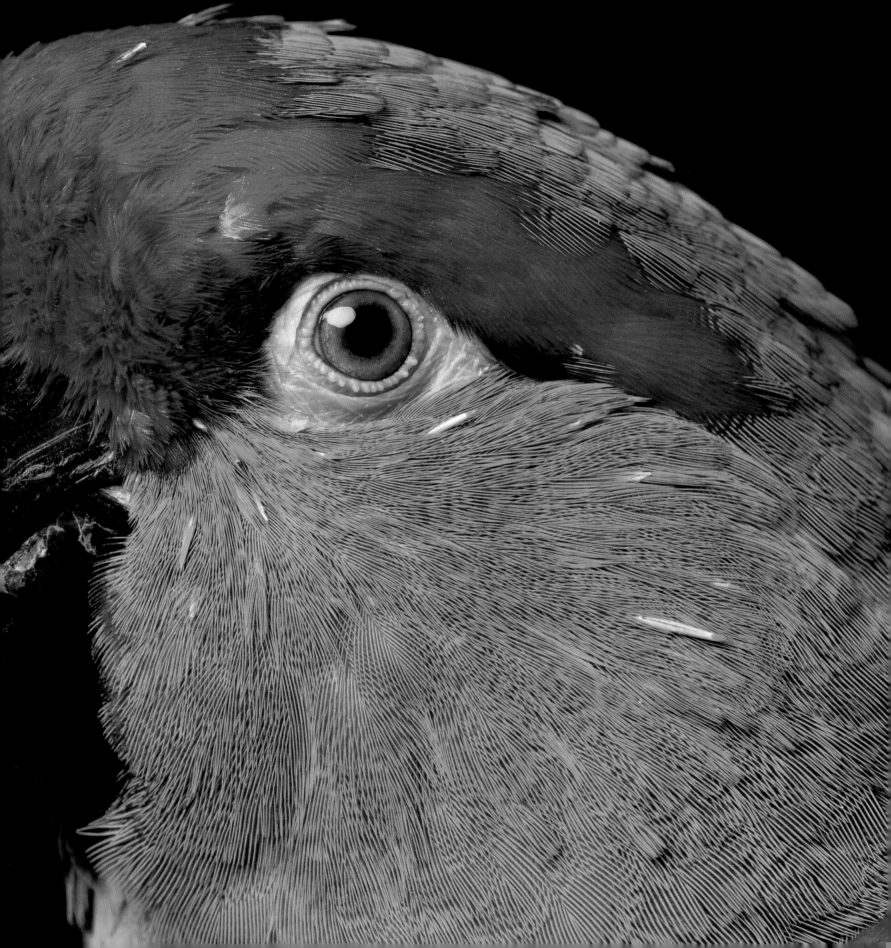

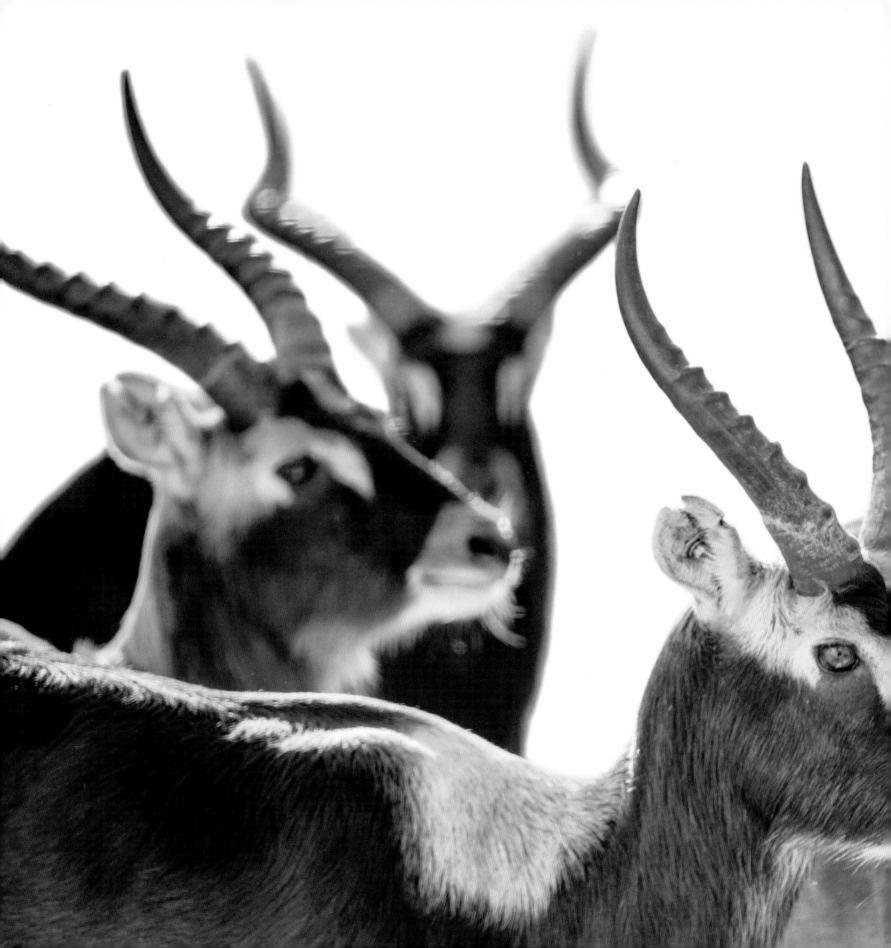

This antelope is native to South Sudan and Ethiopia, where the effects of ongoing military conflict affect humans and animals alike. They suffer from increased hunting pressure and habitat interruptions.

Arboreal alligator lizard, *Abronia graminea* (EN)

Dwelling in the bromeliad flowers of cloud forests,
this Mexican lizard is protected in its home country
but has been threatened by the international pet
trade, leading to overharvesting.

Aye-aye, *Daubentonia madagascariensis* (EN)

Aye-ayes have exceptionally long and sensitive middle fingers that they use to scoop out insects and fruits. Unfortunately, local superstition in Madagascar holds that the aye-aye can curse you with this finger, and the animals are often killed on sight.

Coquerel's sifaka, *Propithecus coquereli* (EN)

Unlike most lemurs which swing through the trees, the sifaka bound through the canopy using the strength of their hind legs. These powerful lemurs can leap up to six meters between trees.

DEADLY FUNGUS

CREATURES OF LAND AND WATER, amphibians absorb water and vital nutrients through their thin, porous skin, and any harm to this delicate cloak can be deadly. That's why chytridiomycosis is such a nightmare. This lethal disease has caused massive die-offs of individuals among hundreds of amphibian species in recent decades, sometimes right before researchers' eyes. Species considered viable last year may be facing extinction the next. A fungus causes the deadly pathogen, which hardens the skin and leads to heart failure. Scientists tracking the fallout think the disease is to blame for the extinction or near extinction of roughly 200 amphibian species. But some—such as the American bullfrog—appear to be resistant and may provide clues to control the disease.

TOP ROW, LEFT TO RIGHT: Panamanian golden frog, *Atelopus zeteki* (CR); Webbed harlequin frog, *Atelopus palmatus* (CR); Plumbeate marsupial frog, *Gastrotheca plumbea* (VU) **BOTTOM ROW, LEFT TO RIGHT:** Tabasara robber frog, *Craugastor tabasarae* (CR); Espada's marsupial frog, *Gastrotheca testudinea* (LC); Limon harlequin frog, *Atelopus sp. Spumarius complex* (CR)

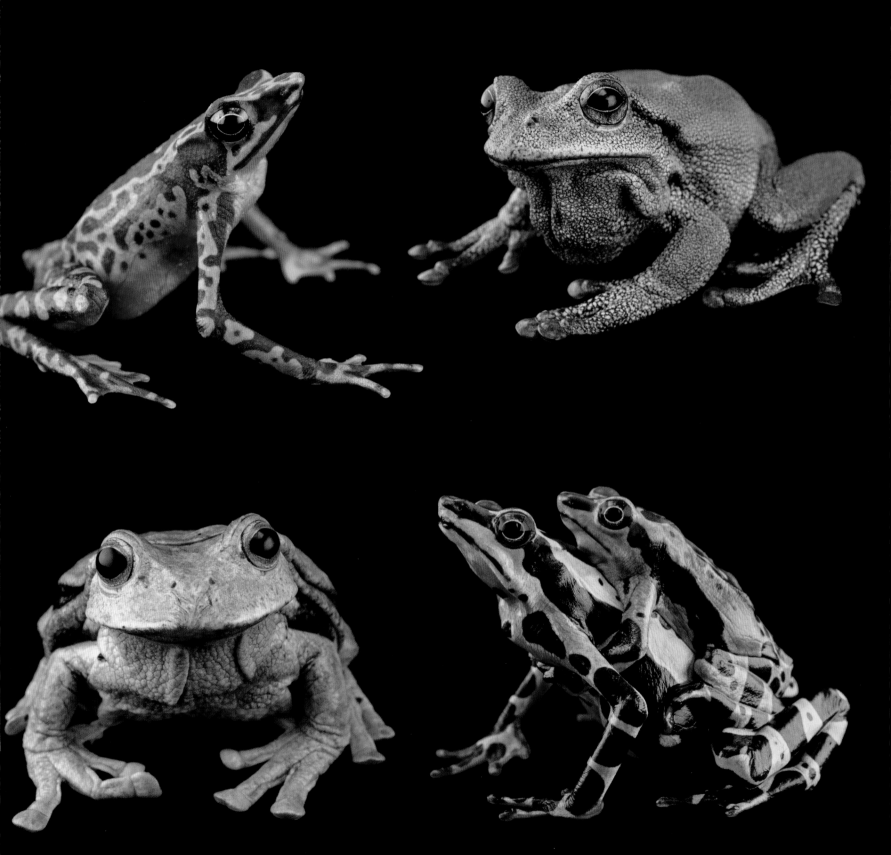

Iberian lynx, *Lynx pardinus* (EN)

In 2001, fewer than 100 Iberian lynx remained in the wild.
Over the past two decades, conservation efforts have
brought that number up to 400, and the animals are now
scouting new territory in Portugal and Spain.

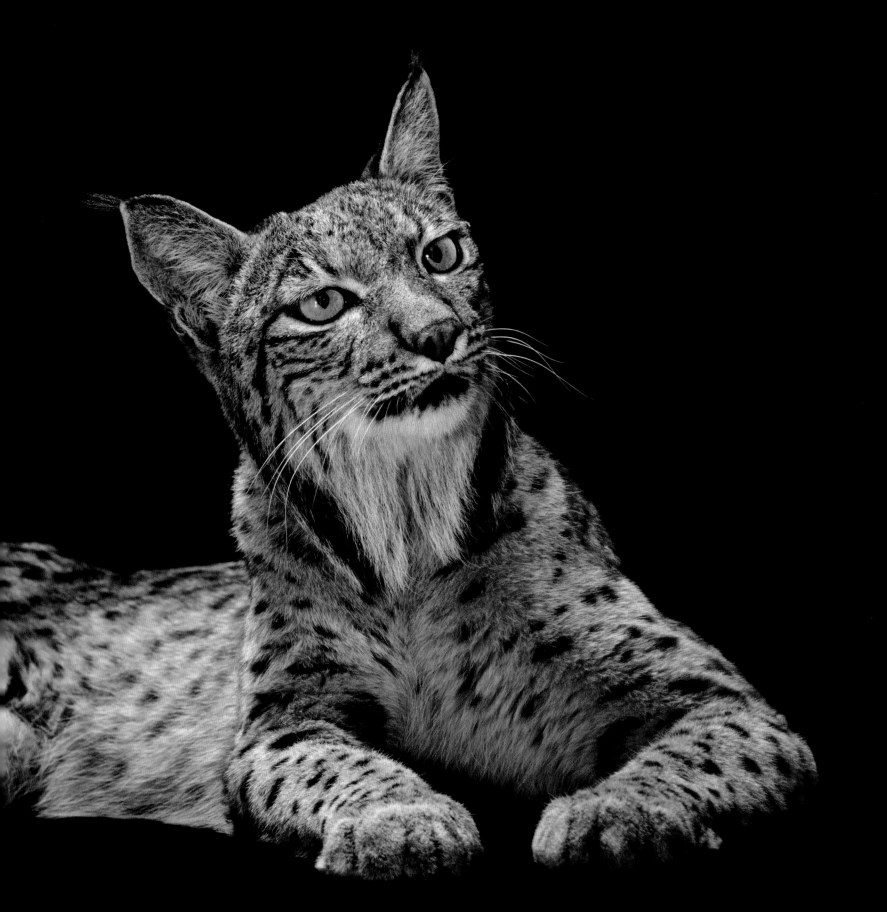

> " CONSERVATION IS ABOUT PEOPLE. WE CANNOT SAVE THESE SPECIES UNLESS PEOPLE UNDERSTAND THE PLIGHT AND WHAT THEIR ROLE CAN BE. THE WAY TO DO THAT IS EYE-TO-EYE CONTACT. THEY MEET A RHINO OR THEY SEE AN OKAPI, AND THAT CONNECTION IS MADE. THAT CONNECTION IS INDELIBLE.

STEVE SHURTER, EXECUTIVE DIRECTOR,
WHITE OAK CONSERVATION

Florida grasshopper sparrow,
Ammodramus savannarum floridanus (LC)

Once considered the "most endangered bird in the continental United States," conservationists are working to save this unique subspecies. Successful captive breeding and reintroduction programs are bringing this songbird back from the brink.

Four-eyed turtle, *Sacalia quadriocellata* (EN)

This freshwater turtle has only the standard two eyes.
It gets its name from four ocelli, or eye spots, that
form on the top of the head.

Alabama waterdog, *Necturus alabamensis* (EN)

Degrading water quality threatens this elusive salamander, native to the Black Warrior River in Alabama. Because these salamanders breathe through their skin, runoff from mining and agricultural and urban waste directly impact their health.

Miyako grass lizard, *Takydromus toyamai* (EN)

This small lizard is found in about 200 square kilometers of the Miyako Islands of Japan. The introduction of weasels and peacocks to these islands has created a new predator for the Miyako grass lizard.

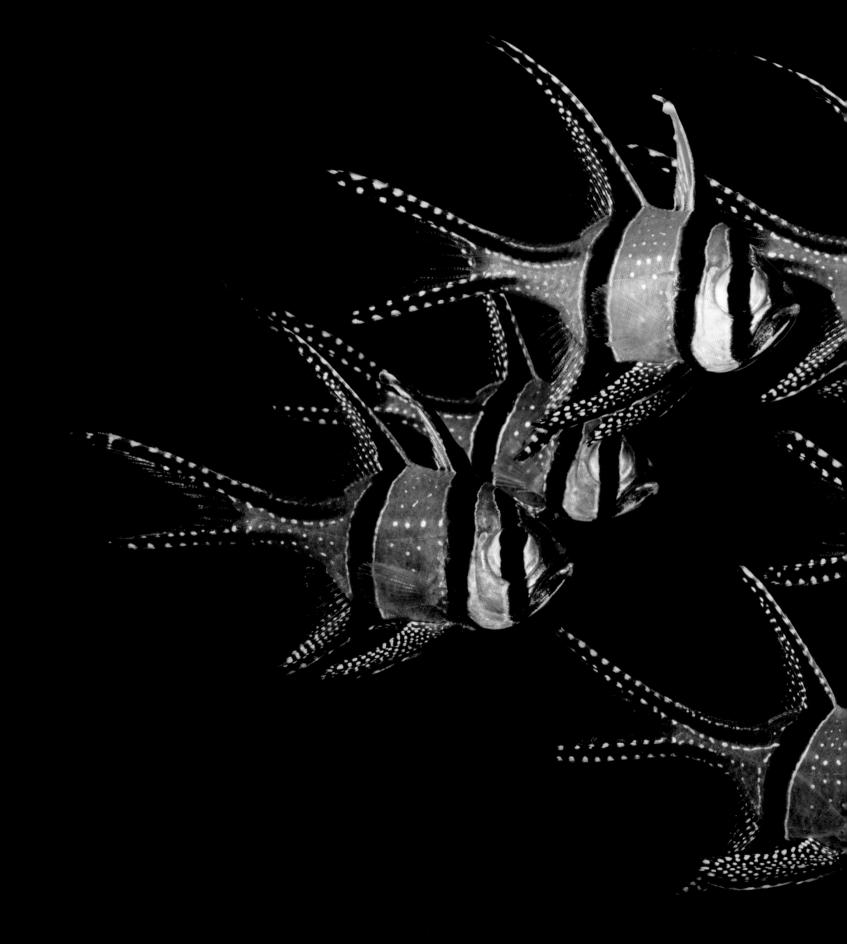

FROM 2001 TO 2004, ONE SUBPOPULATION

OF 6,000 OF THESE FISH DECREASED BY

90%

Banggai cardinalfish, *Pterapogon kauderni* (EN)

These fish are highly valued in the aquarium trade, and currently most fish sold have been captured from wild populations.

Balabac mouse deer, *Tragulus nigricans* (EN)

Averaging just 18 centimeters tall at the shoulder, the Balabac mouse deer is the world's smallest hoofed animal. It is often hunted for its meat or trapped for the exotic pet market.

Pygmy hippopotamus, *Choeropsis liberiensis liberiensis* (EN)

These forest hippos are just 10 percent of the weight of their Nile hippo cousins across the continent. While most live in protected parks, reserves, or zoos, poaching still poses a serious threat.

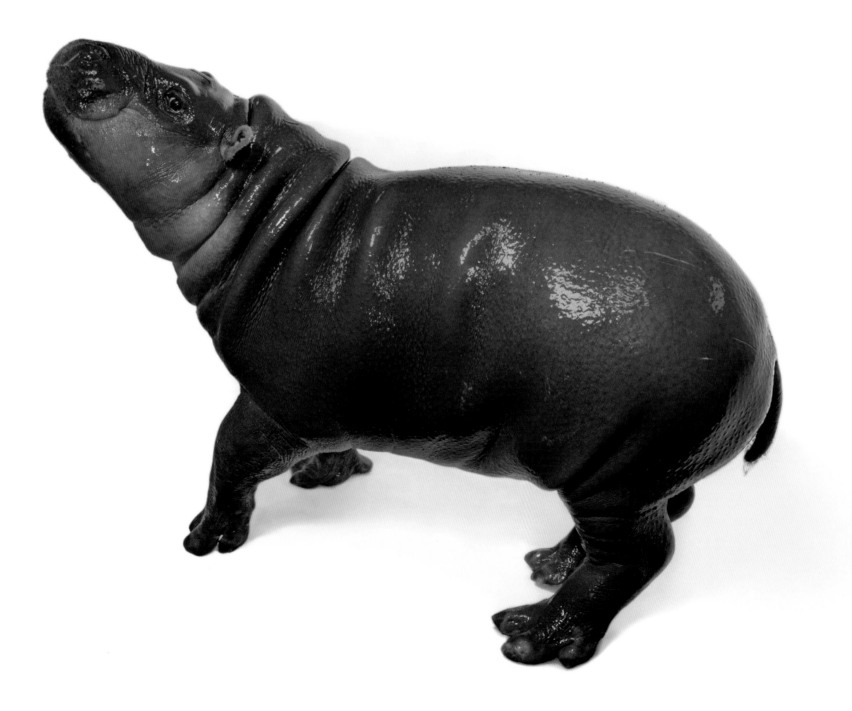

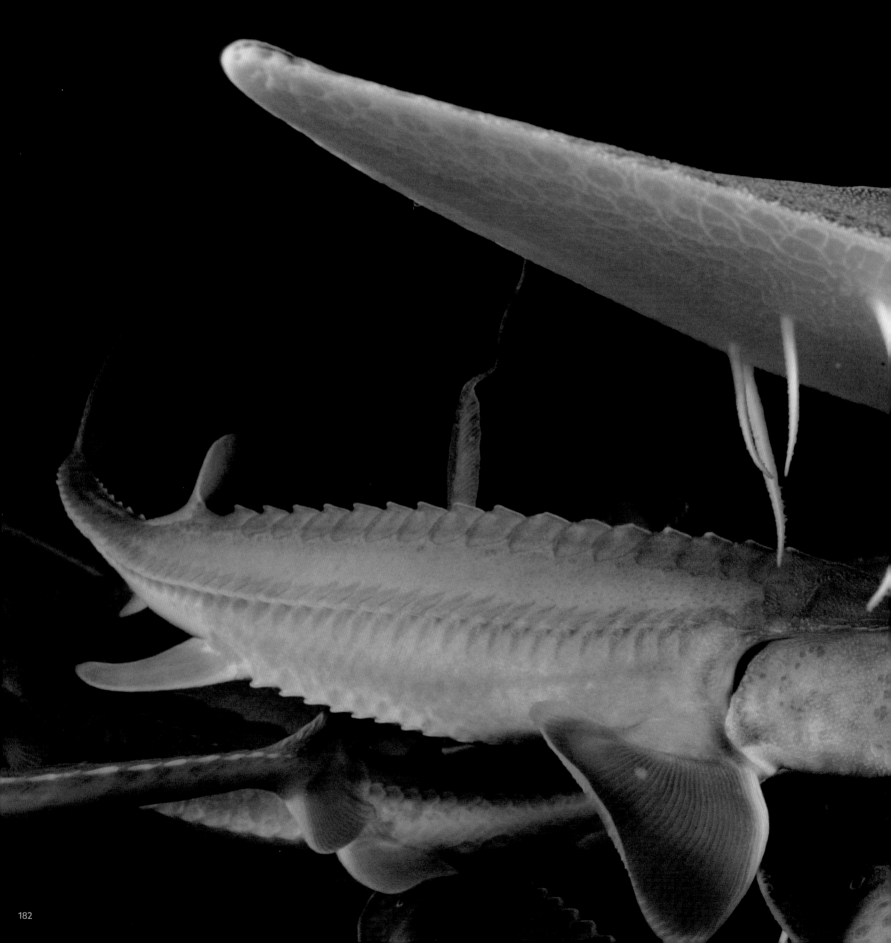

Pallid sturgeon, *Scaphirhynchus albus* (EN)

These massive fish have lived in the Missouri River Basin since the time of the dinosaurs. They are covered in bony plates, rather than the standard scales, and can weigh up to 36 kilograms and live up to 100 years.

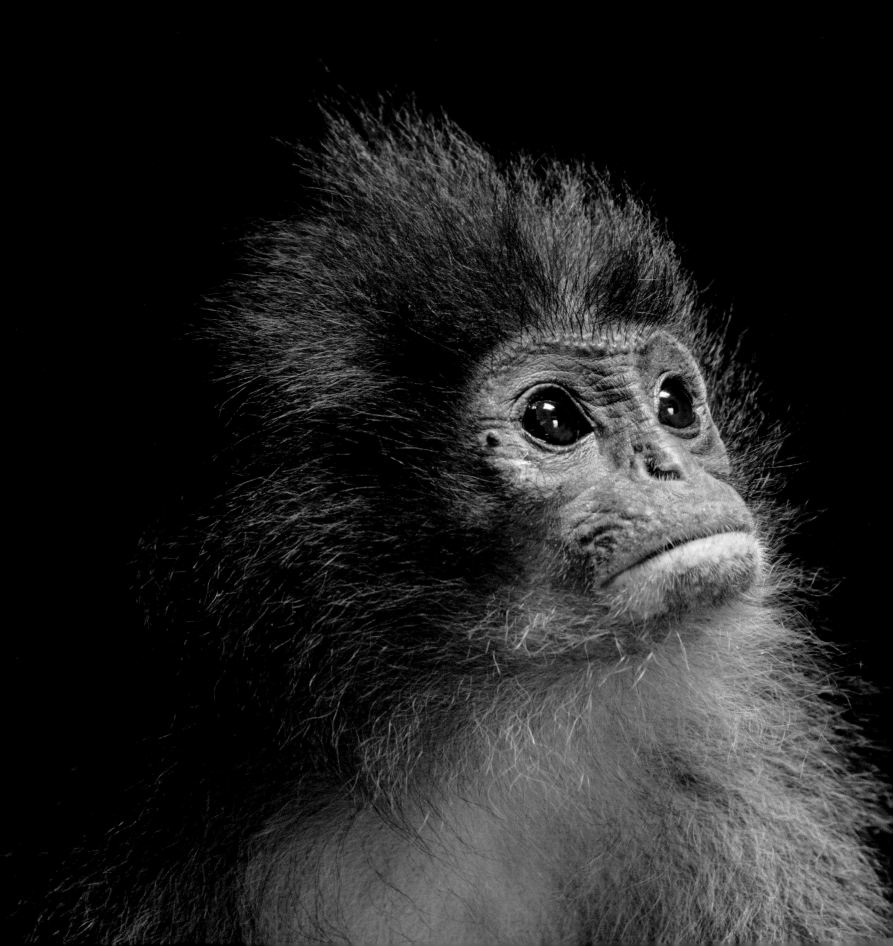

≈2,500

MATURE INDIVIDUALS REMAIN IN THE WILD

LEAVES AREN'T APPETIZING to most animals. Cellulose is hard to digest, and foliage doesn't offer much by way of nutrition. But to the Javan surili, a small, tree-dwelling monkey, the trees hold a feast. The surili has a specially adapted gut packed with bacteria that allows it not only to digest large amounts of leaves, but also to derive the nutrition and energy it needs to survive. These monkeys are social and active during the day, spending hours grooming and looking for food while young monkeys play with one another. The surili was once found in jungles across the Indonesian island of Java, but as the island's rainforests have been cleared, they find refuge in fragments of mountainous forests, mainly in protected areas. The monkey's fondness for leaves bodes well for other creatures of the rainforest: If we protect the surili's tropical home, we help other species as well.

Mariana fruit-dove, *Ptilinopus roseicapilla* (EN)

The invasive brown tree snake has put many species, including
the Mariana fruit-dove, on a path toward extinction. These
doves have already disappeared from their historic range
on Guam and are at risk as the predatory snake becomes
established on other islands.

Panay cloudrunner, *Crateromys heaneyi* (EN)

These tree-dwelling rats are found only on the Indonesian
island of Panay. Their long bushy tails account for about
half their body length.

Javan banteng, *Bos javanicus javanicus* (EN)

Currently the estimated banteng population numbers about 8,000 for the entire species, with more than half of those living in a subpopulation in Cambodia. The rest are scattered in smaller populations throughout Java, Thailand, and Malaysia.

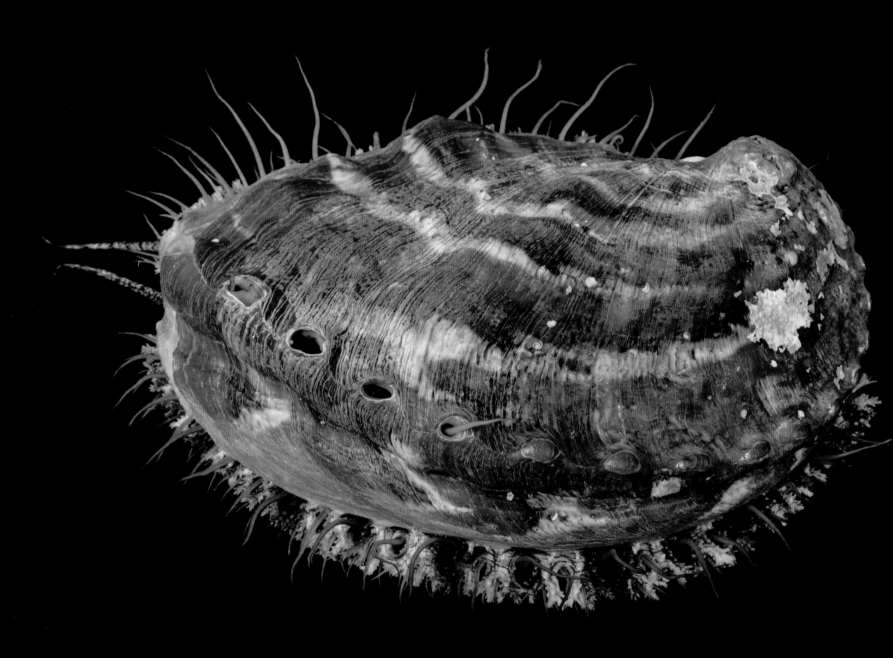

Pinto abalone, *Haliotis kamtschatkana* (EN)

Overfishing has reduced the population density of these Pacific Ocean sea snails to a point where there aren't enough in the wild to successfully reproduce. Without human intervention, extinction is inevitable.

Golden-headed lion tamarin,
Leontopithecus chrysomelas (EN)

Found only in southern Brazil, these small monkeys tend to
live in small family groups. Males and females are monoga-
mous and share responsibility for raising their young.

191

UNTIL 2002, NO INDIVIDUALS OF THIS

SPECIES HAD BEEN SEEN IN THE WILD SINCE

1935

Burmese roofed turtle, *Batagur trivittata* (EN)

More than 60 years had passed since the previous
recorded sighting when scientists found several of
these turtles in a temple pond in 2002. From that small
population, more than 300 turtles have been bred and
have started to be reintroduced to the wild.

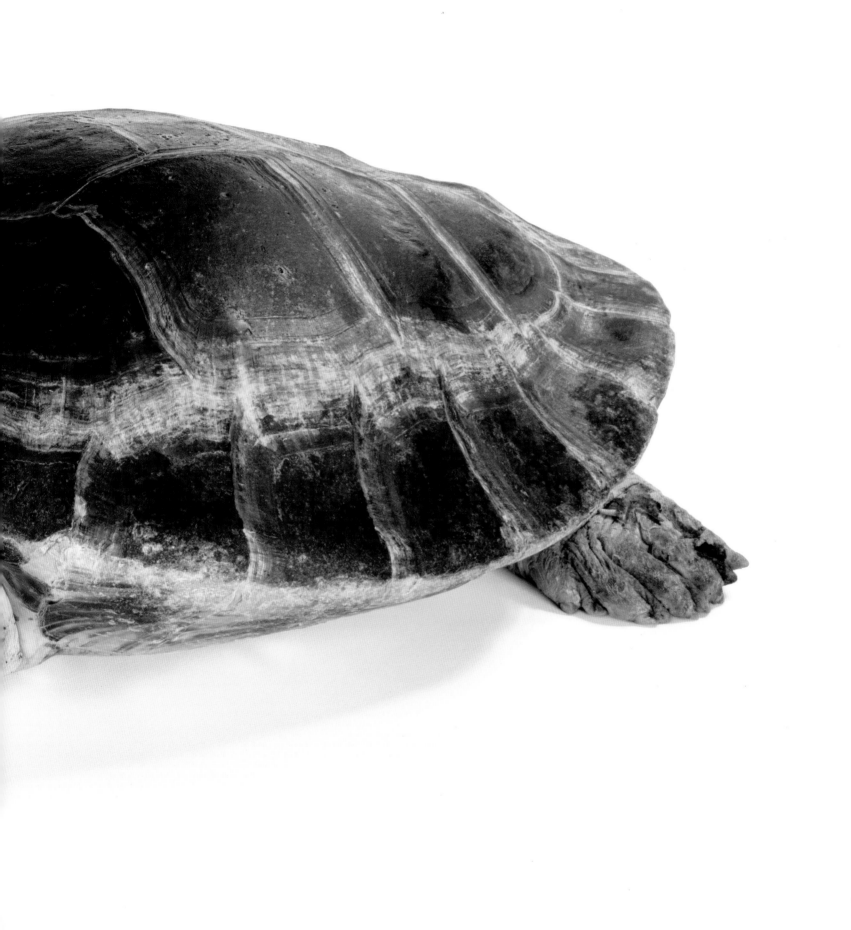

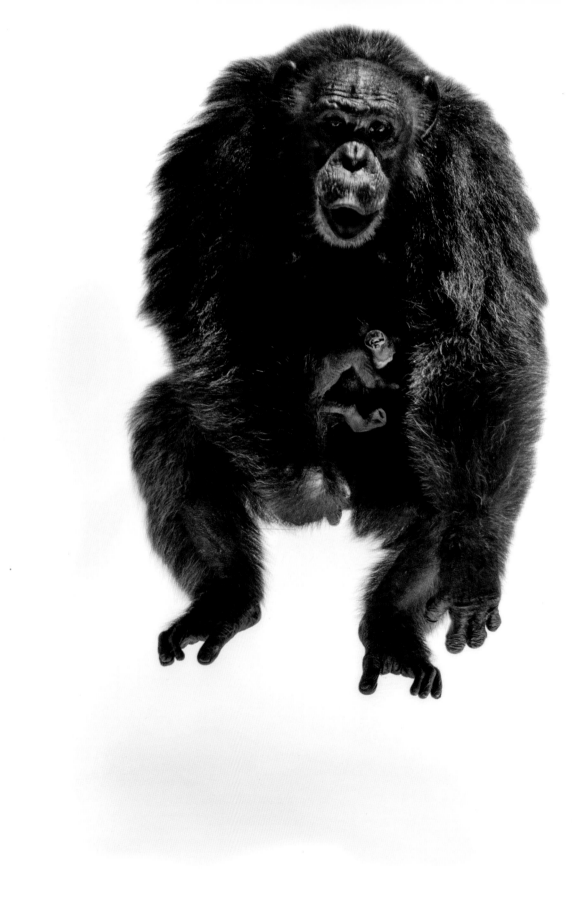

Chimpanzee, *Pan troglodytes* (EN)

Chimps share nearly 99 percent of their genetic code with humans. These social apes have many of our characteristics, from tool use to language. The first attempt to photograph chimpanzees for the Photo Ark was foiled when the chimp peeked its head into the enclosure and promptly made off with the backdrop.

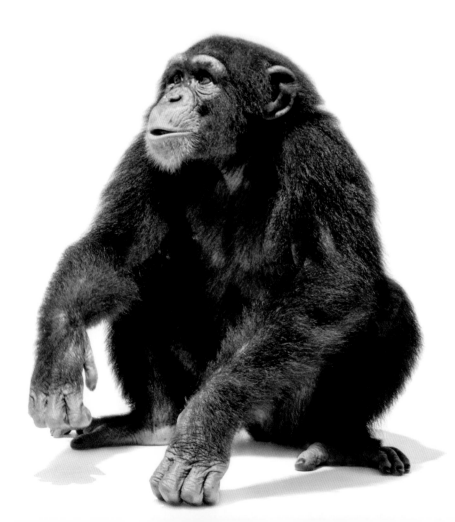

≈2,250

INDIVIDUALS REMAIN IN THE WILD

THE KANAK TRIBES of New Caledonia call the kagu the "ghost of the forest." A flightless bird with gray plumage and an affinity for dense woodlands, the kagu resembles a heron and stalks its territory with loud barks at dawn and quiet hisses. No other bird has a beak quite like the kagu: nasal "corns" cover its nostrils, presumably to keep out soil particles as it digs in the dirt for worms, insects, snails, and lizards. Kagus form long-term bonds, possibly mating for life; both parents take turns incubating and raising chicks, and young birds stay within their parents' territory for up to six years. Like many island species, the kagu has been seriously impacted by the arrival of European settlers and the non-native mammals they have brought with them. Pigs and dogs are predators, and the latest population estimates suggest not many more than 2,000 birds survive in the wild. Scientists think the kagu's future is hopeful. Decades of successful captive breeding have resulted in the reintroduction of many birds to the wild, and control of predators has allowed some local populations to rebound. The kagu may appear ghostlike, but thanks to sustained conservation it's anything but a phantom.

Kagu, *Rhynochetos jubatus* (EN)

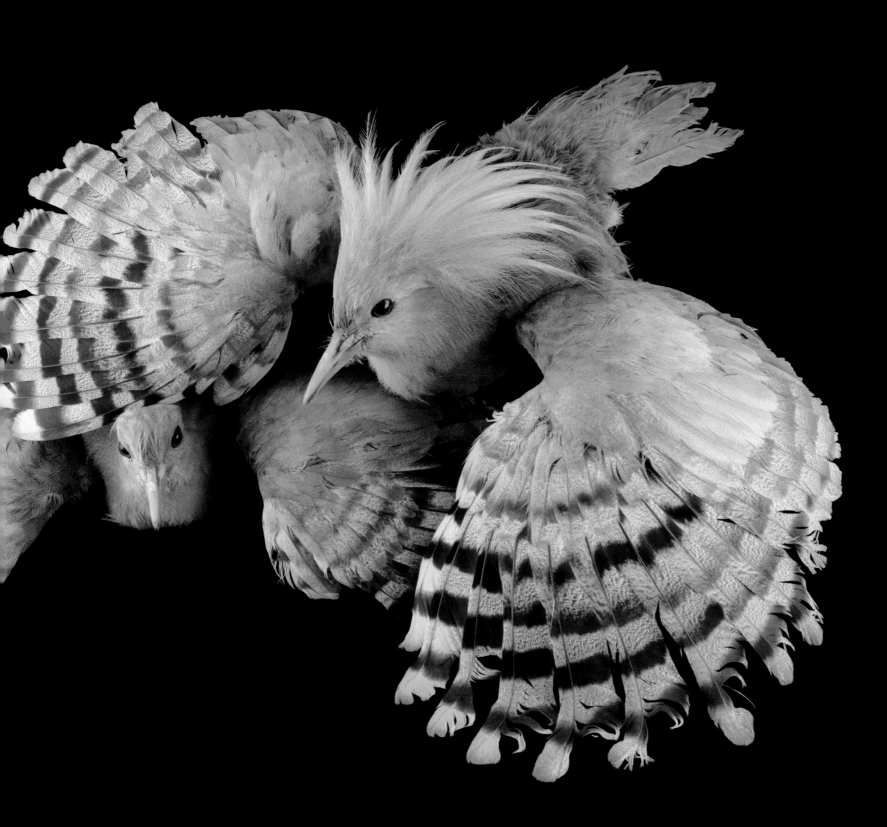

Humphead wrasse, *Cheilinus undulatus* (EN)

On a diet of sea stars, sea hares, and mollusks, these fish can grow to weigh up to 180 kilograms. Some will change gender throughout their lives, spending their youth as females and their late adulthood as males.

Dhole, *Cuon alpinus* (EN)

Though a member of the canine family, dholes are unique,
not quite fitting into the major subfamilies. But like other
dogs, they are social animals. During hunts, they sometimes
communicate through whistles and clucks.

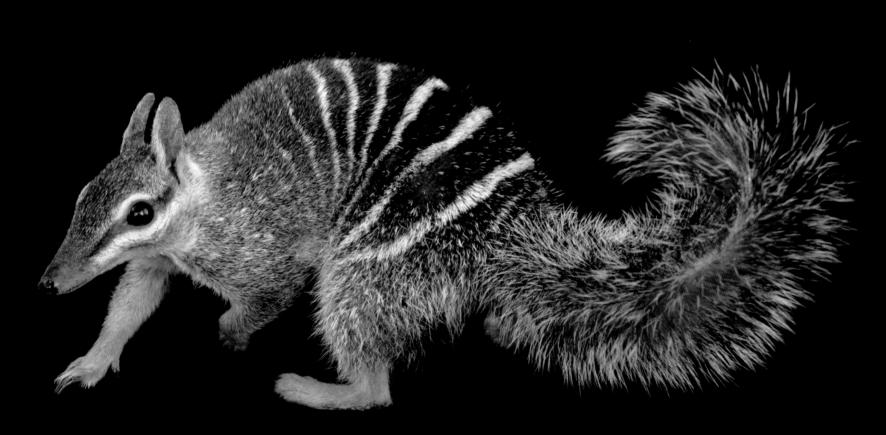

Numbat, *Myrmecobius fasciatus* (EN)

Fewer than 1,000 of these small Australian marsupials exist in the wild today. Predation from red foxes and domestic cats took a toll on their population.

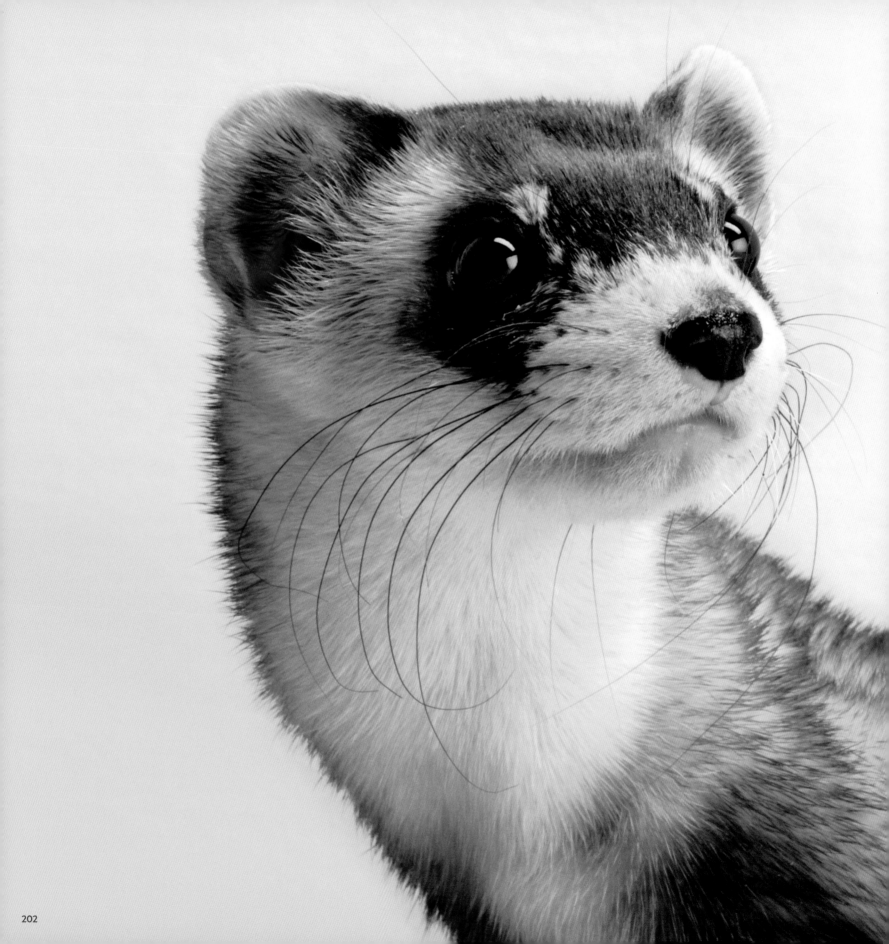

"WE HAVE TO SLEEP WITH OUR EYES OPEN, BECAUSE THE FUTURE OF OUR WILDLIFE AND WILD PLACES DEPENDS ON US.

———————————————————————————

JAMIE RAPPAPORT CLARK, PRESIDENT AND CEO, DEFENDERS OF WILDLIFE

FOLK REMEDIES

HUMANS HAVE LONG RELIED on animals and plants for remedies to soothe our aches and pains, and many modern drugs have roots in nature. But a vigorous demand for folk remedies without any proven medical benefit has pushed the Chinese pangolin, eastern black rhinoceros, proboscis monkey, and other animals to the brink of extinction. Experts believe more than a million pangolins have been taken from the wild in the jungles of Asia and Africa in just a decade to satisfy a hungry market in China and Vietnam for powdered pangolin scales, which are falsely believed to help with rheumatism, skin disorders, and even cancer. Many conservationists think the Chinese government could rein in the trafficking of these rare creatures by banning pangolin products, as it did with banning ivory in 2017. Within a year demand for, and sales of, ivory had dropped.

TOP ROW, LEFT TO RIGHT: Egyptian vulture, *Neophron percnopterus* (EN); Lined seahorse, *Hippocampus erectus* (VU); White-bellied pangolin, *Phataginus tricuspis* (VU) **BOTTOM ROW, LEFT TO RIGHT:** Chinese alligator, *Alligator sinensis* (CR); Proboscis monkey, *Nasalis larvatus* (EN); Axolotl, *Ambystoma mexicanum* (CR); Eastern black rhinoceros, *Diceros bicornis michaeli* (CR)

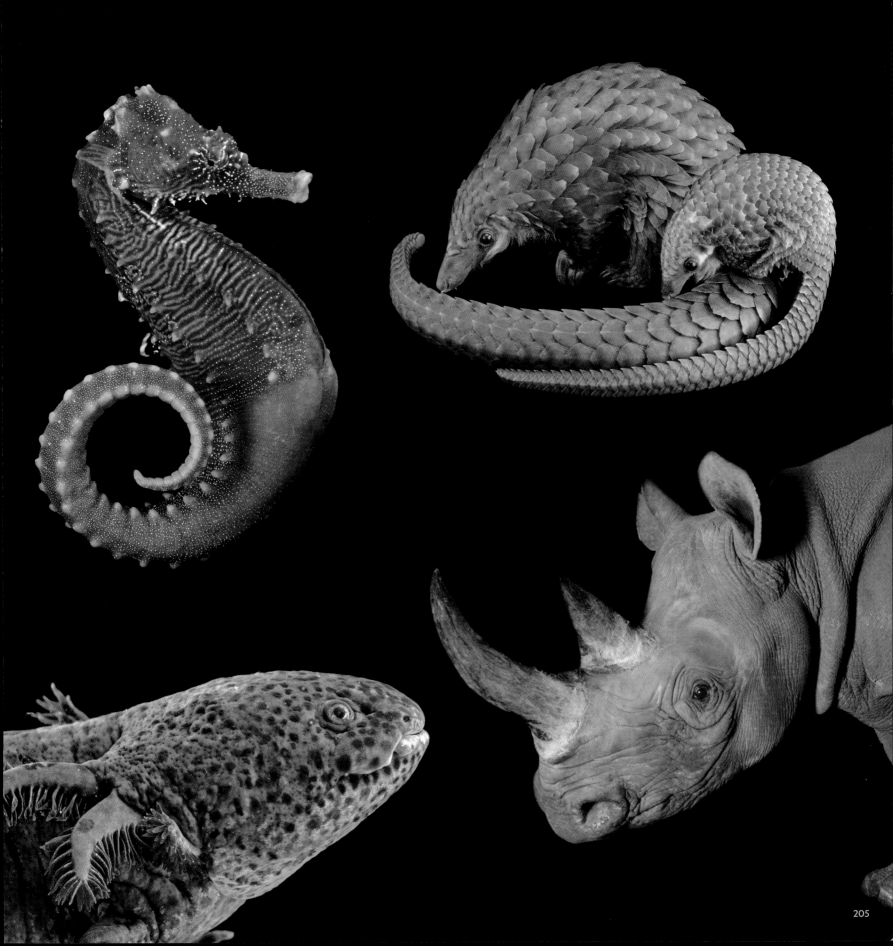

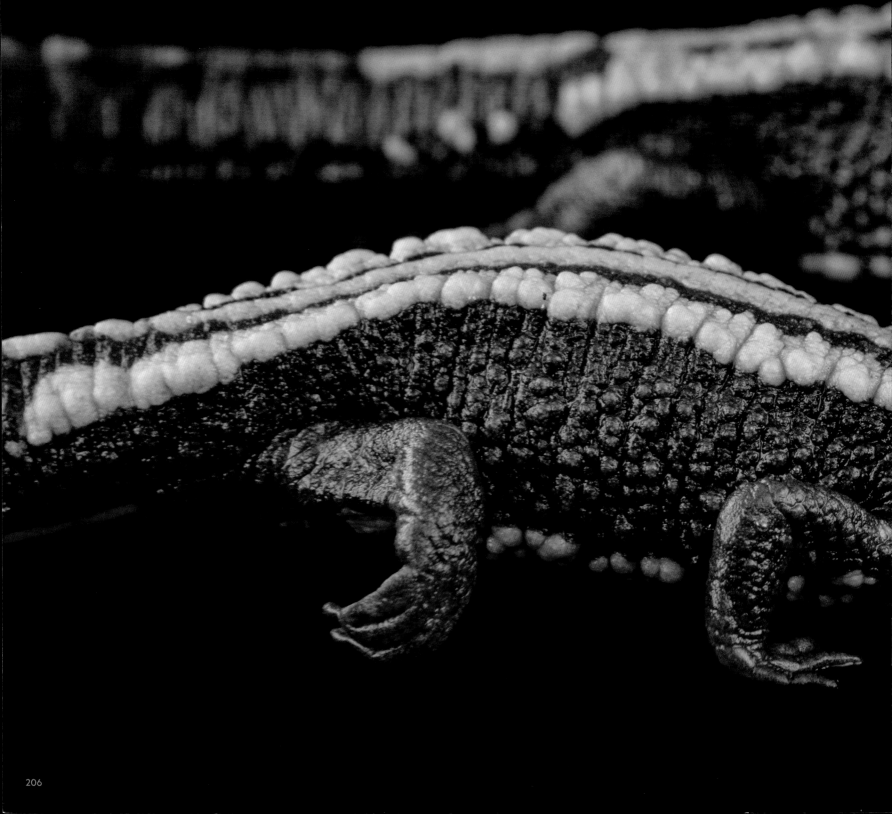

Laos warty newt, *Laotriton laoensis* (EN)

These newts lay their eggs between dead leaves at the bottom of stream pools to incubate.

Southern mountain yellow-legged frog, *Rana muscosa* (EN)

These frogs are native to the lakes and ponds of California's Sierra Nevada. Non-native trout, introduced for sportfishing, have devastated the population across more than 99 percent of their former area.

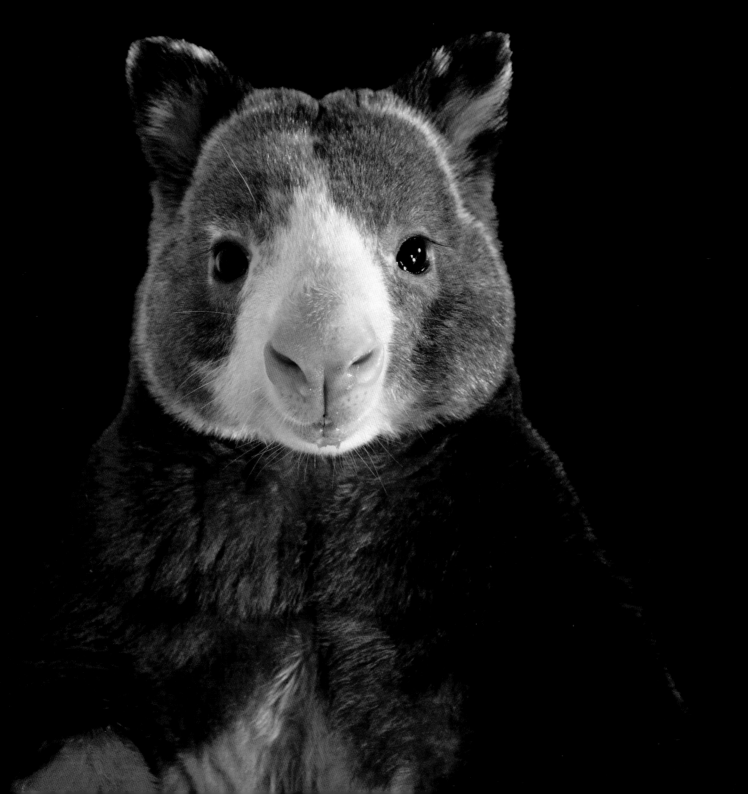

Matschie's tree kangaroo, *Dendrolagus matschiei* (EN)

Now reduced to just one percent of their historical range, these tree kangaroos led to the creation of Papua New Guinea's first conservation protection area. But poaching and deforestation continue to lead to population decline.

March's palm pit viper, *Bothriechis marchi* (EN)

Found in mainland Honduras, these snakes are struggling as amphibian populations, their primary prey, dwindle. Between disease and habitat loss, as their prey disappears so do the pit vipers.

" WHY CARE ABOUT SNAKES? WE'D BE KNEE-DEEP IN RODENTS WITHOUT THEM.

JOEL SARTORE

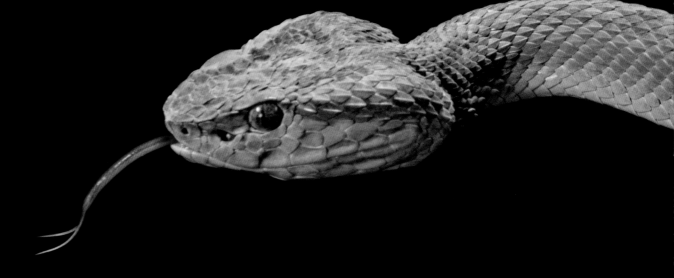

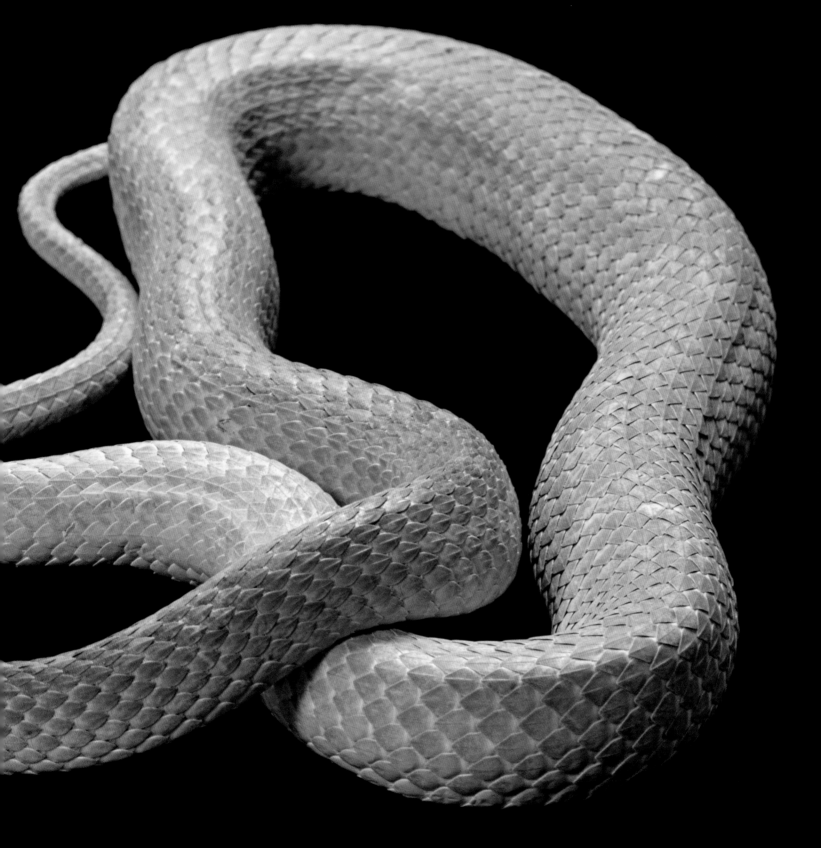

≈7,700

INDIVIDUALS REMAIN IN THE WILD

EVEN THE LITTLEST CREATURES have big tales to tell. Scientists are still uncovering the story of the tiny Frégate Island Enid snail, which lives along a strip of coastline on the tiny island in the Seychelles that it is named for. In 2001, when a poison was used to rid the island of non-native rats, these snails were nearly wiped out as well. Their population plummeted by 87 percent in just two years. But now that the rodenticide and the rats are gone, scientists expect the snail's numbers—tallied at 7,700 in the most recent assessment in 2005—to increase. The snail may be rare, but it could well become an attraction: Frégate Island is privately owned and managed for wealthy tourists, and a key selling point is conservation of native animals. Even the tiniest ones.

Frégate Island Enid snail, *Pachnodus fregatensis* (EN)

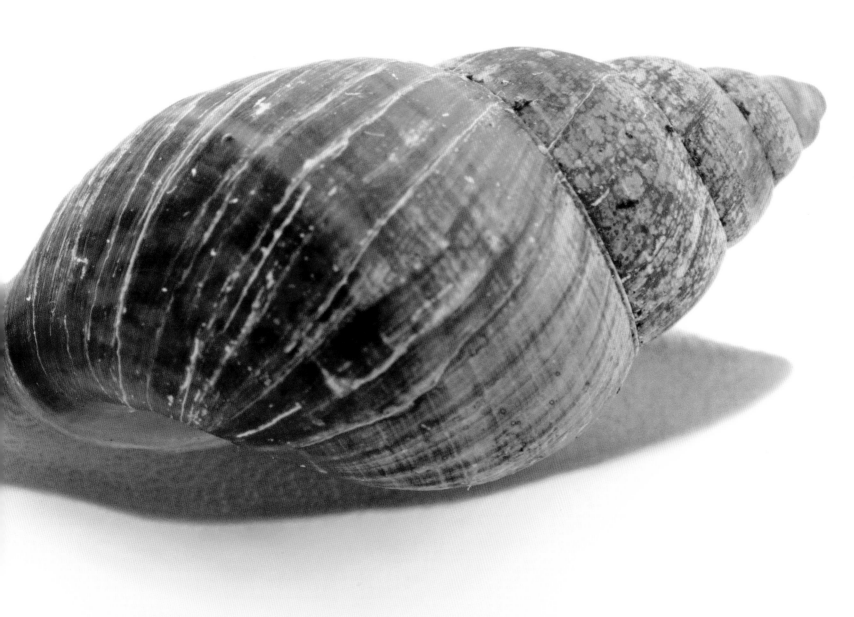

Volcano rabbit, *Romerolagus diazi* (EN)

This small rabbit is aptly named, as its habitat is limited to four volcanoes in Mexico: Popocatepetl, Iztaccihuatl, El Pelado, and Tlaloc.

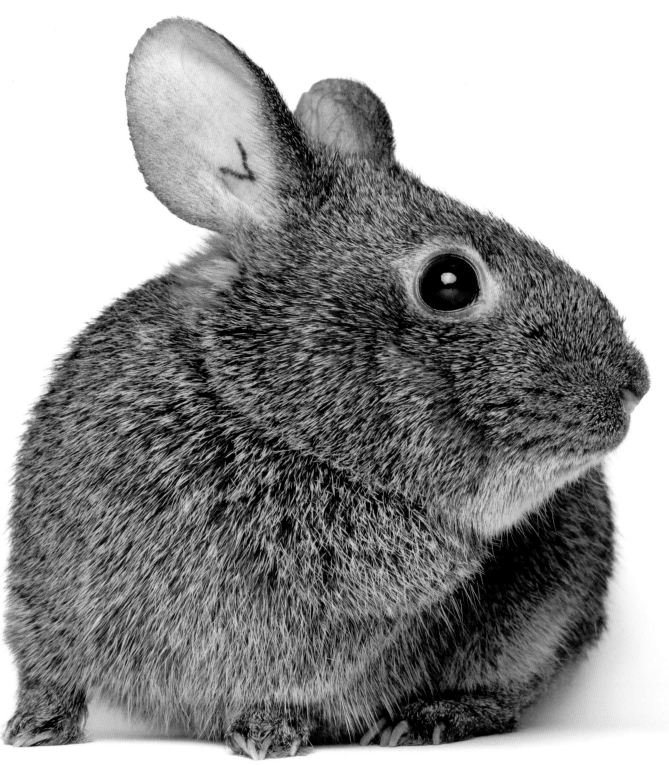

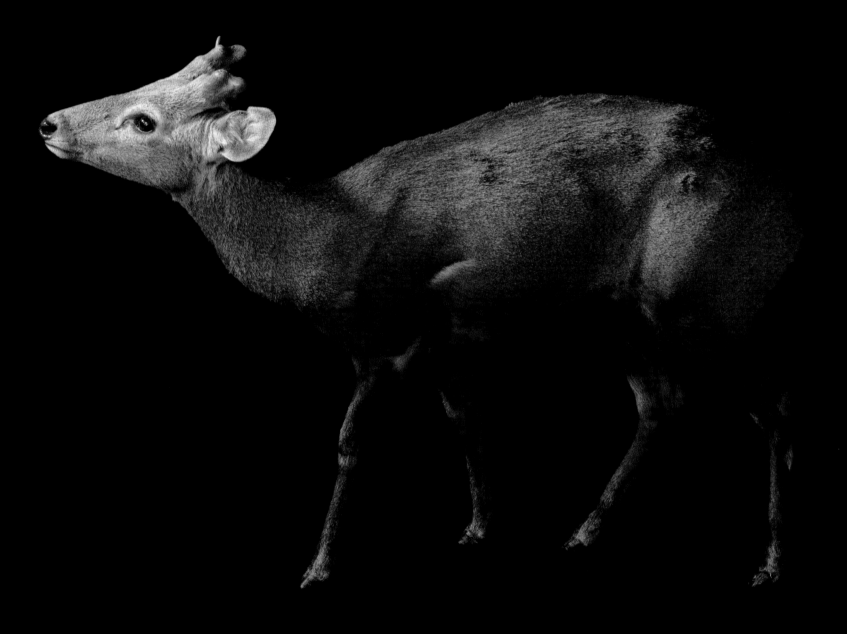

Calamian deer, *Axis calamianensis* (EN)

Unlike other species of deer that will bound over barriers, these deer will lower their heads and charge through underbrush, earning them the alternative name of hog-deer.

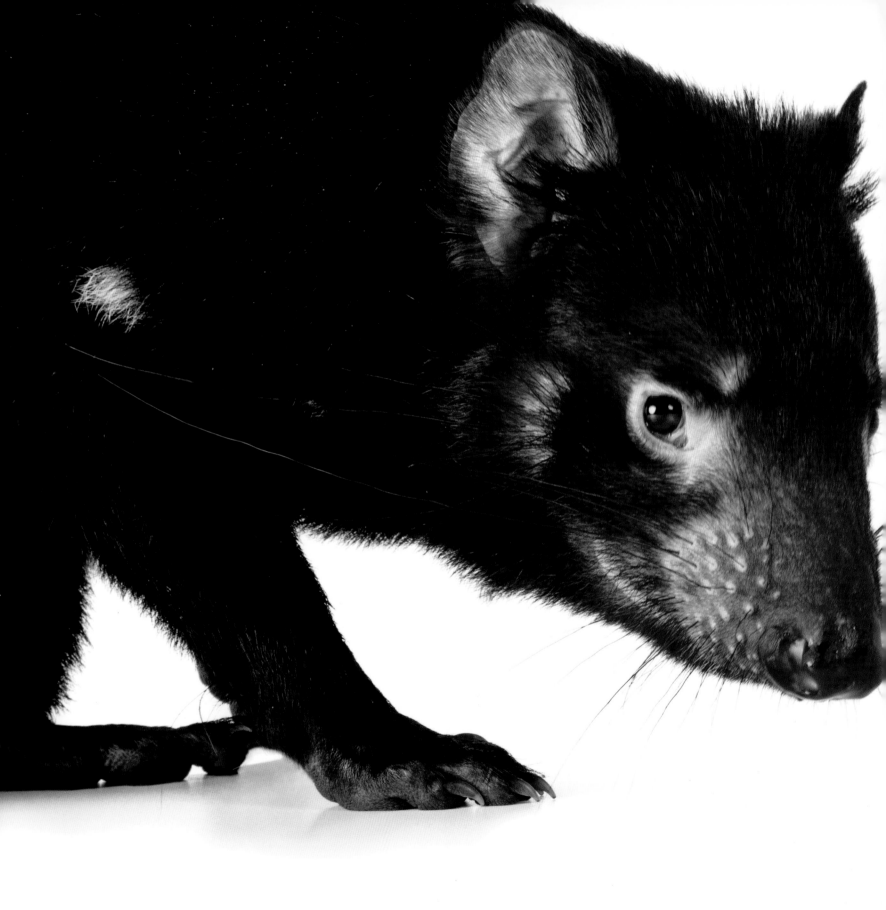

THE NUMBER OF TASMANIAN DEVILS KILLED

ON THE ROAD ANNUALLY IS MORE THAN

2,000

Tasmanian devil, *Sarcophilus harrisii* (EN)

Though highways are dangerous, the real threat for these animals is devil facial tumor disease, a form of cancer that is transmissible between Tasmanian devils. The disease was first observed in 1996, and researchers have yet to find a successful treatment or cure.

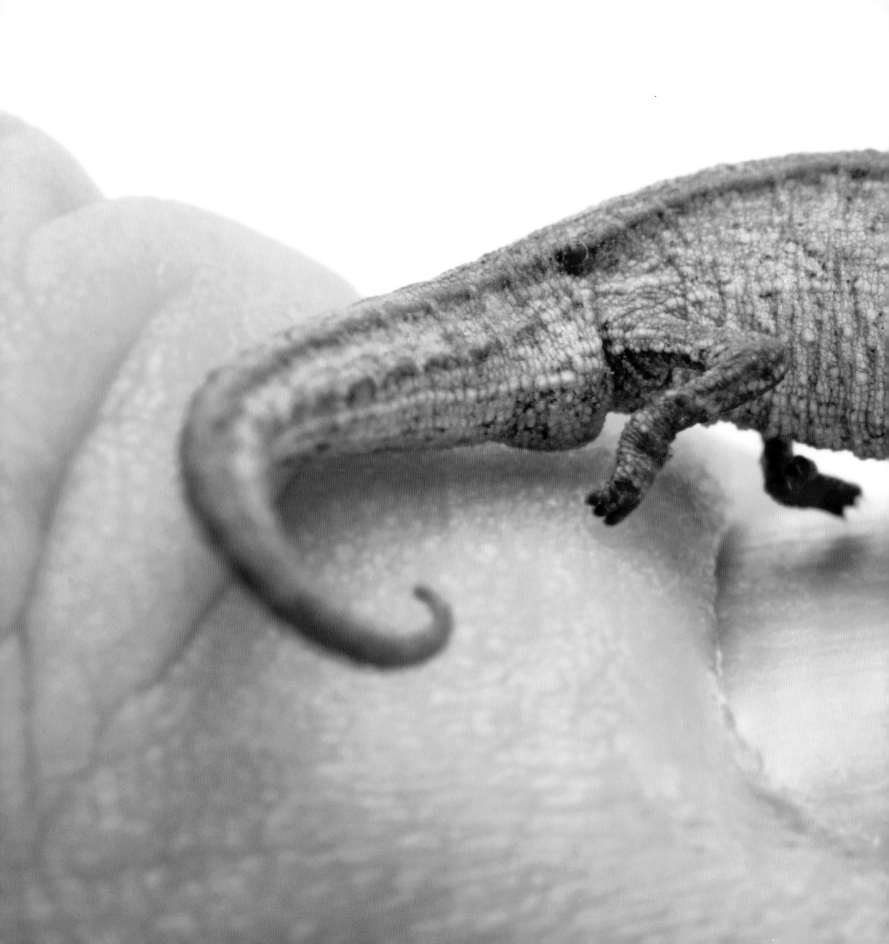

Madagascar dwarf chameleon, *Brookesia minima* (EN)

One of the world's tiniest reptiles, the dwarf chameleon is scarcely larger than a fingernail. Its small size means it is especially vulnerable to habitat changes on the forest floor.

Annamese langur, *Trachypithecus germaini* (EN)

Little is known about these Cambodian langurs—
scientists are still debating whether they are even
an independent species. Logging and habitat loss
are reducing the population still further, making
discovery and analysis even more difficult.

Grey crowned-crane, *Balearica regulorum gibbericeps* (EN)

These elegant birds leap, bow, sprint, and flap their wings, engaging in elaborate dances as gracefully as ballerinas. The dances are used to attract mates, as well as for communication.

Giant otter, *Pteronura brasiliensis* (EN)

Twice the size of their North American relatives, these South American river otters can weigh up to 32 kilograms. Their size means they have few enemies; jaguars and pumas are among their only predators.

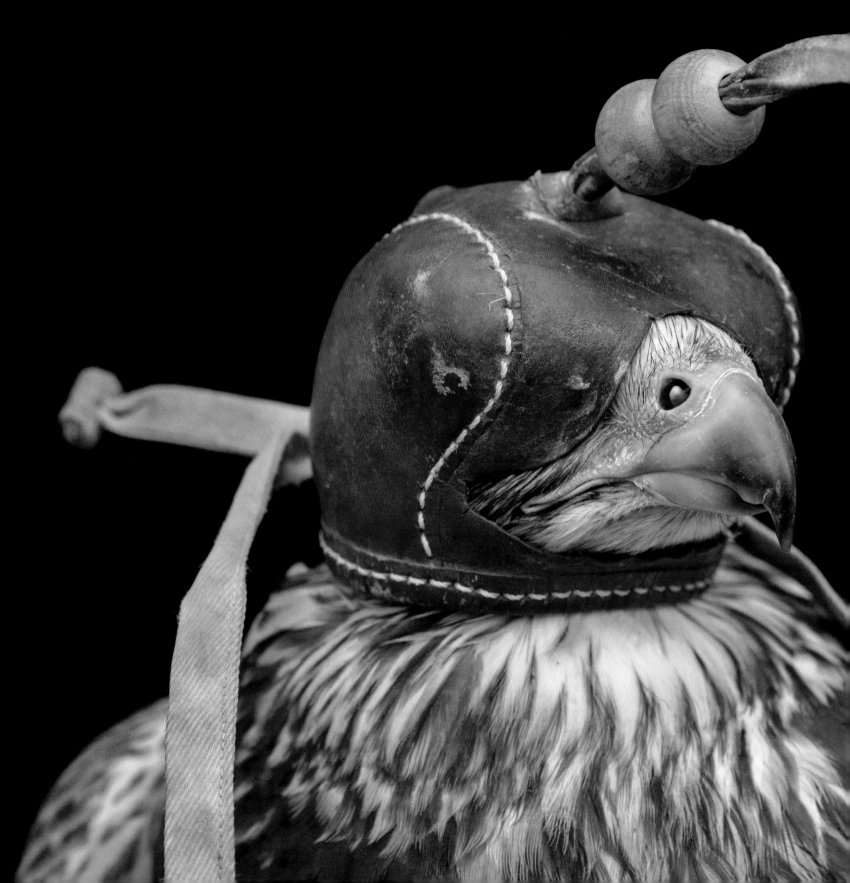

THE NUMBER OF THESE BIRDS CAPTURED EACH YEAR

FOR USE IN FALCONRY IS ESTIMATED AT UP TO

8400

Saker falcon, *Falco cherrug* (EN)

To encourage increases in breeding, more than 5,000
artificial nest sites have been built for saker falcons in
Mongolia. This bird is wearing a falconry hood, used to
keep birds of prey calm during transportation.

South Diamond Gila trout, *Oncorhynchus gilae gilae* (EN)

Wildfires pose risks for aquatic species too. After a long fight
to protect the Gila trout, ash from a New Mexico wildfire nearly
wiped out this freshwater species in 2012.

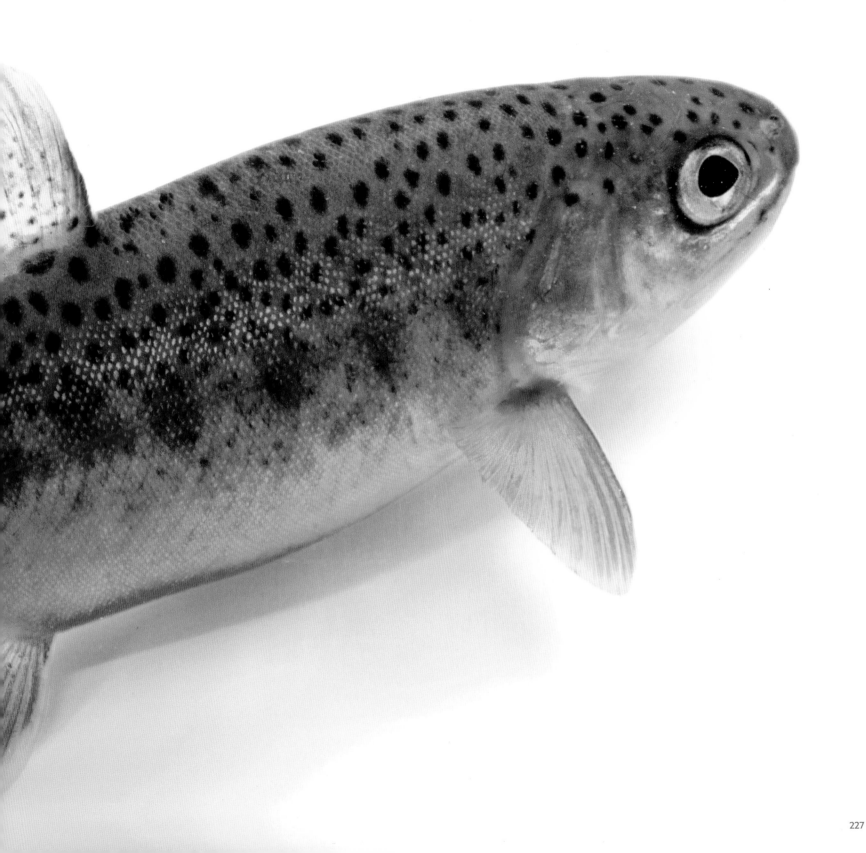

Grévy's zebra, *Equus grevyi* (EN)

Once ranging from Kenya to Somalia and Ethiopia, Grévy's zebras are now limited to small populations in Kenya and Ethiopia. They are social animals, often seen mingling with other species like wildebeest, ostrich, and antelope.

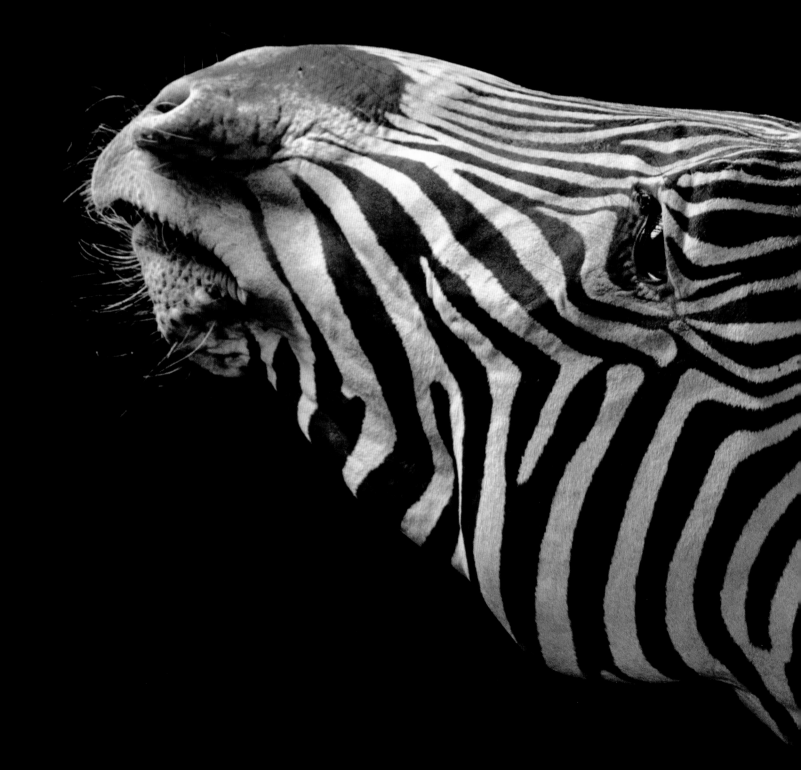

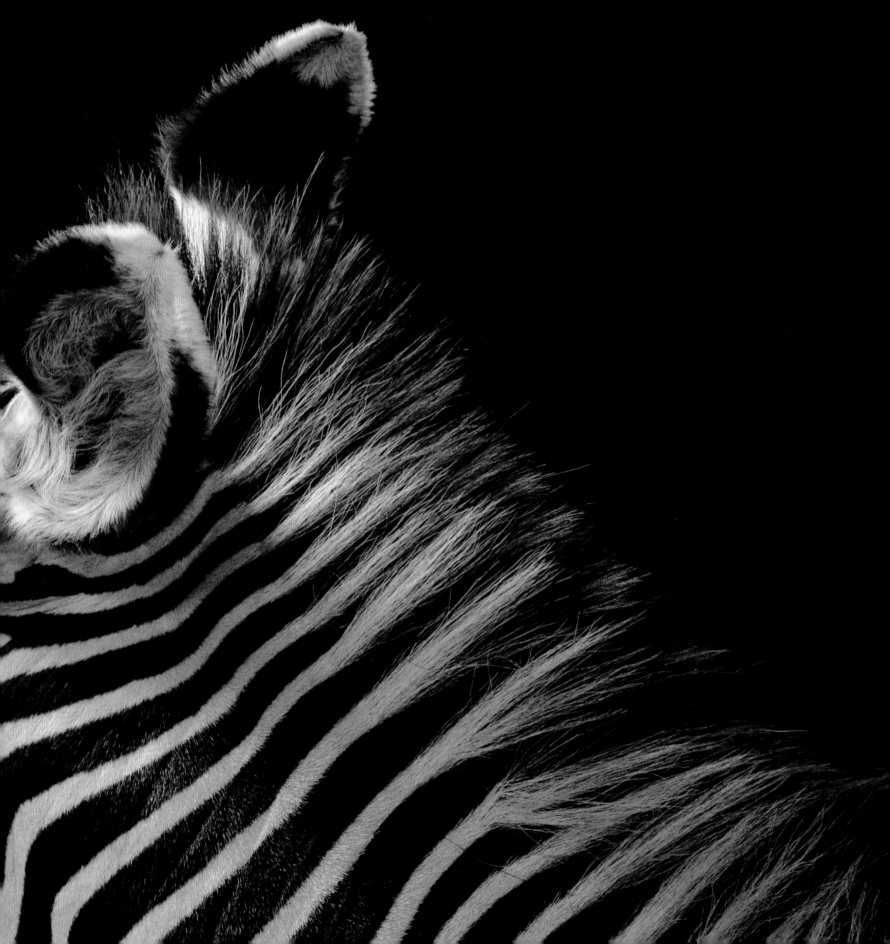

African wild dogs, *Lycaon pictus* (EN)

Also known as painted dogs, these animals are among Africa's top predators, working in cooperative packs to take down large herbivores like gazelle and wildebeest. Their biggest threats are habitat fragmentation and risk of infectious diseases.

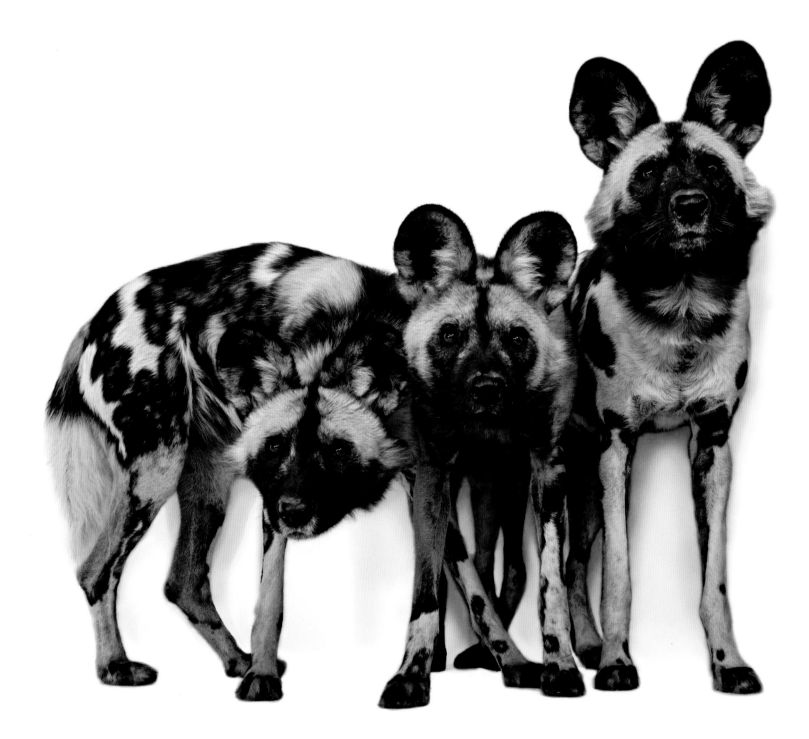

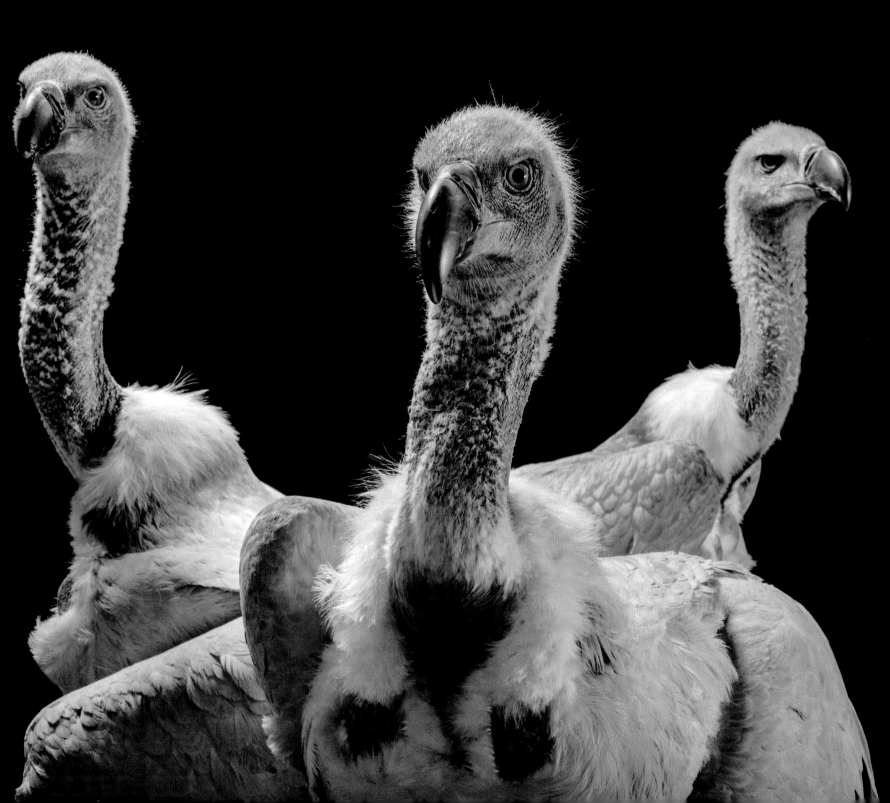

Cape vultures, *Gyps coprotheres* (EN)

When ranchers poison dead livestock to kill off predators, Cape vultures are often caught in the crossfire. These scavengers will frequently make a shared meal out of a carcass.

≈36,000

MATURE INDIVIDUALS REMAIN IN THE WILD

MADAGASCAR'S LARGEST RODENT is fond of its family. Young male rats stay with their families for a year before venturing out to establish their own territory; young females stick around for two years. Adult rats, roughly the size of rabbits, mate for life, and males are actively involved in raising the young, often following their male offspring beyond the family burrow to protect them from predators. But centuries of human settlement have steadily degraded its habitat and introduced predators such as feral dogs. Climate change, meanwhile, has made the rat's range increasingly arid in recent decades. Luckily, most of the rat's current distribution lies within a protected area, and the Durrell Wildlife Conservation Trust has managed a successful captive-breeding program for decades.

Malagasy giant jumping rat, *Hypogeomys antimena* (EN)

THE COST OF COFFEE

WHAT'S THE REAL PRICE of a cup of coffee? Animals that live in the tropical rainforests of Latin America increasingly pay with their lives. A global addiction to coffee is destroying habitat at an alarming rate as coffee producers clear-cut hundreds of thousands of hectares of lush rainforest every year in favor of large-scale coffee-growing operations. The toll is profound for animals that have large ranges or that rely on intact forests to forage and take cover. From the 1970s to the 1990s, for instance, populations of migratory songbirds that spend the winter in the tropics plummeted—the exact same time period of widespread deforestation of coffee-growing lands in Colombia, a leading coffee exporter and home to more than 1,900 bird species.

TOP ROW, LEFT TO RIGHT: Geoffroy's spider monkey, *Ateles geoffroyi* (EN); Golden-cheeked warbler, *Setophaga chrysoparia* (EN); Margay, *Leopardus wiedii* (NT) **BOTTOM ROW, LEFT TO RIGHT:** Oncilla, *Leopardus tigrinus* (VU); Blue-billed curassow, *Crax alberti* (CR); Yucatán black howler monkey, *Alouatta pigra* (EN); Golden-capped parakeet, *Aratinga auricapillus* (NT)

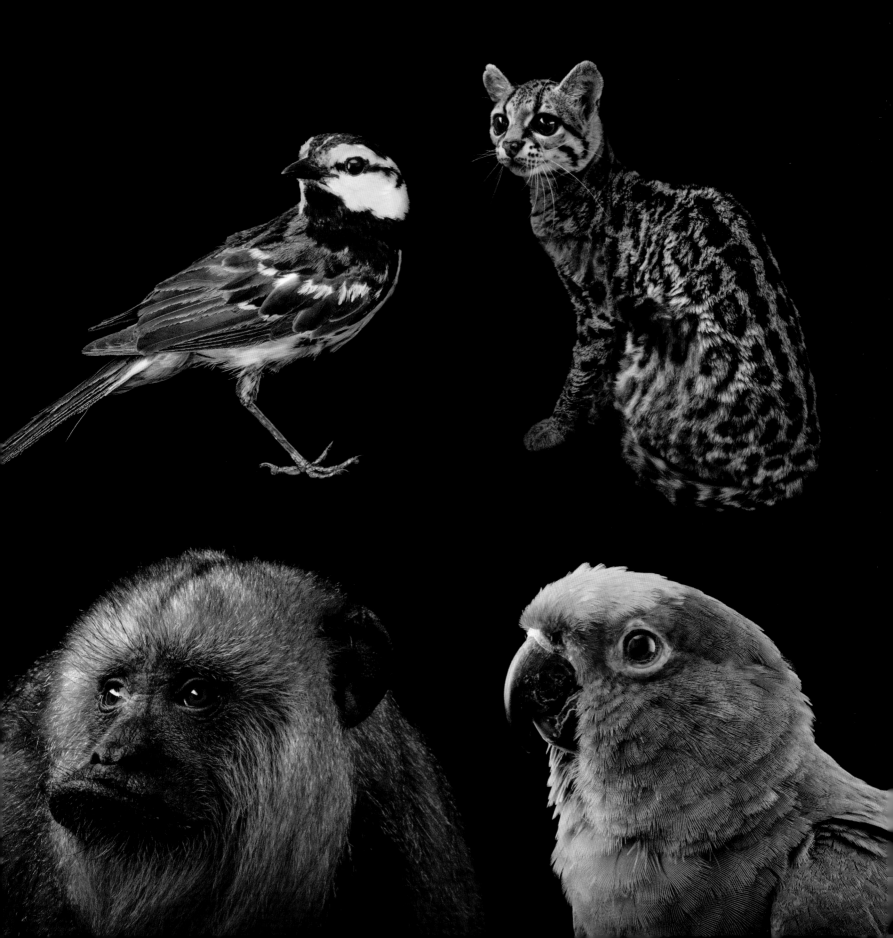

Native to Colombia, the white-fronted capuchin has decreased in number by more than 50 percent over the past 48 years thanks to multiple threats to its native habitat.

Silvery gibbon, *Hylobates moloch* (EN)

The upper canopy of Java's rainforests, where these gibbons make their homes, is rapidly disappearing. Deforestation and agriculture have radically reduced the gibbons' forests and fragmented what remains of their population.

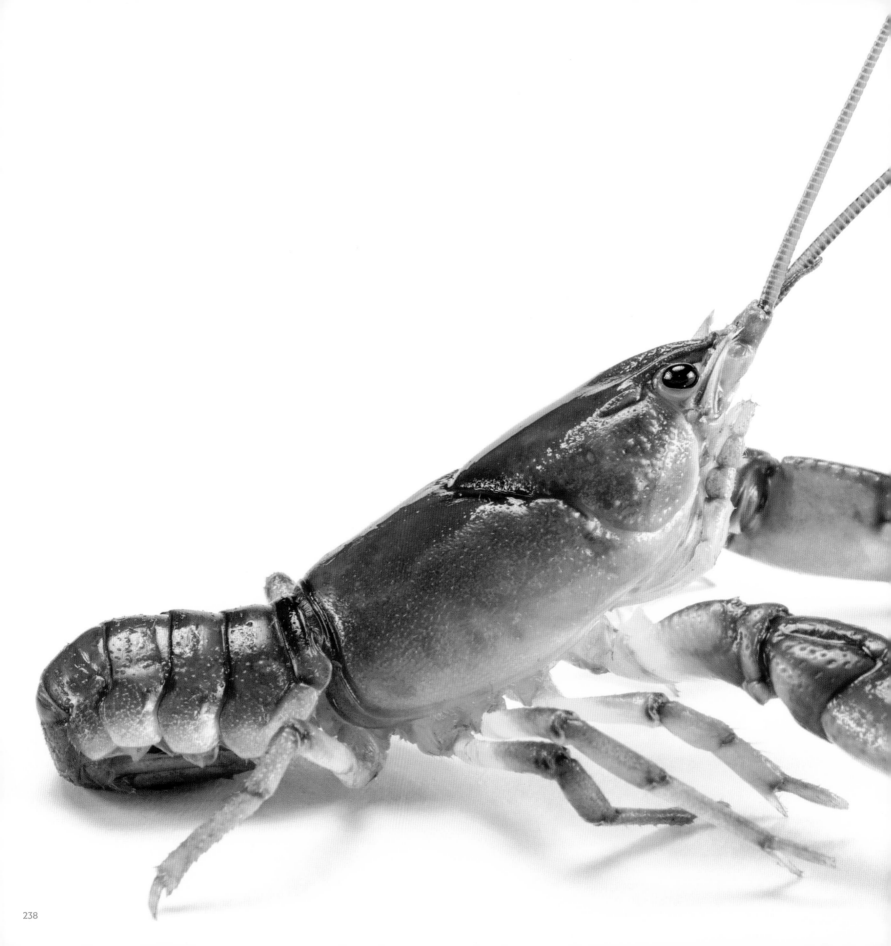

" **IT'S MY JOB TO DO THE SCIENCE. BUT IT IS EVERY BIT AS IMPORTANT FOR ME TO TEACH FUTURE CONSERVATIONISTS HOW TO DO THE SCIENCE, TOO. MORE CONSERVATIONISTS LEAD TO MORE CONSERVATION ACTION DOWN THE ROAD AND MORE APPRECIATION FOR THESE ANIMALS.**

ZACHARY LOUGHMAN, ASSOCIATE PROFESSOR OF BIOLOGY AND ZOO SCIENCE AND APPLIED CONSERVATION BIOLOGY COORDINATOR, WEST LIBERTY UNIVERSITY

Guyandotte River crayfish, *Cambarus veteranus* (DD)

This small crustacean was listed as federally endangered in 2016. Found in the Guyandotte River Basin in southern West Virginia, the Guyandotte River crayfish is under serious threat from mountaintop removal mining, which affects the health of the waterways where it lives.

Silverstone's poison frog, *Ameerega silverstonei* (EN)

This small frog from the Cordillera Azul of Peru may lack the intense poison of other dart frogs, but it still bears the bright coloration warning of its toxicity.

Golden poison frog, *Phyllobates terribilis* (EN)

This small frog is the most poisonous animal on Earth. A single individual has enough poison in its body to kill 10 adult men. Males carry larvae from the forest floor to water, where they mature.

≈2,500

MATURE INDIVIDUALS REMAIN IN THE WILD

IN THE MARSHES of Sumatra, Borneo, and the Malayan Peninsula, a feline the size of a small house cat prowls a tropical wetland. Flat-headed cats are small but fierce, capturing slippery fish with their webbed paws and carrying off their prey with pointed teeth. Like its close relative the fishing cat, the flat-headed cat is designed for life near the water. Along with those webbed feet and powerful jaws, its close-set eyes allow it to spot and catch underwater prey—mostly fish, crustaceans, and amphibians—with ease. Flat-headed cats need a very specific kind of habitat to survive, and the wetlands they favor are rapidly being drained or developed for agriculture and human settlement. Scientists may know little about these water-loving felines, but the degradation of Asia's tropical waterways is well documented and sounds an alarm for this rare and mysterious species.

Flat-headed cat, *Prionailurus planiceps* (EN)

Lesser chameleon, *Furcifer minor* (EN)

Unlike most other chameleons, females of this species are more intensely colored than the males (such as this one), especially during mating season. While they are predominantly forest creatures, lesser chameleons are becoming common in agricultural fields and other disturbed landscapes.

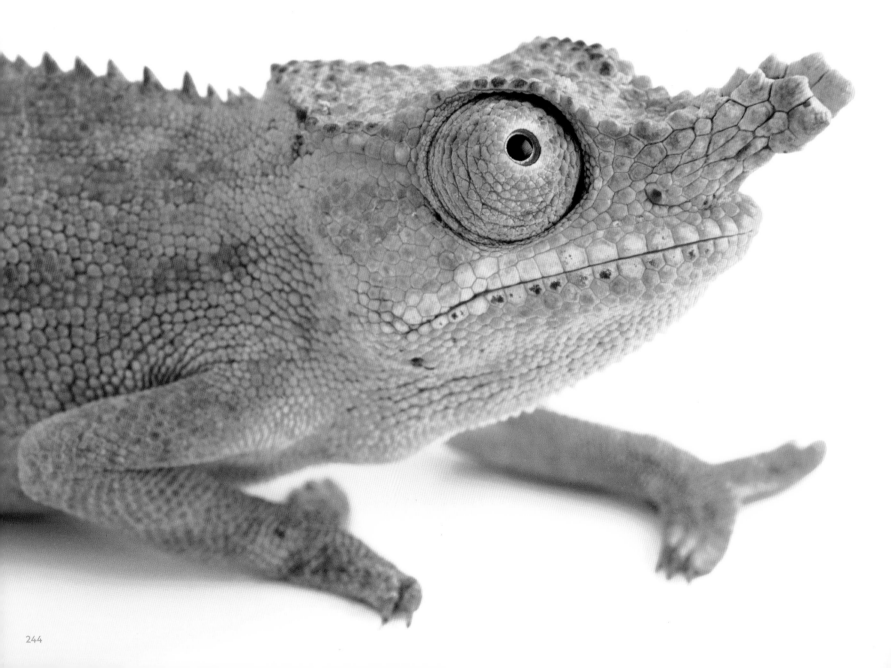

Helmeted curassow, *Pauxi pauxi* (EN)

The "helmet" on this curassow is actually called a casque. During mating season, male curassows use the casque to amplify their low booming calls.

IN THREE GENERATIONS, THE POPULATION OF THIS

SPECIES HAS DECLINED BY APPROXIMATELY

57%

Australian sea lion, *Neophoca cinerea* (EN)

For many years, sea lions and other marine mammals were hunted for food and other purposes. Though the species is now protected from hunting, it has yet to recover to precolonial population size.

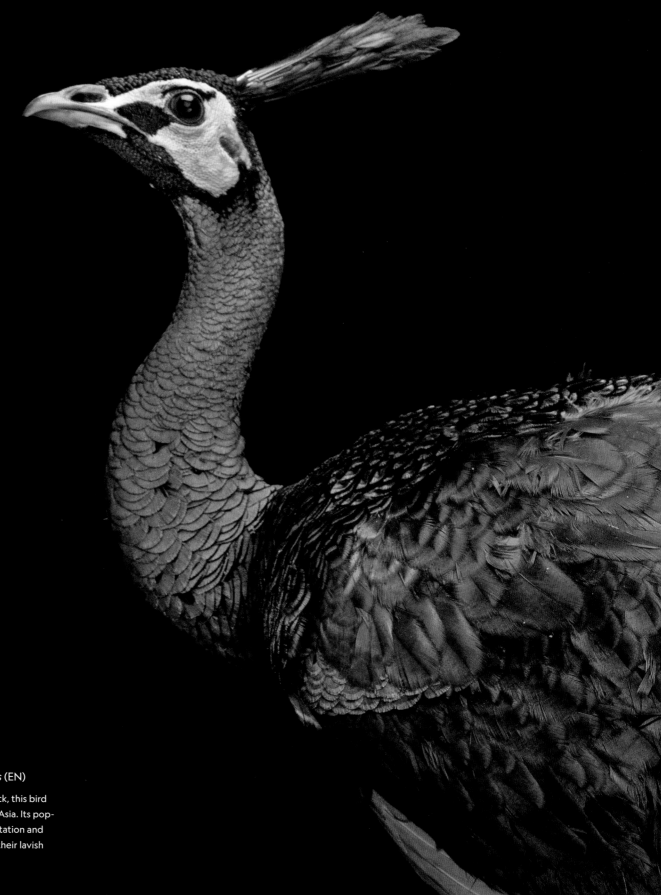

Green peafowl, *Pavo muticus muticus* (EN)

A relative of the well-known Indian peacock, this bird was once common throughout Southeast Asia. Its population has dwindled as a result of deforestation and hunting; males especially are pursued for their lavish and elaborate tail feathers.

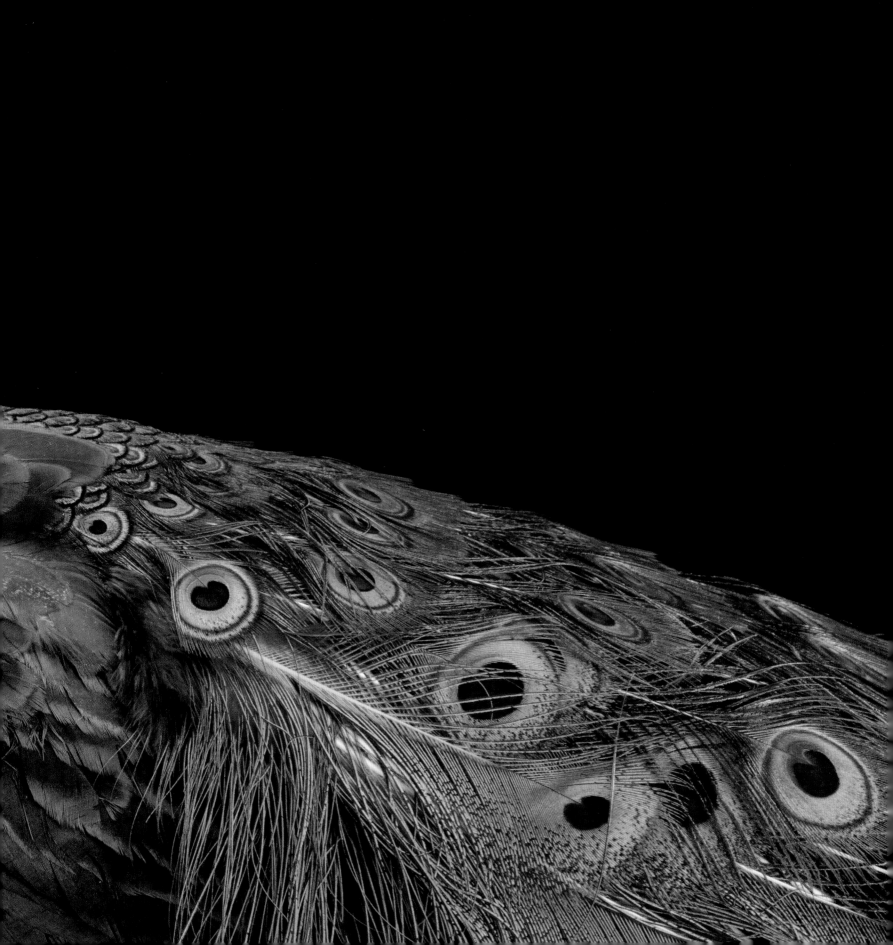

White-naped mangabey, *Cercocebus lunulatus* (EN)

Until 2008, this species was categorized as a subspecies of the sooty mangabey. The two species are closely related but occupy different ranges and have notable physical differences.

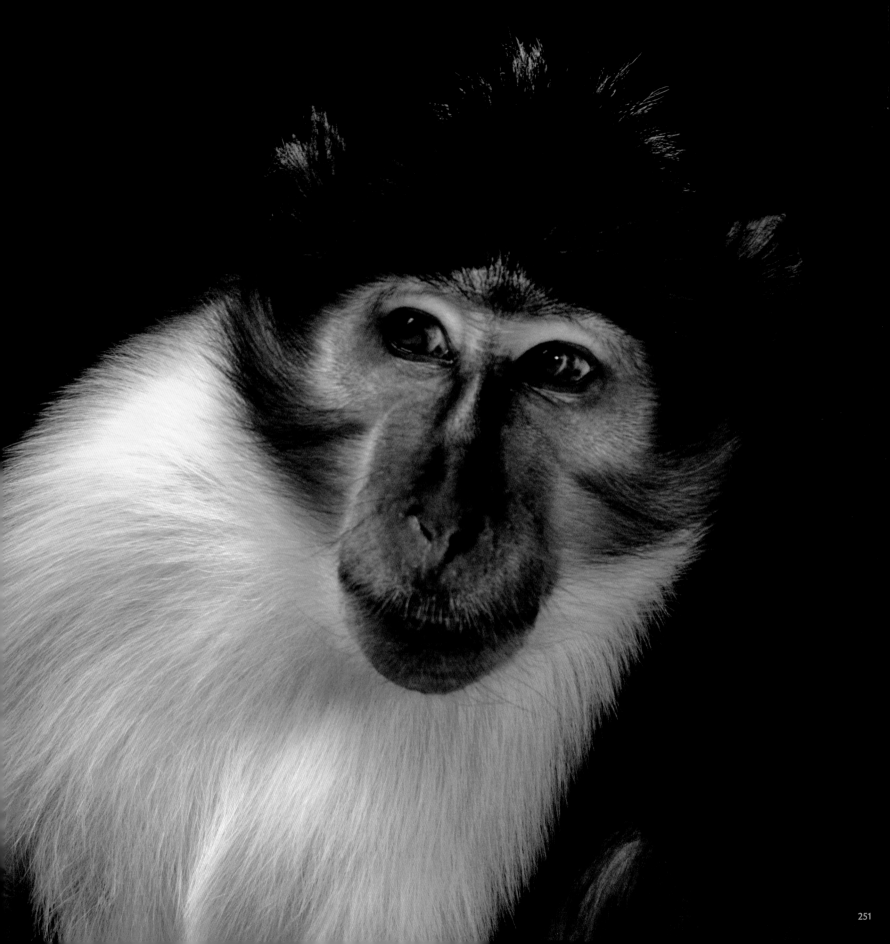

≈600

MATURE INDIVIDUALS REMAIN IN

THE WILD AND IN HUMAN CARE

WITH A SPINY CREST along its back and sporting vivid colors during the breeding season, the Grand Cayman blue iguana is as dazzling as the Caribbean waters of its island home. But this large rock lizard has been on the verge of extinction since scientists first identified it in 1940. The iguana lives only in small swaths of Grand Cayman Island. Predation by feral cats and dogs is a persistent threat, and decades of development have reduced its range to fewer than 26 square kilometers. But it has proven surprisingly resilient: Several captive-breeding programs have succeeded in rearing young iguanas and releasing them back into the wild. And the lizard appears to be unfussy about real estate, settling easily into a modified habitat. As promising as these gains are, conservationists face an urgent need to secure more protected land—without it, the species' future remains uncertain.

Grand Cayman blue iguana, *Cyclura lewisi* (EN)

DIMMING

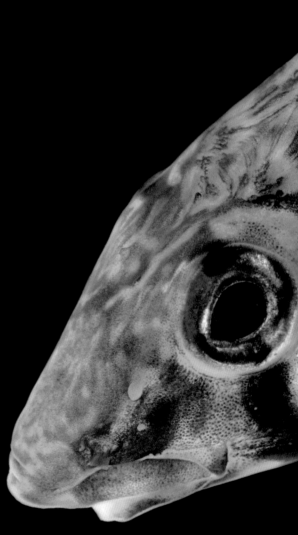

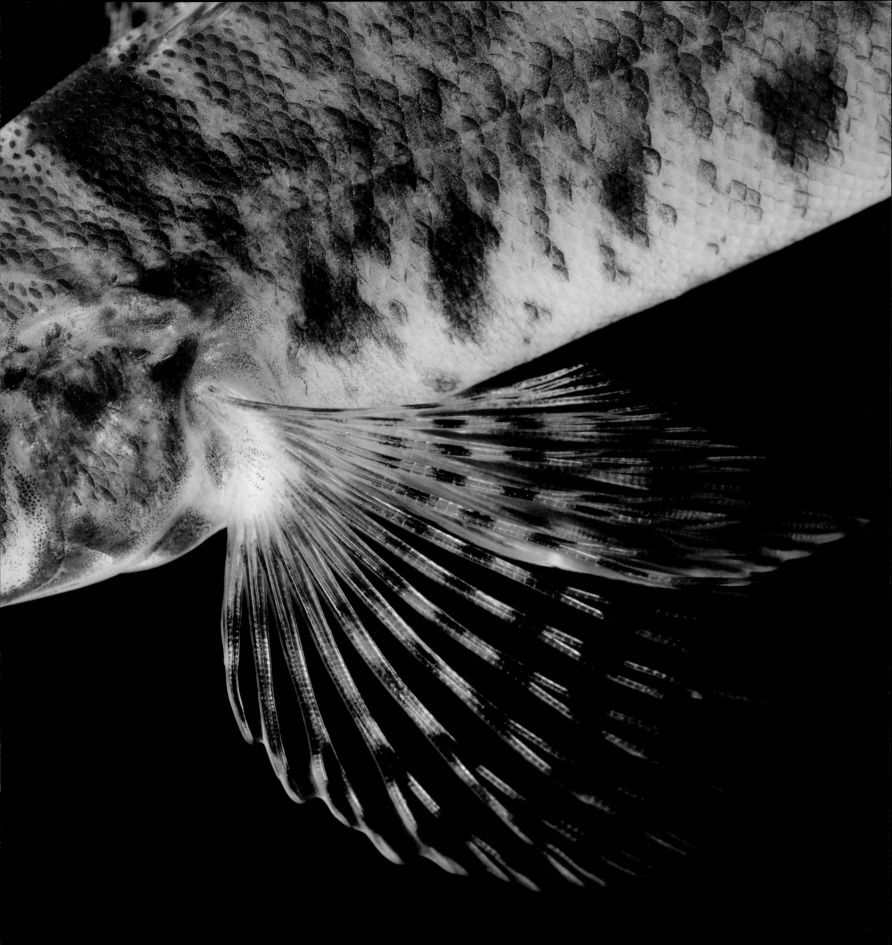

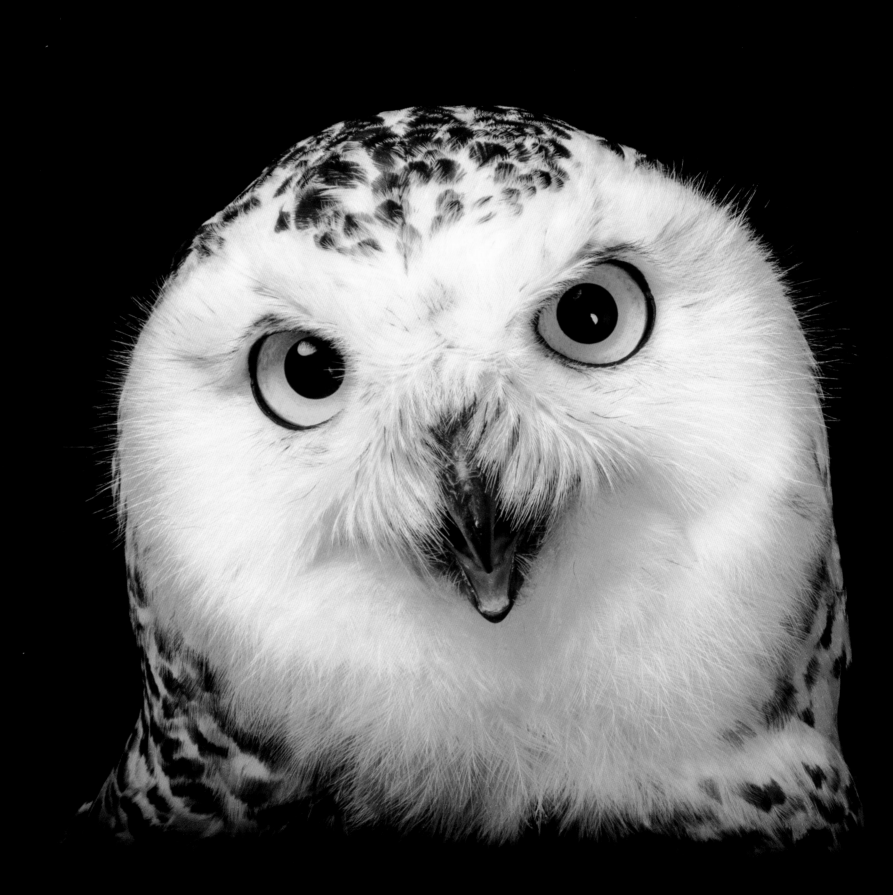

I n a well-lit room, the sudden switching off of a light is a shock. But turn a dimmer slowly, and the change is subtle, almost unseen. So it goes with animals. Populations can plummet in a few short years or slide steadily downward over decades. Whether the decline comes all at once or gradually, when they approach the threshold of concern, scientists are poised to sound the alarm.

For the snowy owl, that moment came in 2017. For many years, the yellow-eyed sentinel of the Arctic tundra occupied a relatively stable perch on the IUCN Red List, classified as Least Concern. The species had made some well-documented migrations into the eastern United States, showing up at airports and beaches as far south as Florida. But even as the owl captured headlines (and new admirers) in the lower 48, scientists were eyeing its population trends with concern. They worried most about the impact of a warming planet: Earlier springs, melting snow, and fluctuations in prey were bad news for the owl. The population, thought to be 200,000, was proved to be much lower—only 28,000 individuals. So conservationists uplisted the species to Vulnerable. The snowy owl was officially in trouble.

For animals that were once on the brink and have rebounded thanks to intensive conservation—like two species in this chapter, the Arabian oryx and the Mallorcan midwife toad—a dim glow is an improvement. But for most creatures, it symbolizes a long struggle ahead. And for us, the realization that a species has slipped on our watch is a sobering rebuke. If we act quickly, there could still be time to turn the light back up. Animals who once shined brightly may do so again. ■

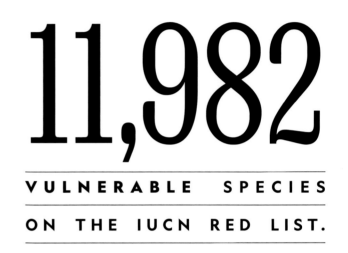

AS OF JAN. 2019, THERE ARE

11,982

VULNERABLE SPECIES
ON THE IUCN RED LIST.

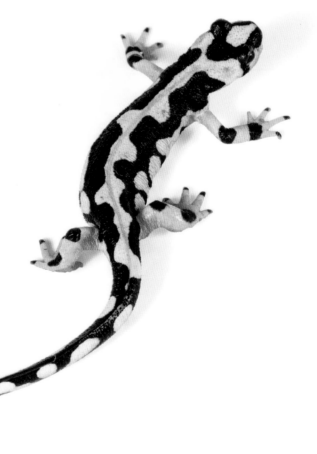

PREVIOUS: Roanoke logperch, *Percina rex* (VU)
OPPOSITE: Snowy owl, *Bubo scandiacus* (VU)
RIGHT: Luristan newt, *Neurergus kaiseri* (VU)

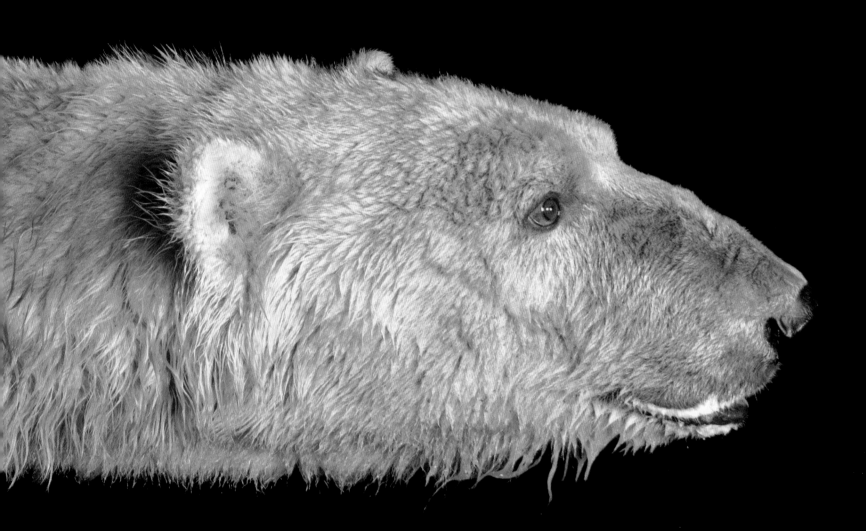

Polar bear, *Ursus maritimus* (VU)

The largest carnivores in North America, polar bears are heavily dependent on sea ice to hunt and move around their Arctic environment. As the sea ice disappears, so will they.

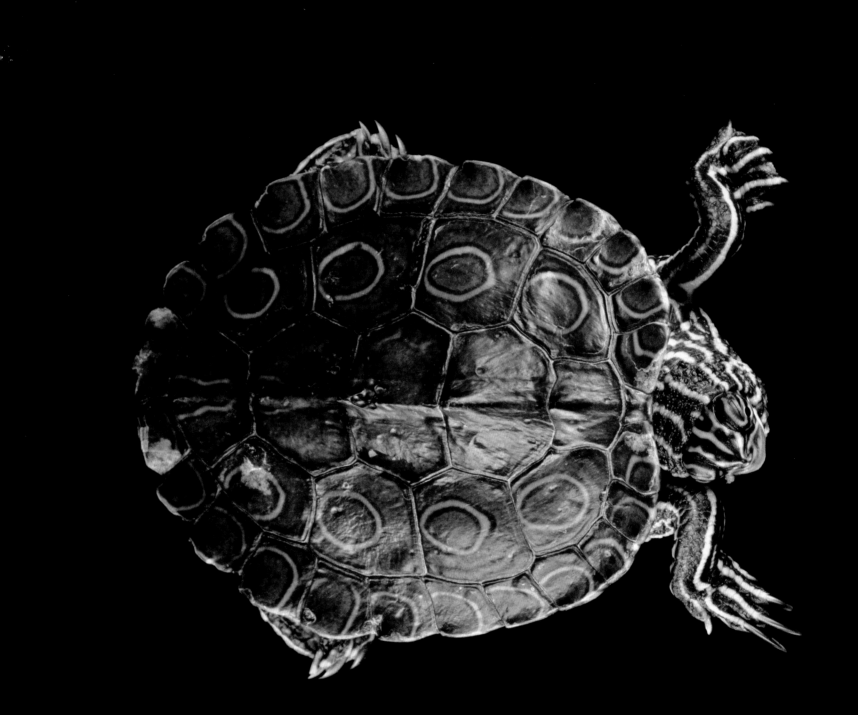

Ringed sawback, *Graptemys oculifera* (VU)

This Cajun turtle, found in two rivers of Louisiana and Mississippi, spends many hours basking in the sun. When sunbathing in a group, each turtle will face a different direction to more easily spot and react to threats.

These giants of the South Pacific are efficient filter feeders, but they also grow some of their own food by cultivating algae that feed off their waste, and in turn become food for the clams when they die.

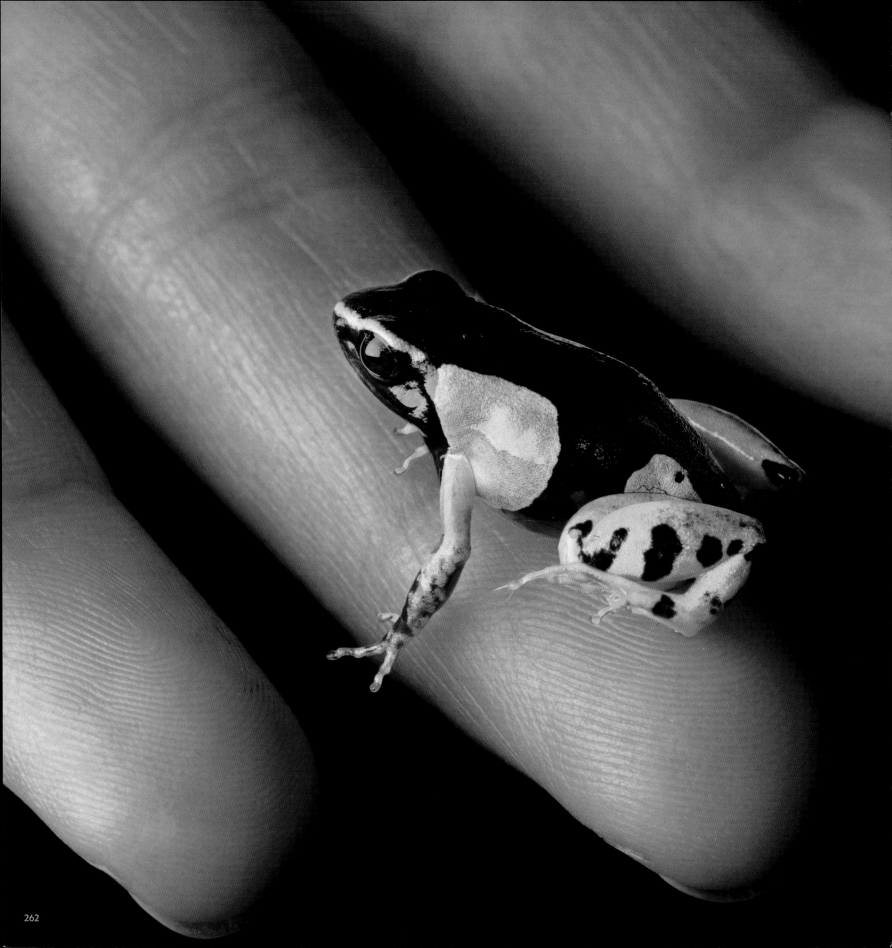

THIS FROG'S ENTIRE RANGE EXTENDS ACROSS A
NARROW STRIP OF MADAGASCAR THAT MEASURES

9434

SQ KM

Madagascar painted frog, *Mantella madagascariensis* (VU)

Nearly 300 species of frogs are found on Madagascar, including this small poisonous frog. Like many other species endemic to the large island, its population is threatened by deforestation.

African dwarf crocodile, *Osteolaemus tetraspis* (VU)

Unlike Nile crocodiles, African dwarf crocodiles have been deemed to have poor quality skin for harvesting. This saves them from being routinely poached for the animal goods trade.

Visayan leopard cat,
Prionailurus bengalensis rabori (VU)

These small wild cats are often found hunting mice in the
sugarcane plantations of the Philippines. Though they are
sometimes confused with domesticated kittens, they often
suffer health problems when adopted by humans.

Chinese blind cave fish, *Sinocyclocheilus furcodorsalis* (NE)

This odd-looking fish is one of the many fascinating creatures that come from an underground landscape in southern China. Beyond what it looks like, and that it's blind, we know very little about this fish, which was first described to science in 1997.

Bengal slow loris, *Nycticebus bengalensis* (VU)

Large eyes and specially adapted hands and feet help this small nocturnal primate climb the canopy of its native forests. Slow lorises are highly sought after in the pet trade.

≈8,200

INDIVIDUALS REMAIN IN THE

WILD AND IN HUMAN CARE

HERDS OF ARABIAN ORYX once roamed much of the Middle East, sensing rainfall from miles away and moving toward the fresh plant growth that was soon to follow. The antelope is designed to thrive in a severe desert environment, with white fur that reflects the sun and hooves made for treading on hot sand. Legend has always trailed the nomadic oryx: In profile, its long, slender horns can appear to be one, leading some to believe this animal is the inspiration for the unicorn. Hunters have followed, too. By the early 20th century the oryx's range had shrunk considerably, and the last known wild oryx were shot in the early 1970s. IUCN deemed the species extinct in the wild. But the story doesn't end there: A captive-breeding program at the Phoenix Zoo that started in the 1960s allowed conservationists to reintroduce herds in Oman in the early 1980s. Today the Arabian oryx roams in the wild once more across parts of the Arabian Peninsula. But with fewer than a thousand mature individuals in the wild, it's clear this animal's long recovery is not yet complete.

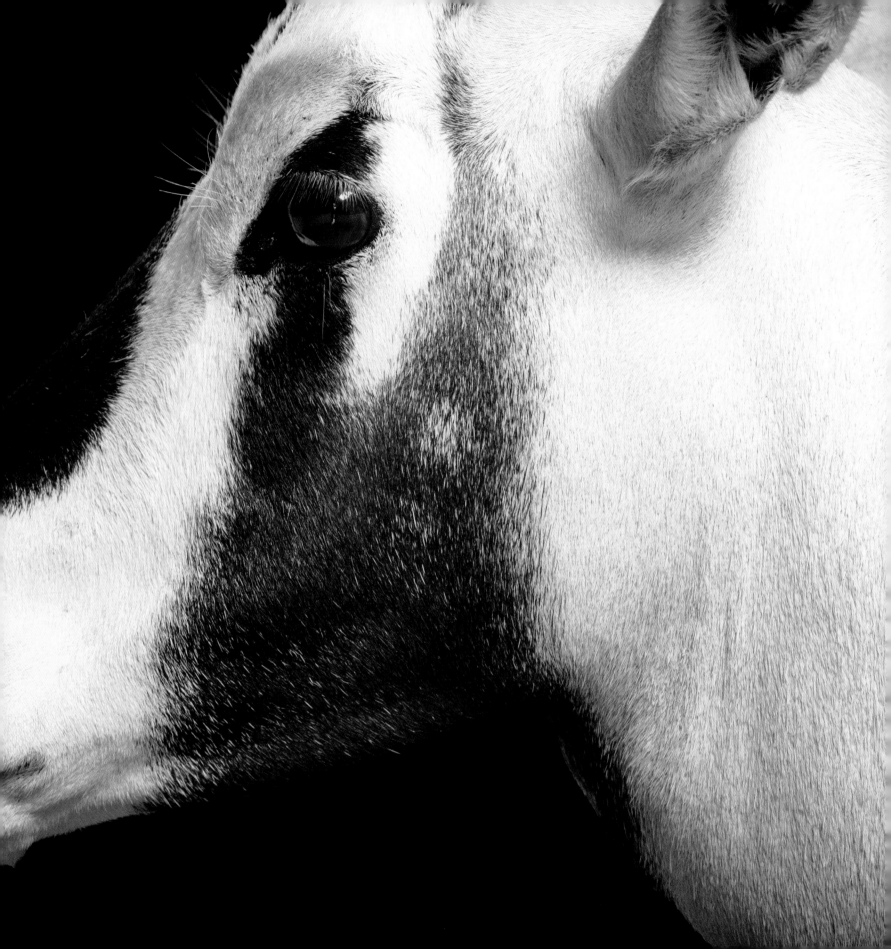

Barrens topminnow, *Fundulus julisia* (EN)

Over time, the geographic range of this small freshwater fish has rapidly declined. In the early 1980s, it was known to exist in 14 locations, then only in seven a decade later. Now, only two locations in Tennessee remain.

Fossa, *Cryptoprocta ferox* (VU)

The largest mammalian predator in Madagascar, fossa populations are dwindling as they lose forested space on the island. Though they are often solitary creatures, juveniles like these two may remain in pairs until they're fully grown.

Dakota skipper, *Hesperia dacotae* (VU)

This orange-brown butterfly was once common
across the Great Plains of America and Canada.
As the native prairie was plowed, their population
shrank significantly.

Gray's monitor, *Varanus olivaceus* (VU)

This lizard is one of the largest in Asia. Despite its long, well-developed claws and sharp teeth, it is mainly a fruit eater, only supplementing its diet with snails, crabs, and other insects.

PALM OIL PRODUCTION

PALM OIL IS FOUND in roughly half of all packaged products sold in super-markets—lipstick, pizza dough, detergent, instant noodles—and its production is causing a global environmental crisis. Large tracts of forested land are clear-cut to cultivate palm oil trees in tropical countries, particularly in Malaysia and Indonesia, destroying habitat in some of the most biodiverse regions on the planet. Palm oil production is expected to increase and could affect more than half of threatened mammals and nearly two-thirds of threatened bird species globally: IUCN esti-mates that palm oil production is a main threat for nearly 200 threatened species, including Goodfellow's tree kangaroo and the helmeted hornbill. The good news? Consumer companies are increasingly committed to buying only palm oil that has been produced without deforestation.

TOP ROW, LEFT TO RIGHT: Wrinkled hornbill, *Rhabdotorrhinus corrugatus* (EN); Bornean gibbon, *Hylobates muelleri* (EN); Black hornbill, *Anthracoceros malayanus* (VU) **BOTTOM ROW, LEFT TO RIGHT:** Goodfellow's tree kangaroo, *Dendrolagus goodfellowi buergersi* (EN); Bornean crested fireback, *Lophura ignita* (NT); Helmeted hornbill, *Rhinoplax vigil* (CR); Bornean bearded pig, *Sus barbatus barbatus* (VU)

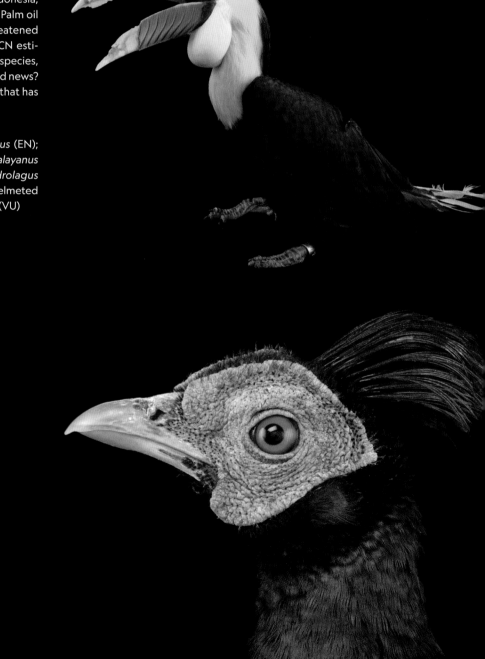

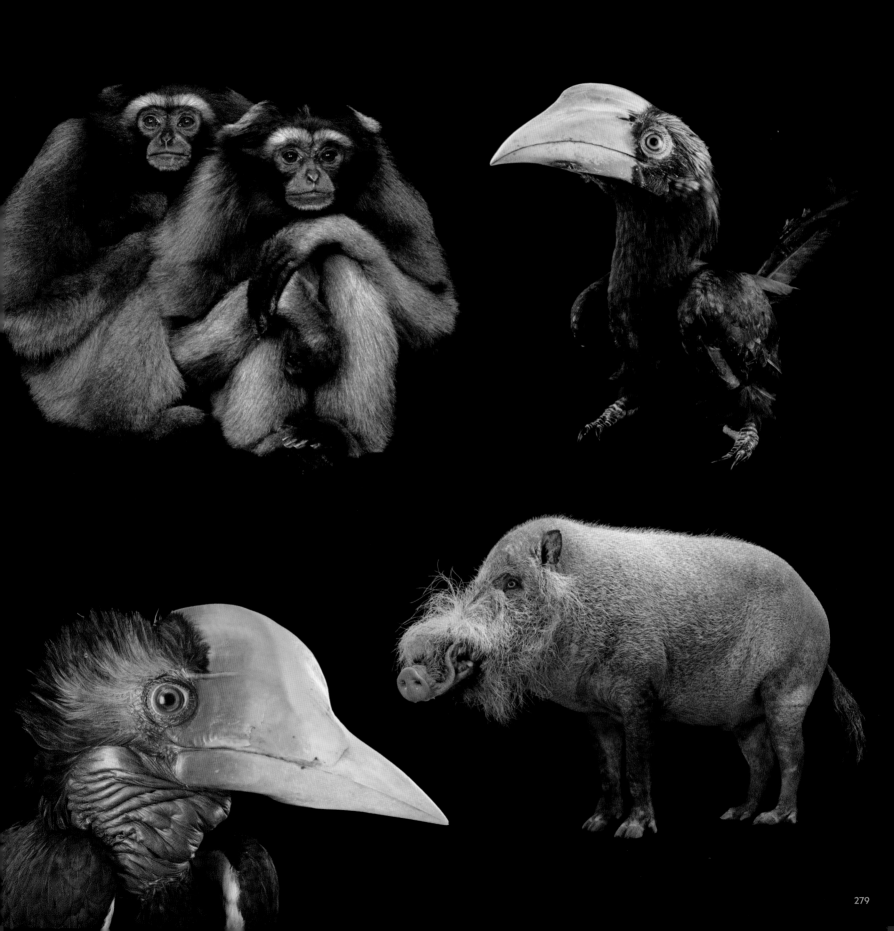

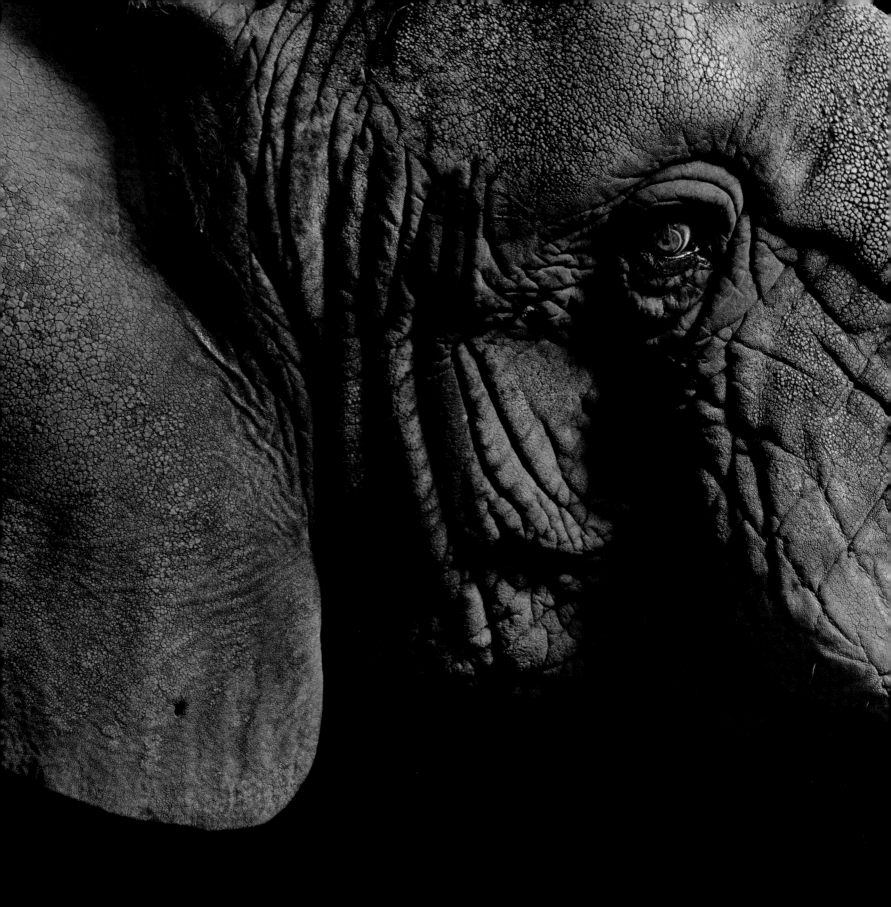

African elephant, *Loxodonta africana* (VU)

In 1930, an estimated 10 million African elephants roamed the continent from the Cape to the Sahara. In 2016, surveyors counted at least 400,000, 70 percent of which live on protected land in South Africa.

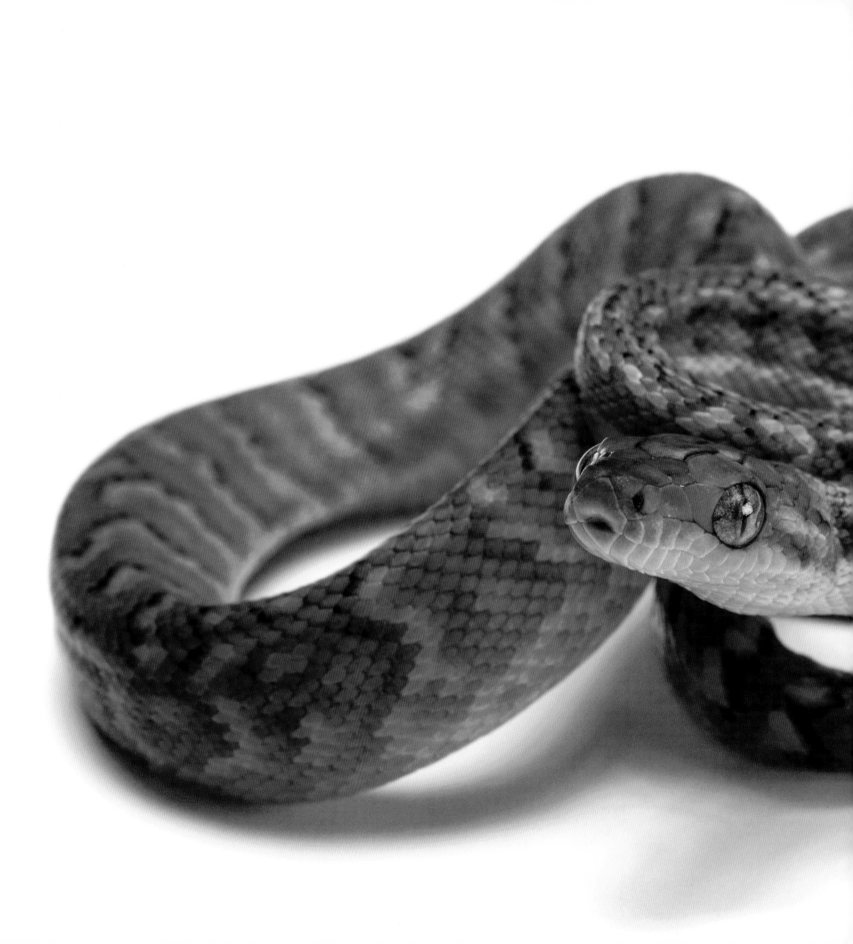

Jamaican boa, *Chilabothrus subflavus* (VU)

This constrictor is the largest predator native to Jamaica. In the wild, juveniles like this seek out small lizards and frogs and move on to larger prey such as bats and birds once they reach full size.

> " THE SAVING OF SPECIES, IN THE END, IS ABOUT SAVING OURSELVES. ALL THE ESSENTIAL LIFE-SUPPORTING THINGS WE TAKE FOR GRANTED—FRESH AIR, CLEAN WATER, FOOD—DEPEND ON FUNCTIONING ECOSYSTEMS, WHICH IN TURN DEPEND ON MYRIAD OF SPECIES INTERACTING IN A COMPLEX INTERCONNECTED RELATIONSHIP.

DR. CHENG WEN-HAUR, DEPUTY CHIEF EXECUTIVE OFFICER/
CHIEF LIFE SCIENCES OFFICER, WILDLIFE RESERVES SINGAPORE

Greater hog badger, *Arctonyx collaris* (VU)

Occurring across a wide range of habitats, the Greater hog badger is an adaptable species. Its population decline is most likely the result of hunting—either intentional or as these badgers get caught in traps meant for larger animals.

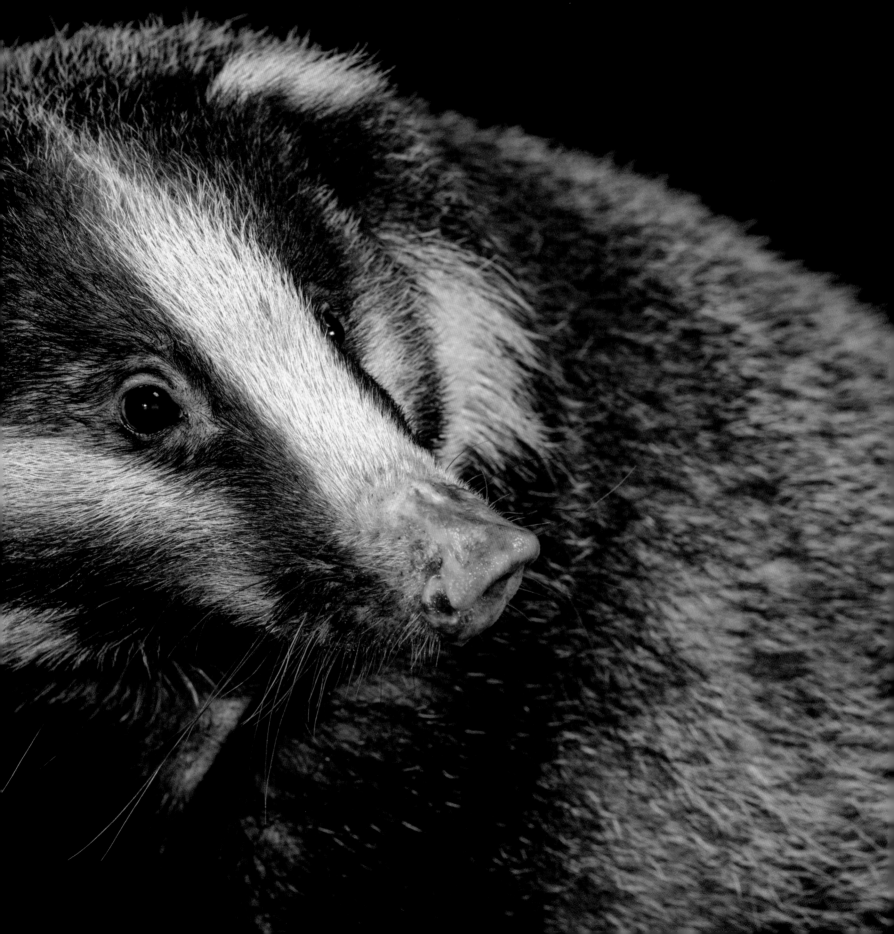

Nubian ibex, *Capra nubiana* (VU)

Both male and female ibex have impressive horns,
though a male's will grow much larger, measuring up
to 1.2 meters in length.

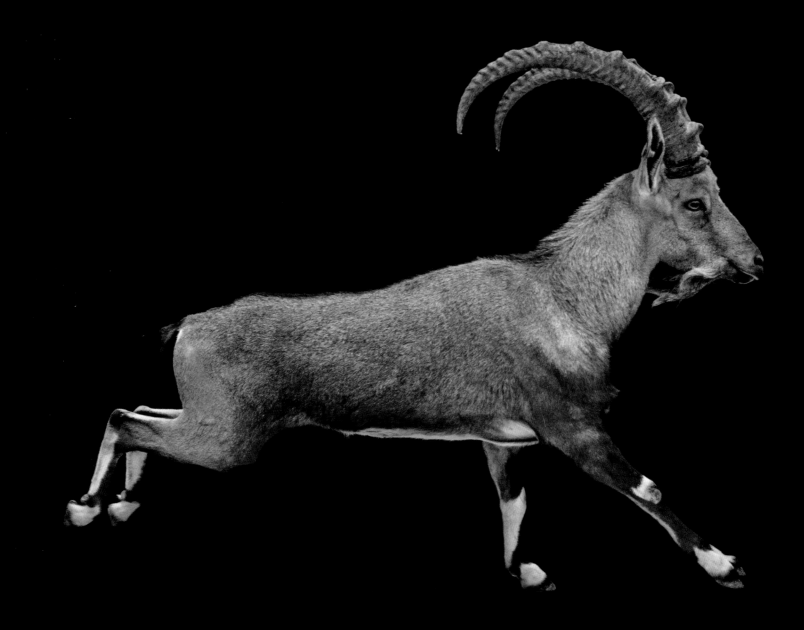

Pinyon jay, *Gymnorhinus cyanocephalus* (VU)

These birds are named for their favorite food: pinyon pine tree seeds. They can expand their esophagus to swallow up to 50 seeds at once and store them in caches across their range.

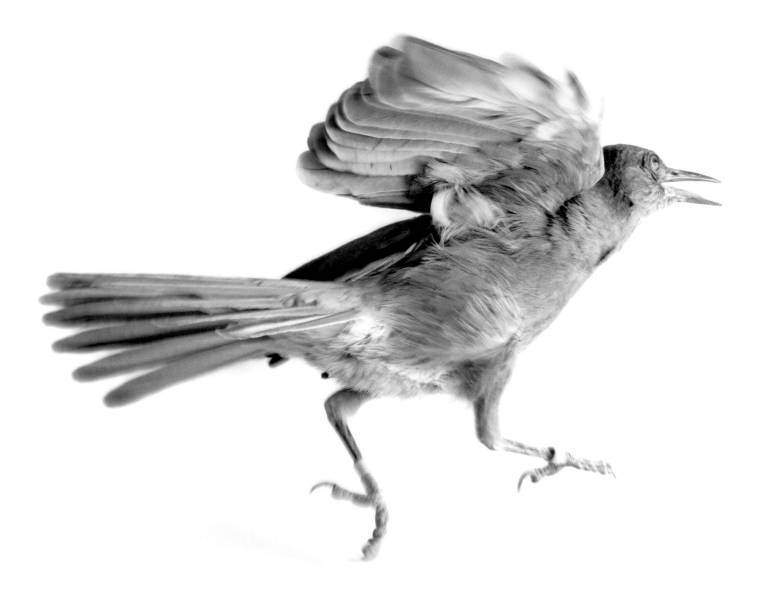

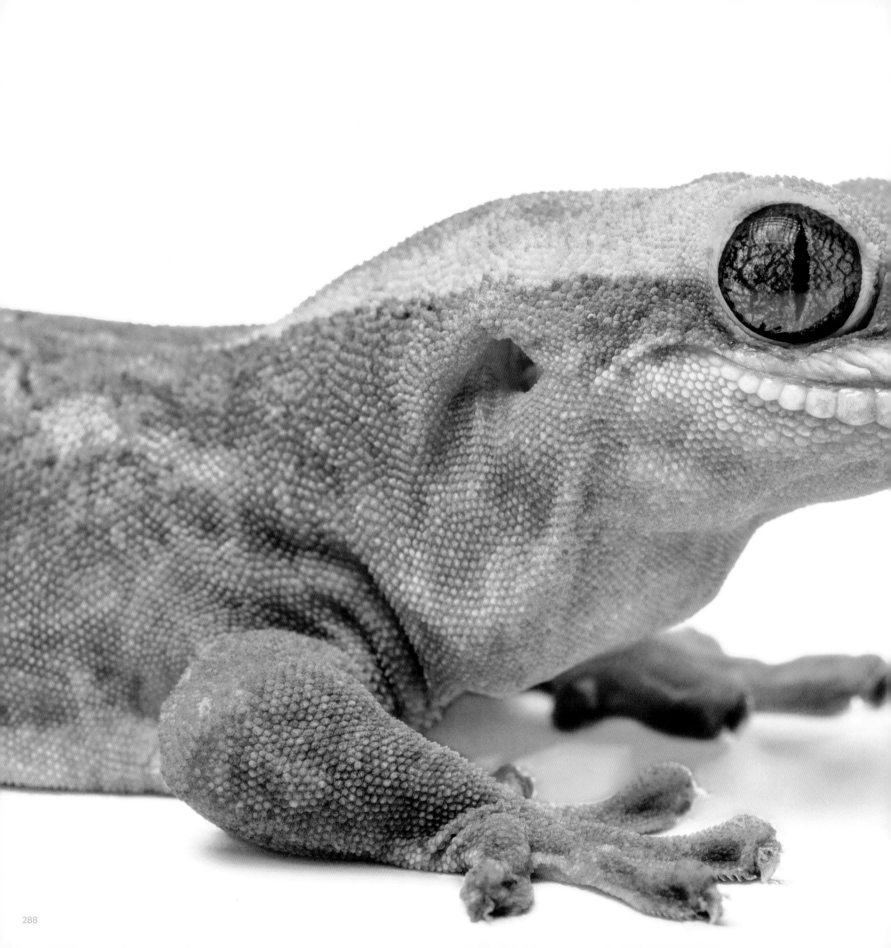

THIS GECKO OCCURS ONLY IN SOUTHERN

NEW CALEDONIA—ITS RANGE IS ABOUT

900

SQ KM

Nancy Ma's night monkey, *Aotus nancymaae* (VU)

This South American monkey's large eyes absorb more light, to let them see through the nighttime jungles of Peru, Brazil, and Colombia. Thousands are captured for use in medical research.

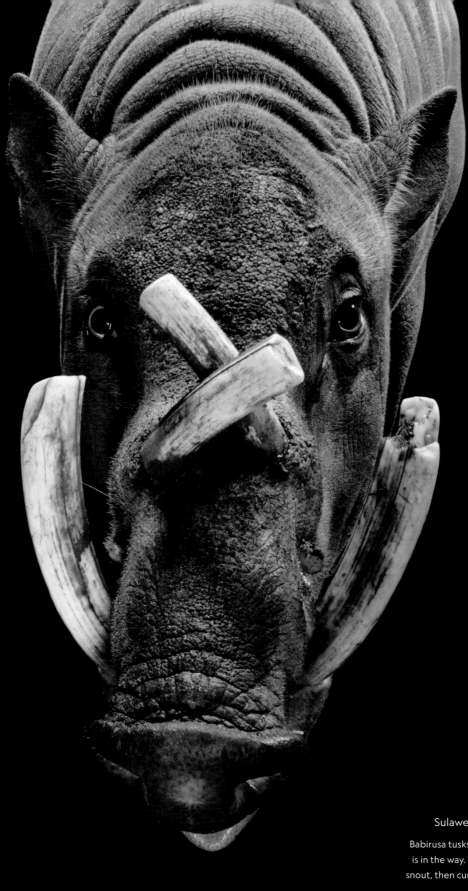

Sulawesi babirusa, *Babyrousa celebensis* (VU)

Babirusa tusks never stop growing, even if their own flesh is in the way. Their top tusks grow through the top of the snout, then curl back to the forehead. It's earned them the moniker "pig deer."

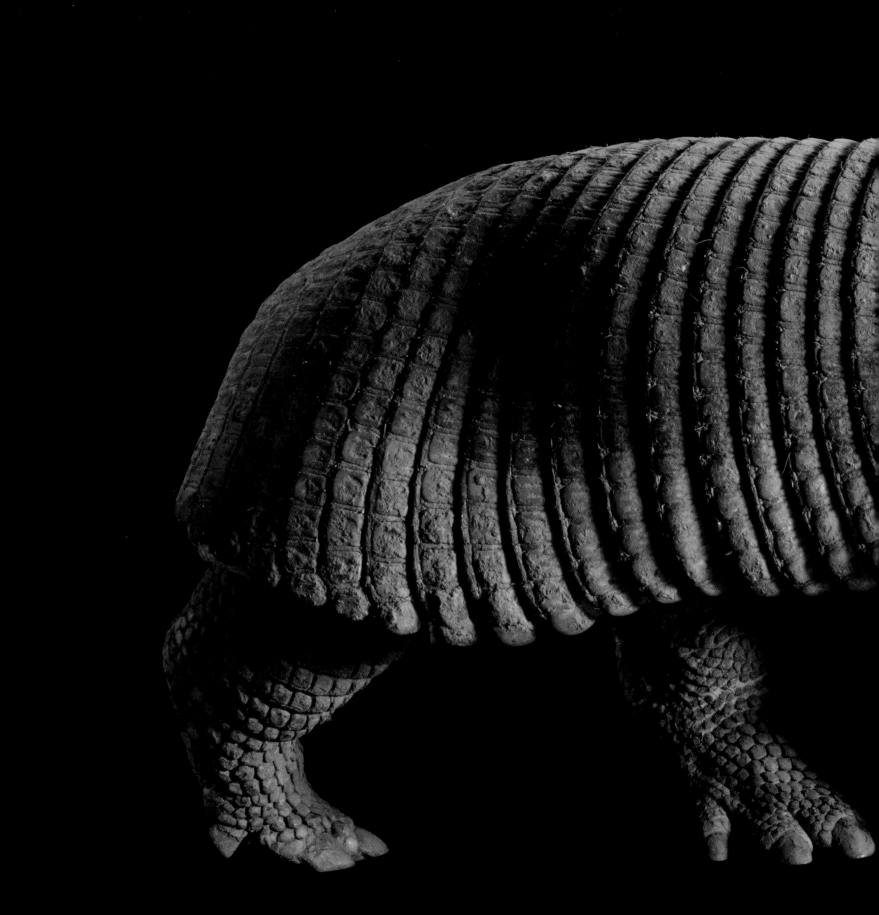

Giant armadillo, *Priodontes maximus* (VU)

The population of the giant armadillo, which is hunted for its meat, collected as a rare pet, or sold as a "living fossil" on black markets, is estimated to have declined by at least 30 percent in the past 21 years.

This small, shy pheasant can be found in the western Himalaya. Western tragopans are hunted for their meat and for their decorative plumage, but efforts to better assess and protect the species are under way.

≈1,500

ADULT PAIRS REMAIN IN THE WILD

THE MALLORCAN MIDWIFE TOAD lived undetected for millennia in the gorges and streams of Mallorca's mountains. In the late 1970s, scientists examining fossil records discovered evidence of the toad and declared that it had gone extinct more than 2,000 years ago. A few years later, to their surprise they found living toads. But by the 1990s, the IUCN determined the species to be critically endangered and on the verge of extinction. Today this smooth, shiny toad is slowly rebounding once more thanks to intensive conservation programs. Named for the male toads' practice of carrying eggs wrapped in strands around their ankles, the species is vulnerable to the invasive viperine snake—said to have been introduced to Mallorca in Roman times—and ongoing urbanization of the island, which is popular with tourists. The good news is this amphibian responds well to captive breeding, and conservationists think it can make yet another comeback.

Mallorcan midwife toad, *Alytes muletensis* (VU)

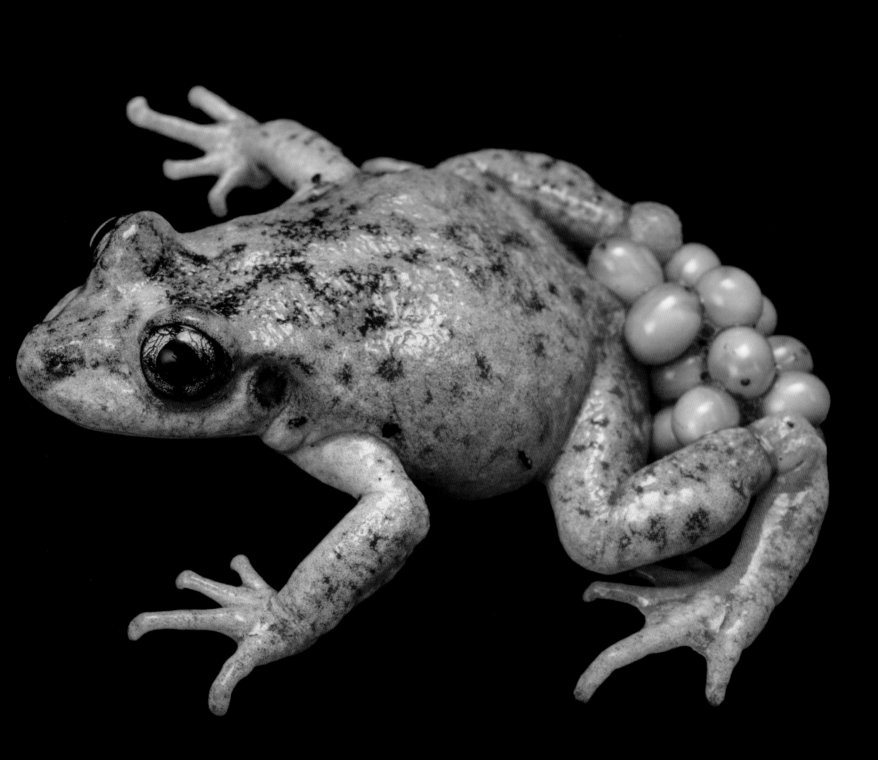

Indian rhinoceros, *Rhinoceros unicornis* (VU)

At one point, fewer than 200 of these rhinos remained.
Thanks to intensive breeding efforts and strict protections,
the Indian rhinoceros has begun to recover—today there
are more than 2,500.

Lake Kutubu rainbowfish, *Melanotaenia lacustris* (VU)

Found in Papua New Guinea, the eponymous rainbowfish
has seen its population threatened by the past decade's
introduction of gill nets and motorboats in Lake Kutubu.

Regal fritillary, *Speyeria idalia* (NE)

Though this butterfly has not been evaluated by the IUCN or declared federally endangered, its numbers have dwindled as native prairie grasses disappear. Restoring that habitat benefits the regal fritillary and other native animals.

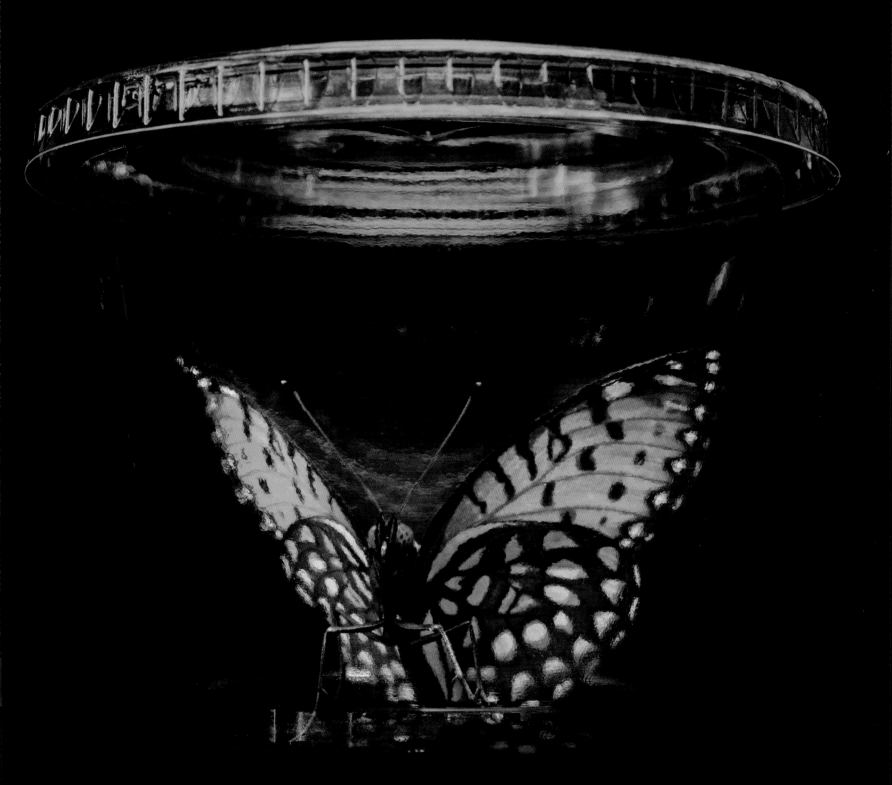

Giant anteater, *Myrmecophaga tridactyla* (VU)

These large terrestrial mammals have a wide range and are especially vulnerable to forest fires. The prevalence of slash-and-burn agriculture in South American rainforests poses a massive threat to giant anteaters.

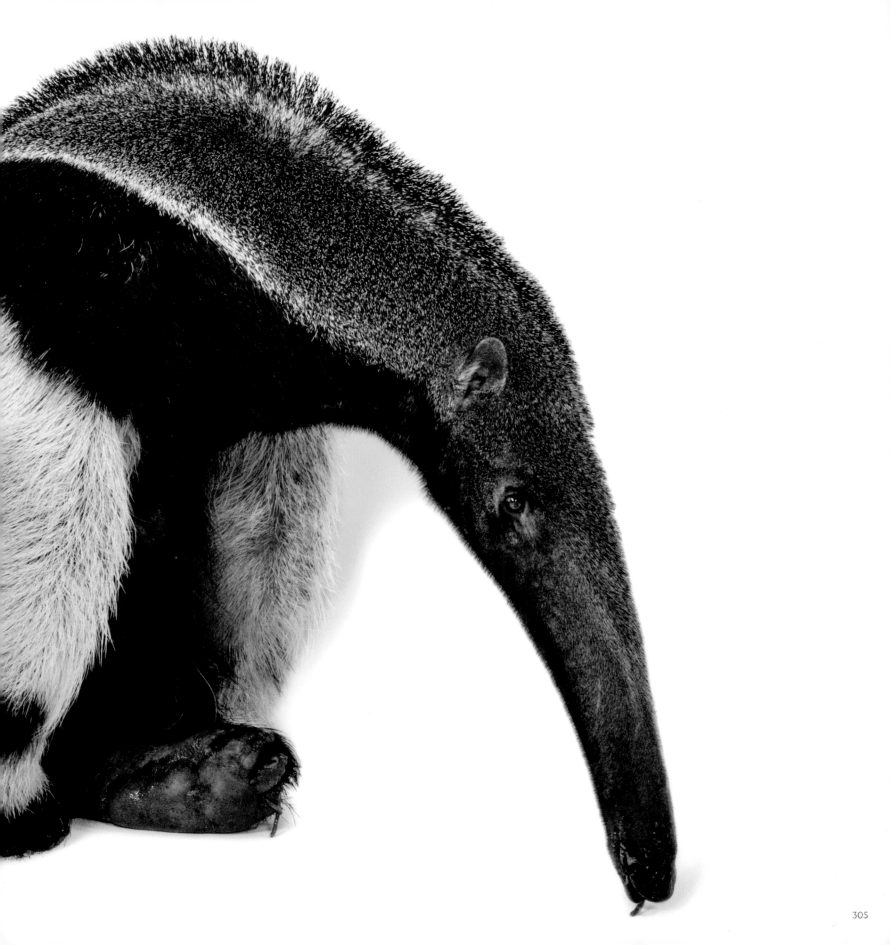

Southern rockhopper penguin,
Eudyptes chrysocome chrysocome (VU)

Some penguins waddle—these penguins jump.
The appropriately named avians can be found
bounding along the rocky shores and fishing in
the cold waters of the Southern Ocean.

Okarito kiwi, *Apteryx rowi* (VU)

These flightless birds are facing an onslaught of stoats and other invasive species devouring their nests and young. The conservation program Operation Nest Egg harvests and incubates the birds' eggs and reintroduces the grown chicks to the bush once they are strong enough to ward off threats.

IN THE NEXT 80 YEARS, THE PANDA'S BAMBOO

HABITAT COULD DECLINE BY AS MUCH AS

100%

Giant panda, *Ailuropoda melanoleuca* (VU)

An adult panda consumes between 9 and 18 kilograms of
bamboo every day, spending upward of 10 hours foraging.
As the bamboo forests in China's mountain regions shrink,
the risk for this iconic species grows.

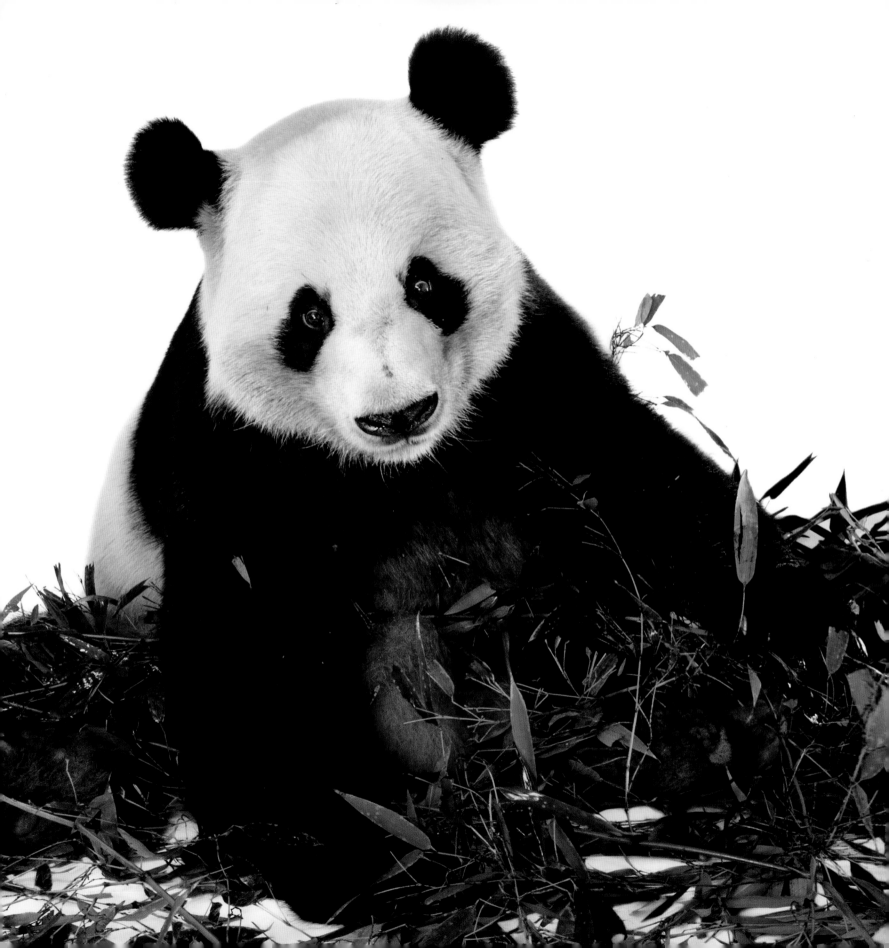

Buckley's glass frog, *Centrolene buckleyi* (VU)

During recent fieldwork in the equatorial cloud forests of Amazonian Ecuador, only a few of these frogs were found. Those studying the species think it may be not vulnerable but critically endangered.

Mexican caecilian, *Dermophis mexicanus* (VU)

Though it may look like a worm, this is actually a legless amphibian. It spends most of its life burrowed in loose soil waiting for earthworms or other small insects to come close.

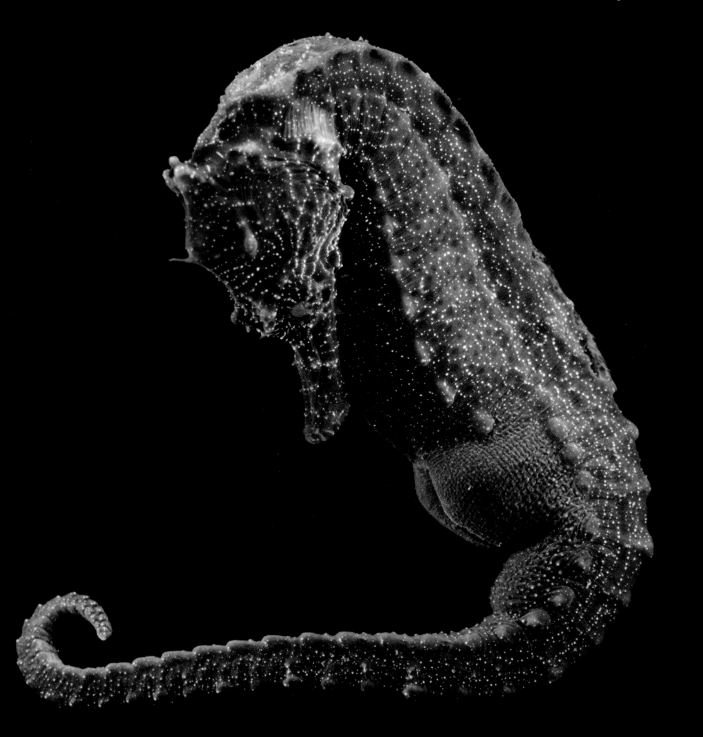

Spotted seahorse, *Hippocampus kuda* (VU)

Seahorses are considered one of the most valuable species in the Chinese medicine trade. An estimated 25 million seahorses are caught for this market every year.

Bilby, *Macrotis lagotis* (VU)

≈9,000

MATURE INDIVIDUALS REMAIN IN THE WILD

UP COME THE EARS. Then the snout, a coat of silky gray fur, and a black tail. Poking out of its underground burrow after sunset, the greater bilby emerges for a night of foraging. Its spindly legs resemble those of a kangaroo, but the bilby doesn't hop—it scampers around the desert, digging for insects, plants, and other food. And it uses its long, sticky tongue to trap prey. Bilbies can't see very well, but they can smell and listen, and by placing their large ears on the ground, they can hear insects rustling below. Bilbies once roamed arid areas across most of Australia, but feral cats and foxes have preyed on the species so intensively that its range is now limited to the northern and western parts of the country. Bilbies have responded well to captive breeding, and attention to the animal's plight has grown in recent decades. (Chocolate bilbies are in the running to displace Easter bunnies in Australia.) Hopes are high to save this species, as it's the last of its kind: Its closest relative, the lesser bilby, is believed to be extinct.

False gharial, *Tomistoma schlegelii* (VU)

These Indonesian crocodiles can grow over 4.6 meters long, and their narrow snouts are filled with 75-85 sharp teeth. They are hard to study, living in scattered low-density populations.

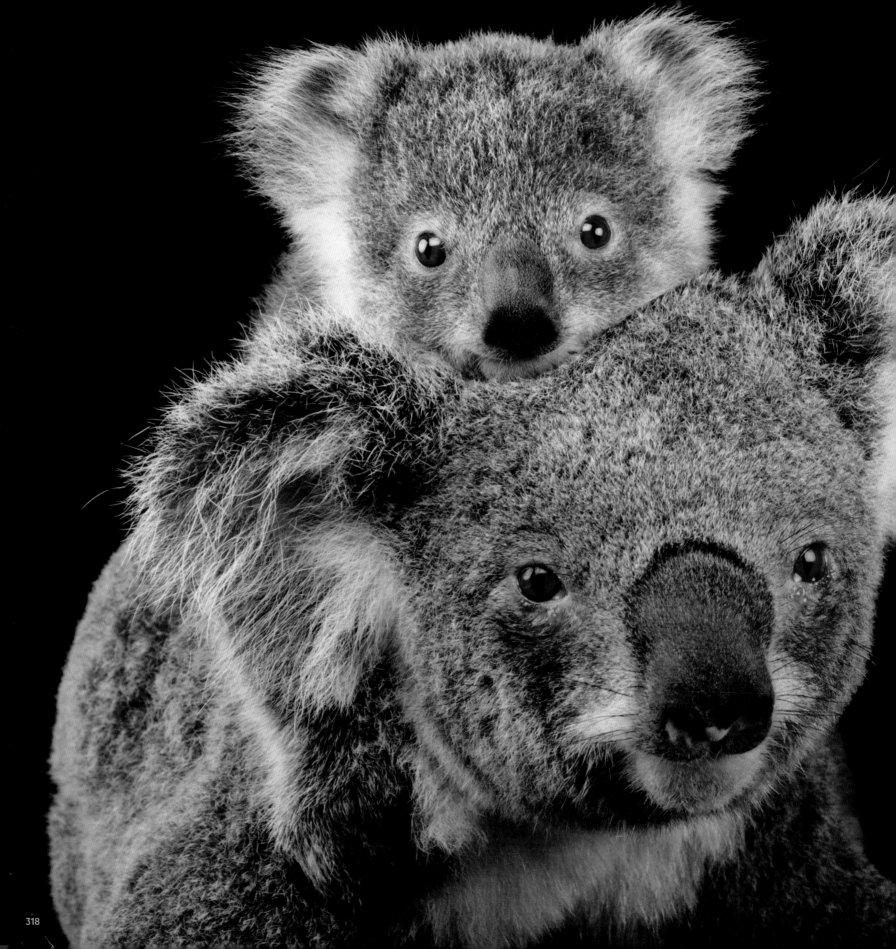

OVER TWO RECENT DECADES, THE POPU-
LATION OF KOALAS DROPPED BY ABOUT

28%

Koalas, *Phascolarctos cinereus* (VU)

Though koala populations in some parts of Australia are
robust, the tree-dwelling marsupials are threatened by
widespread disease and persistent drought.

Kowari, *Dasyuroides byrnei* (VU)

These burrowing marsupial rats are found in Australia's rocky plains and scrubland. Livestock grazing and habitat change have devastated their populations.

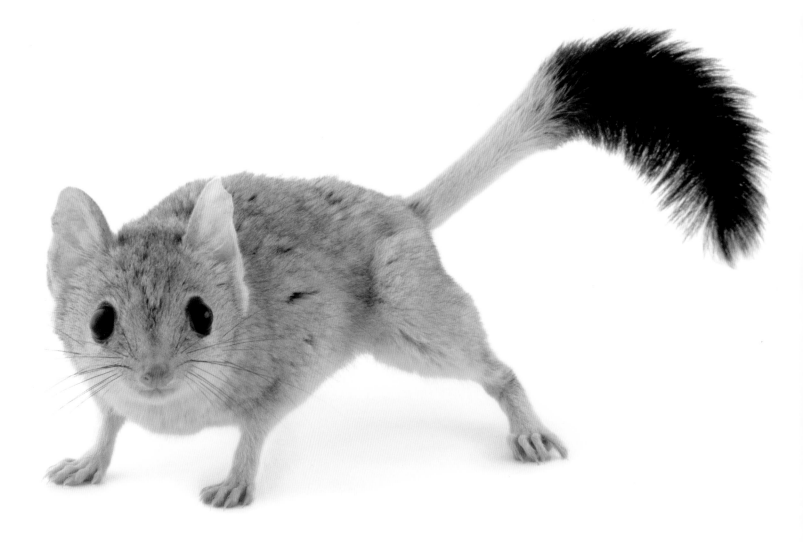

These miniature marsupials are part of the same family as kangaroos. They reside in pockets of lowland and tropical forest in Papua New Guinea and Indonesia. Because of their gentle, adaptable nature, they are commonly hunted for food.

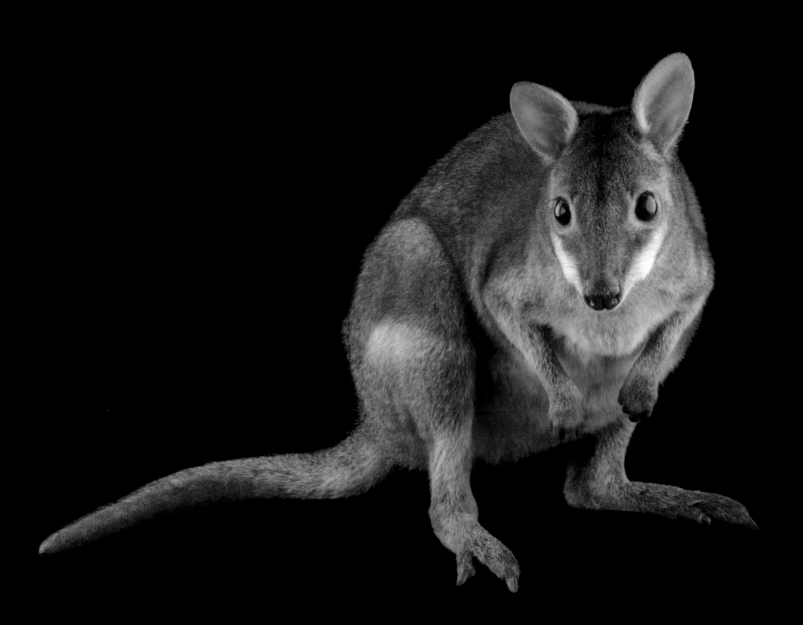

Greater prairie-chicken, *Tympanuchus cupido pinnatus* (VU)

Once abundant in central and eastern North America, prairie-chickens are disappearing as their habitat has been exchanged for urban and agricultural development. Efforts to restore and protect grasslands in the Great Plains aim to preserve what remains of this bird's population.

" THE WHOLE NATURAL ENVIRONMENT
IS LIKE A HUGE JIGSAW PUZZLE, AND
WHENEVER YOU LOSE A SPECIES, YOU
LOSE A PART OF THE PICTURE. I DON'T
WANT TO LOSE THAT PICTURE.

STEVE SHERROD, EXECUTIVE DIRECTOR EMERITUS, DIRECTOR OF CONSERVATION,
SUTTON AVIAN RESEARCH CENTER

FROZEN WORLD FADING

THE ARCTIC IS MELTING. It's warming nearly twice as fast as any other area on the planet, signaling trouble for animals adapted to live in a world of ice. Pacific walrus, Atlantic puffin, spotted seal: All need ice in the sea or on land to survive. Perennial Arctic sea ice has shrunk by 23 percent since the 1980s, and by 2030 the Arctic Ocean could be completely ice free. As these frigid waters warm, the range and behavior of animals elsewhere are changing, too. Orcas have been venturing to the Canadian Arctic earlier and staying longer in greater numbers. Their arrival as a major predator could further imperil some recovering Arctic species—a reminder that, as one conservation organization puts it, "What happens in the Arctic doesn't stay in the Arctic."

TOP ROW, LEFT TO RIGHT: Spectacled eider, *Somateria fischeri* (NT); Spotted seal, *Phoca largha* (LC); Pacific walrus, *Odobenus rosmarus divergens* (DD)
BOTTOM ROW, LEFT TO RIGHT: Atlantic puffin, *Fratercula arctica* (VU); Orca, *Orcinus orca* (DD); Caribou, *Rangifer tarandus* (VU); Arctic fox, *Vulpes lagopus* (LC)

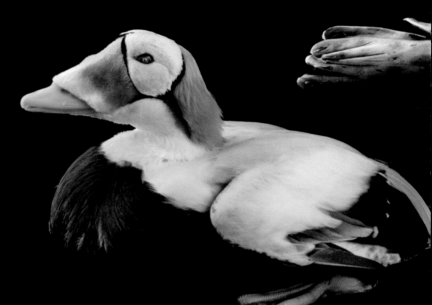

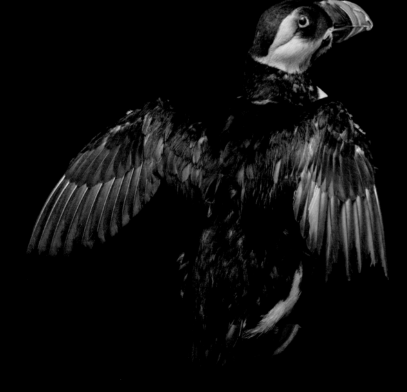

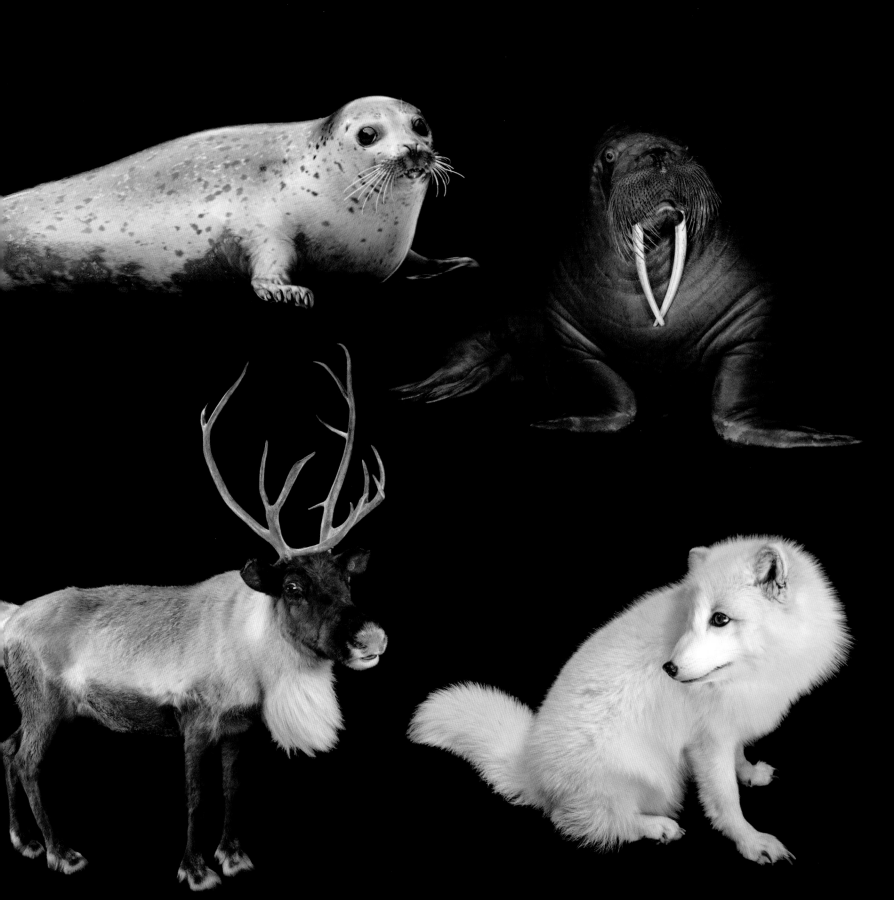

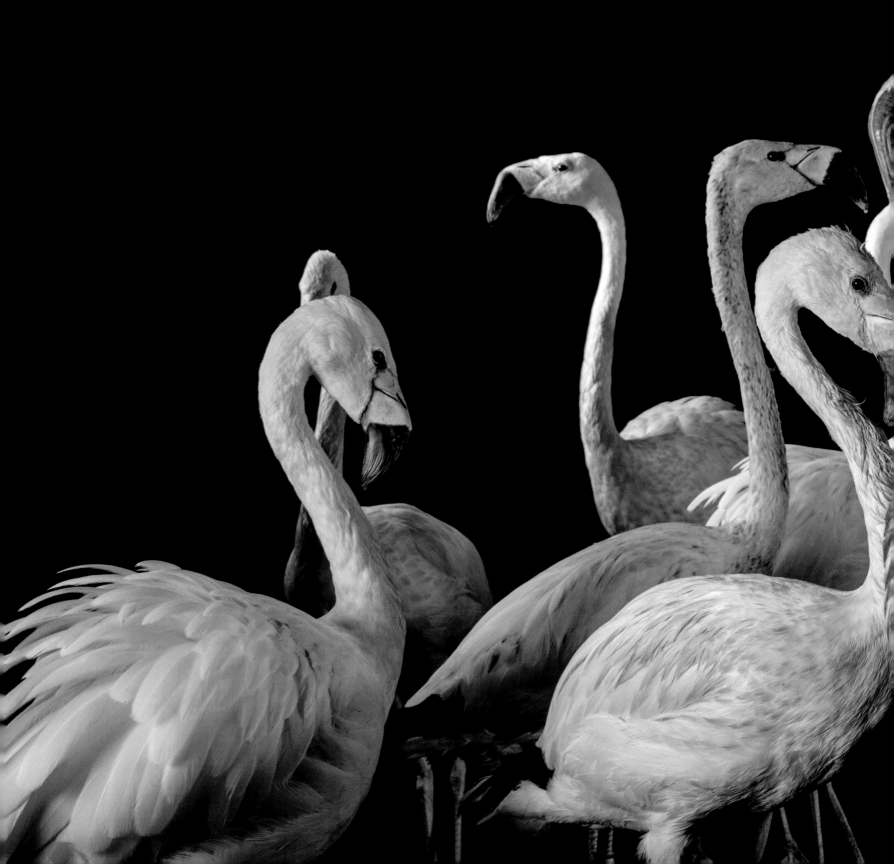

Andean flamingo, *Phoenicoparrus andinus* (VU)

These flamingos live in the same region of lakes year-round. They have a strengthened lower bill, specially adapted to sift through the sediment for small particles of food. But because they don't migrate, they're particularly vulnerable to drought and climate change.

Transcaspian urial, *Ovis orientalis arkal* (VU)

One of the original ancestors of all domesticated sheep, Transcaspian urials were eliminated from all but a few islands of Europe through hunting but are now being successfully reintroduced to the continent.

Mindanao brown deer, *Rusa marianna nigella* (VU)

While their populations are declining in their native Philippines, these small deer are considered invasive pests on other islands where they were introduced in the 19th century.

> " MOST PEOPLE WILL NEVER GET AN OPPORTUNITY TO GO TO AFRICA TO SEE THINGS, TO GO TO AUSTRALIA. SO BY SHOWING THEM THIS, WE'RE GIVING THEM AN OPPORTUNITY TO APPRECIATE IT AND THEN GO HOME AND DO SOMETHING ABOUT IT. IF PEOPLE DON'T SEE IT, SMELL IT, WATCH IT MOVE, BE UP CLOSE TO IT, THEY'RE NOT GOING TO TAKE OWNERSHIP OF THAT.

KATHY RUSSELL, GENERAL CURATOR, SANTA FE COLLEGE TEACHING ZOO

Perdido Key beach mouse,
Peromyscus polionotus trissyllepsis (CR)

One of eight subspecies of beach mouse, the Perdido Key beach mouse is found on a small island in the Gulf of Mexico. A shrinking habitat, invasive predators, and increasingly powerful hurricanes put this small but mighty rodent at risk of disappearing.

Philippine sailfin lizard, *Hydrosaurus pustulatus* (VU)

With a scientific name that means "water lizard," these animals are amazing swimmers. They are also able to sprint across the surface of water in order to escape from predators.

Blue leg poso, *Caridina caerulea* (VU)

Found exclusively in Lake Poso on the Indonesian island of Sulawesi, this translucent shrimp is vulnerable to an invasion of carp, which has already killed off numerous local species.

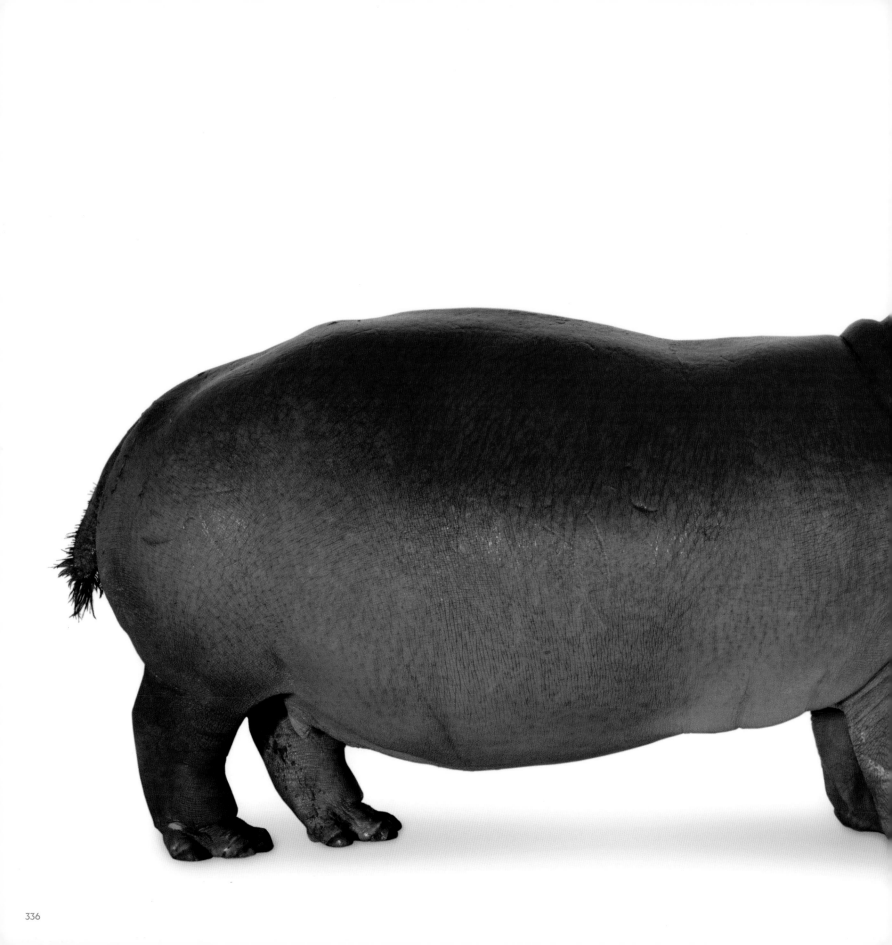

IN 2016, UGANDAN INVESTIGATORS

SEIZED HIPPO TOOTH IVORY

TOTALING A WEIGHT OF NEARLY

400
KG

Hippopotamus, *Hippopotamus amphibius* (VU)

The biggest threats facing hippos today are poaching and habitat loss. Though hippos are protected in many of the areas where they are found, illegal hunting for meat and ivory persists on a massive scale.

Asiatic black bear, *Ursus thibetanus* (VU)

Though separated by the Pacific Ocean, this bear is more closely related to the American black bear than any other species. The Asiatic black bear's keen sense of smell can detect the scent of grubs and other food up to one meter below the ground.

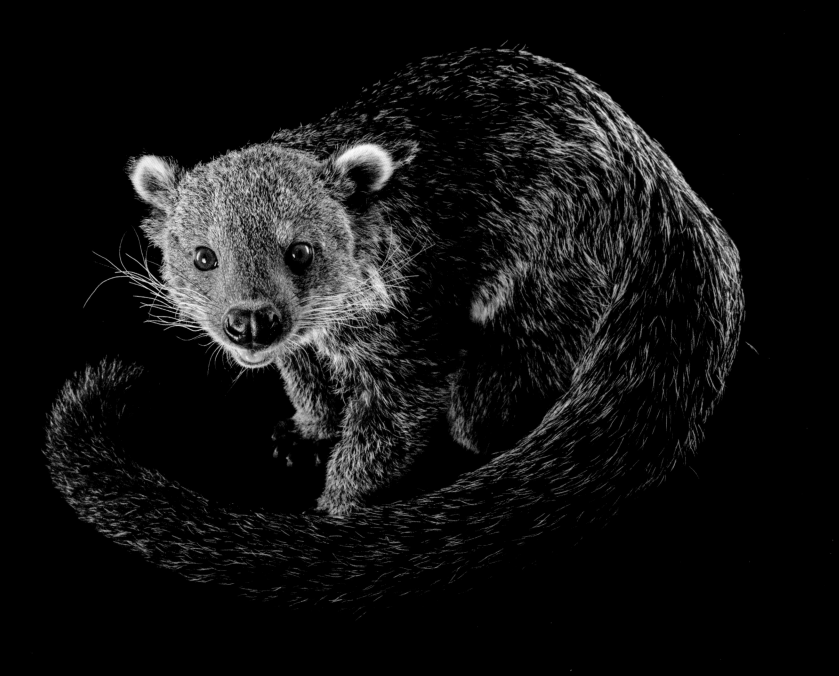

Binturong, *Arctictis binturong* (VU)

The binturong is one of only two carnivores to possess a prehensile tail, which provides balance as it roams through the canopy of forests in its native Southeast Asia.

Red-billed toucan, *Ramphastos tucanus* (VU)
Yellow-ridged toucan, *Ramphastos culminatus* (VU)

Toucans have serrated beaks to peel back the tough outsides
of fruit or insects and a bristly tongue to scoop out the insides.
Rapid clearing of the forest in the Amazon Basin threatens
these toucans' continued survival.

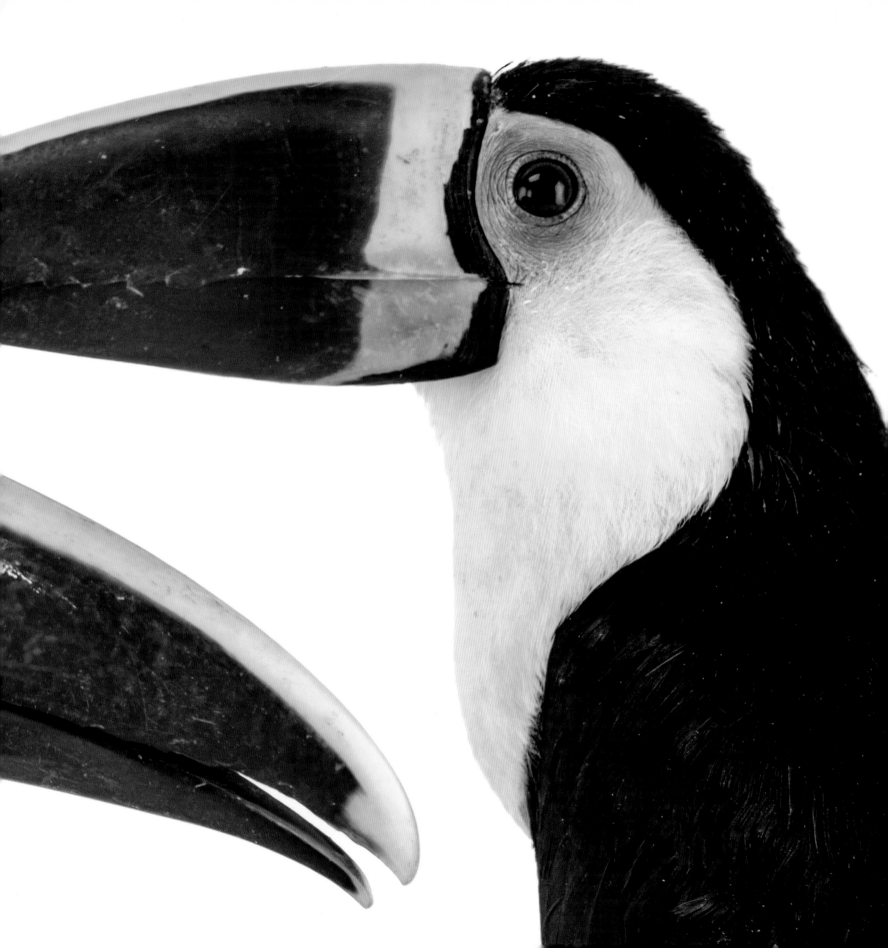

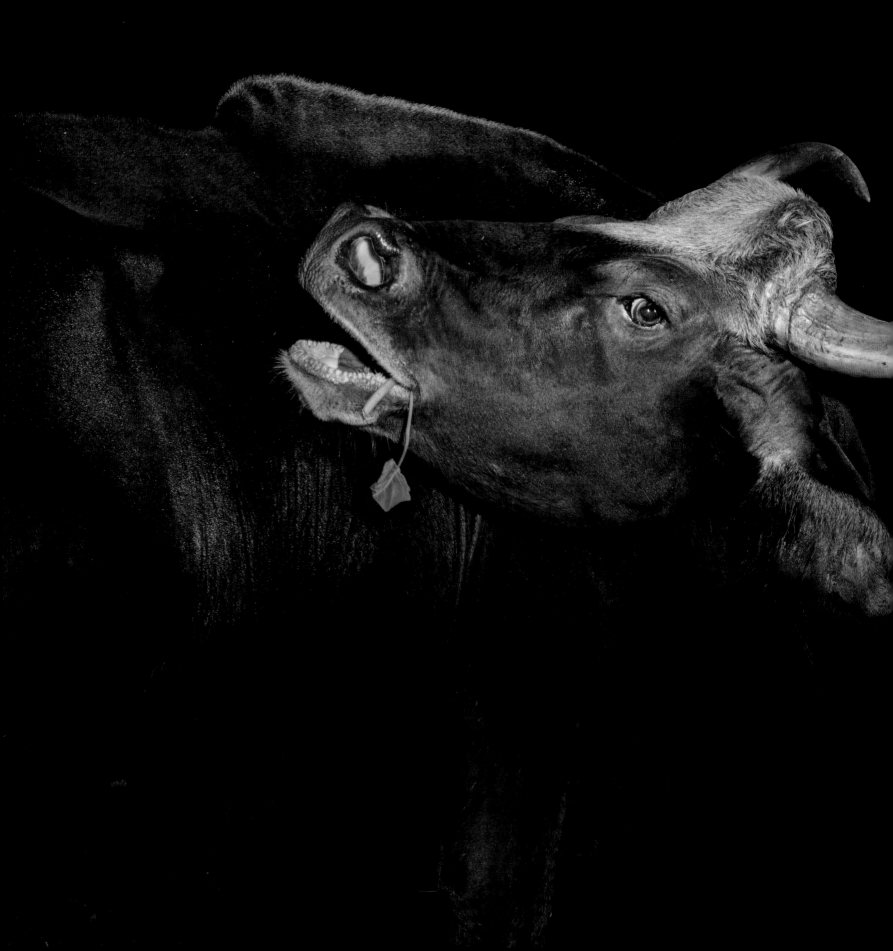

≈20,000

MATURE INDIVIDUALS REMAIN IN THE WILD

TIPPING THE SCALES at more than a ton, the gaur is among the largest living land mammals on Earth. Only a handful of other animals, including elephants and rhinoceroses, outweigh it. This wild ox can be found across India and Southest Asia, where small herds of gaurs move together through forests and glades, eating grasses, leaves, fruit, twigs, and bark. Its bulk and heft might seem ungainly, but the gaur is fast and alert—making the animal with the curved, graceful horns a prize among trophy hunters. Hunting was historically a major threat to this species across its range. Two subspecies of gaur are currently recognized, one found largely in India and Nepal, and another (pictured here) that is found throughout Southeast Asia.

Indochinese gaur, *Bos gaurus laosiensis* (VU)

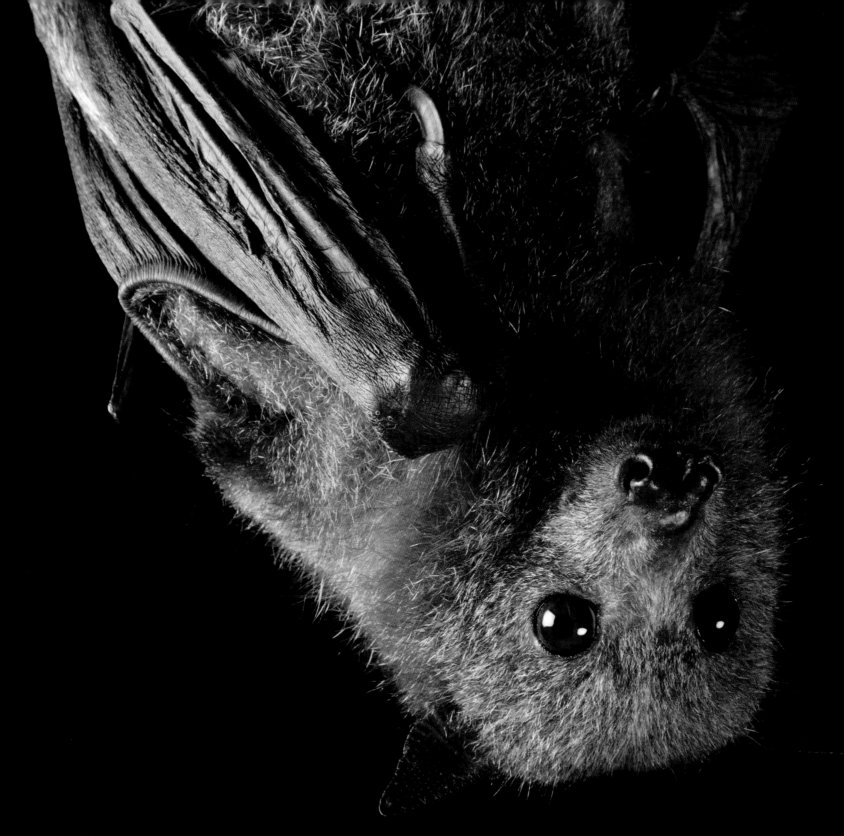

Gray-headed flying fox, *Pteropus poliocephalus* (VU)

As the extent of their forest habitat in southeastern Australia has decreased, these bats have moved into urban areas, feeding on gardens and planted flowers.

Mandrill, *Mandrillus sphinx* (VU)

The largest known species of monkey, mandrills are identifiable from the blue and red skin on their faces and their brightly colored rumps. In their native equatorial Africa, their meat is considered a delicacy and hunting has led to population decline.

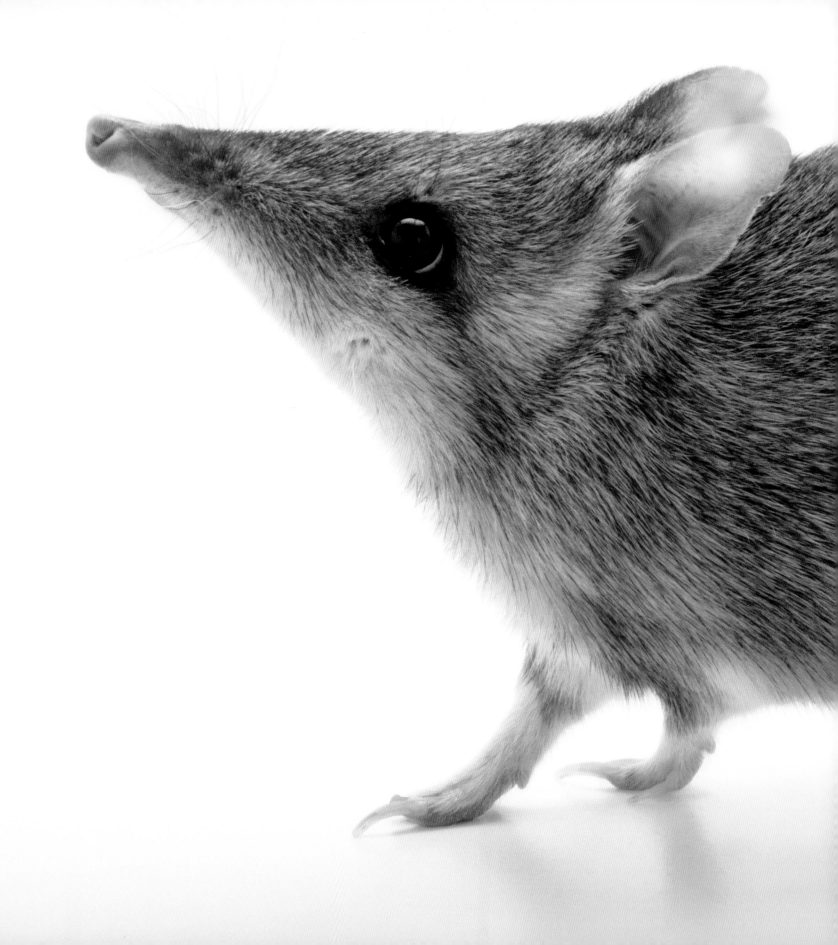

Eastern barred bandicoot, *Perameles gunnii* (VU)

Once widespread in southern Australia, the eastern barred bandicoot was pushed to the edge of extinction by invasive foxes. Since 1991, more than 650 bandicoots have been bred in captivity and reintroduced to predator-free islands and protected areas.

THIS FISH LIVES IN LOCATIONS

NUMBERING FEWER THAN

10

Ashy darter, *Etheostoma cinereum* (VU)

This small fish lives in just a handful of rivers and streams throughout Kentucky and Tennessee. Pollution and construction of reservoirs have impacted their habitats and led to a shrinking of their already small range.

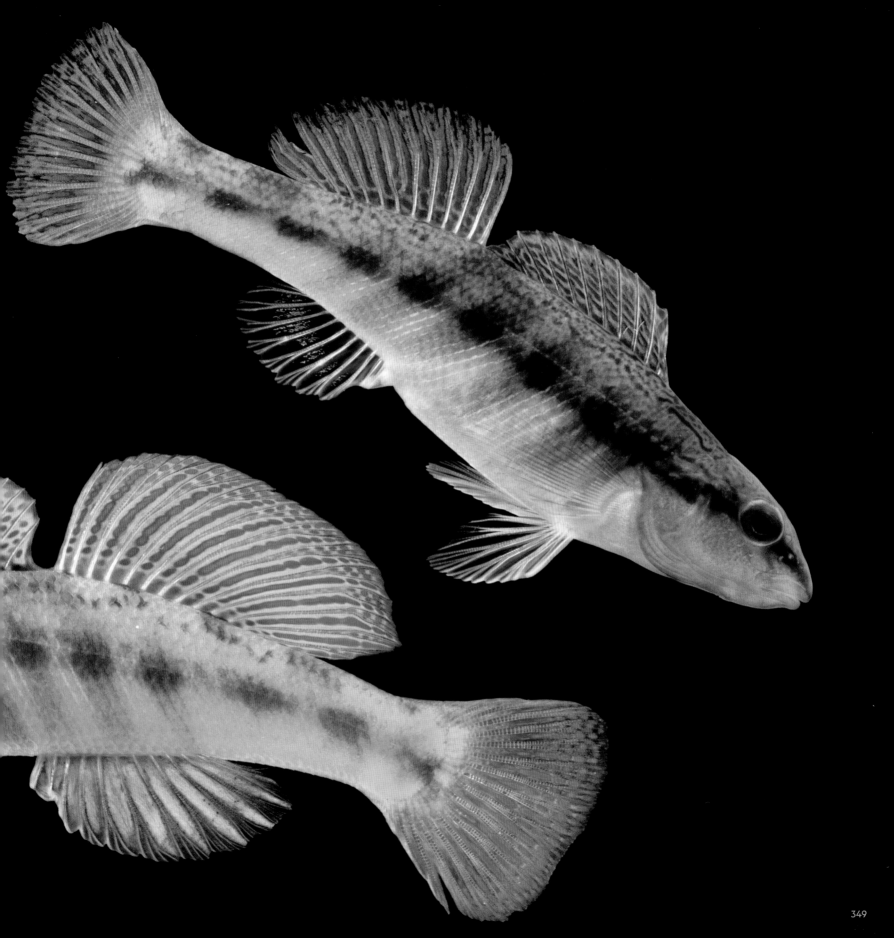

Cook Strait giant weta, *Deinacrida rugosa* (VU)

Measuring nearly 1.2 centimeters from end to end, this heavily armored insect is one of the largest in the world. It has been to known to wave its spiked rear legs above its head for defense when attacked.

Leatherback, *Dermochelys coriacea* (VU)

With huge fins to propel it through the open ocean, this species can only move forward—a swimming habit that means it cannot be cared for in captivity, since it smashes into the walls of any holding tank over and over.

Horned parakeets, *Eunymphicus cornutus* (VU)

Found only on the island of New Caledonia, these colorful birds have suffered a relatively slow decline as their forest habitats are cleared for human development.

Snow leopard, *Panthera uncia* (VU)

A snow leopard's coat resembles the colors of rocks mixed with snow, the perfect camouflage. Its long tail serves as a rudder and balancing device for climbing and running through steep, uneven terrain.

Javan lutung,
Trachypithecus auratus (VU)

This Indonesian monkey has a unique genetic quirk—it cannot taste sweetness. This allows it to eat unripe fruits and other foods that other species might find less palatable.

Diana monkey, *Cercopithecus diana* (VU)

Because of their white bow-shaped eyebrow, these African monkeys are named for Diana, the Roman goddess of nature, woodlands, and hunting.

≈2,000

BREEDING PAIRS REMAIN IN THE WILD

IT'S EASY TO SEE WHY the scientific name for this distinctive bird means "bald old man." Wrinkled and pale-faced, the southern bald ibis moves across the grasslands of southern Africa gobbling softly like a turkey and pecking at the ground for insects. The social ibis roosts in large numbers in trees or cliffs and forages in flocks on the ground. Humans have long hunted the ibis for its feathers and meat, and in Lesotho it is used in traditional medicine and for ceremonial purposes. Today the bird is legally protected across its range in South Africa. Hunting is still a concern, but habitat loss is the species' biggest threat: Agriculture, overgrazing, the planting of conifer trees, and the impacts of climate change have altered the high-altitude grasslands the ibis needs to survive.

Southern bald ibis, *Geronticus calvus* (VU)

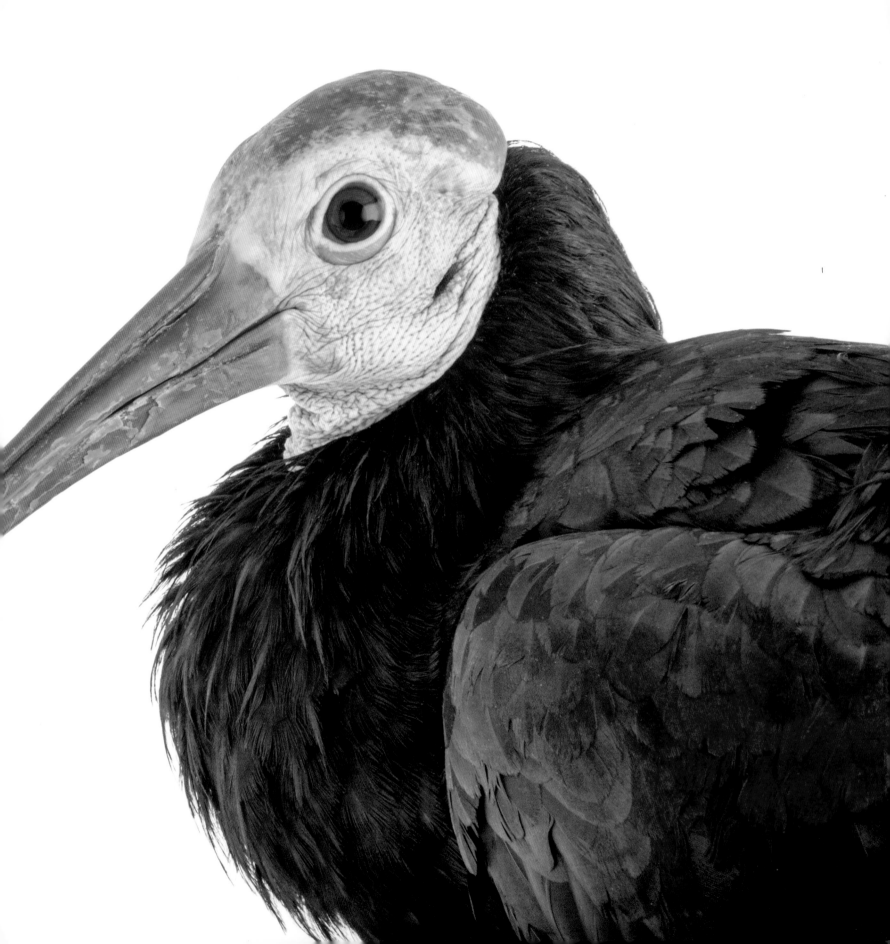

AFTERMATH OF MINING

MORE THAN 2,100 ANIMAL species live in the thickly forested Congo Basin, which spreads across six countries in Central Africa. This lush region is also rich in many of the rare earth elements used to make electronics and smartphones, including cobalt and columbium-tantalite, or coltan. Mining in the Congo Basin tends to be small-scale and unregulated. But collectively, it is taking a severe toll on the region's considerable bio-diversity, contributing to the decline of such species as the slender snouted crocodile, forest elephant, okapi, and eastern lowland gorilla. The extraction process alone degrades habitat by causing deforestation and contaminating water sources, but mining also intro-duces secondary problems by opening up new areas for human settlement and encour-aging the hunting of animals for bushmeat.

TOP ROW, LEFT TO RIGHT: African golden cat, *Caracal aurata* (VU); Bonobo, *Pan paniscus* (EN); Wattled crane, *Bugeranus carunculatus* (VU) **BOTTOM ROW, LEFT TO RIGHT:** Congo peacock, *Afropavo congensis* (VU); Lesser flamingo, *Phoeniconaias minor* (NT); Okapi, *Okapia johnstoni* (EN); Slender-snouted crocodile, *Mecistops cataphractus* (CR)

Yellow-footed tortoise, *Chelonoidis denticulata* (VU)

This large, slow-moving reptile is often found in humid wooded environments, where it feeds on fruit, insects, snails, fungi, and sometimes rotting carrion.

Yellow scroll coral, *Turbinaria reniformis* (VU)

In the warm waters of the Indo-Pacific, this coral plays an important role as a habitat for the diverse communities that make up a reef.

> " THAT'S THE KIND OF HOPE WE NEED
> FOR SOME ENDANGERED SPECIES—THAT
> THEY CAN FIGURE IT OUT, OR WE CAN
> LEARN TO COEXIST WITH THEM, EVEN
> WHEN EVERYTHING'S CHANGING.

FRANK RIDGLEY, DIRECTOR OF CONSERVATION
AND RESEARCH, ZOO MIAMI

Florida bonneted bat, *Eumops floridanus* (VU)

This large bat is native to southern Florida, where it lives
in small colonies. Because they're difficult to study, their
population size is unknown, but estimates range from
the low hundreds to the low thousands.

Blue-eyed cockatoo, *Cacatua ophthalmica* (VU)

The striking physical feature that this parrot is named for is actually a ring of blue skin that surrounds the eye, not the color of the eye itself.

Volcán Alcedo giant tortoise,
Chelonoidis vandenburghi (VU)

Of the Galápagos tortoises, this population
is one of the largest existing today, with
more than 6,000 individuals. Historically
their population is estimated to have
reached 38,000 tortoises.

OVER THE LAST TWO DECADES, HABITAT SUP-

PORTING THIS SPECIES DECLINED BY AT LEAST

30%

Horsfield's tarsier, *Tarsius bancanus* (VU)

This primate is no taller than a saltshaker when seated, and each
of its eyeballs has roughly the same volume as its entire brain.
Born with a full coat of fur and their eyes wide open, these small
monkeys are able to climb in their forest habitats of Brunei, Indo-
nesia, and Malaysia when they're just one day old.

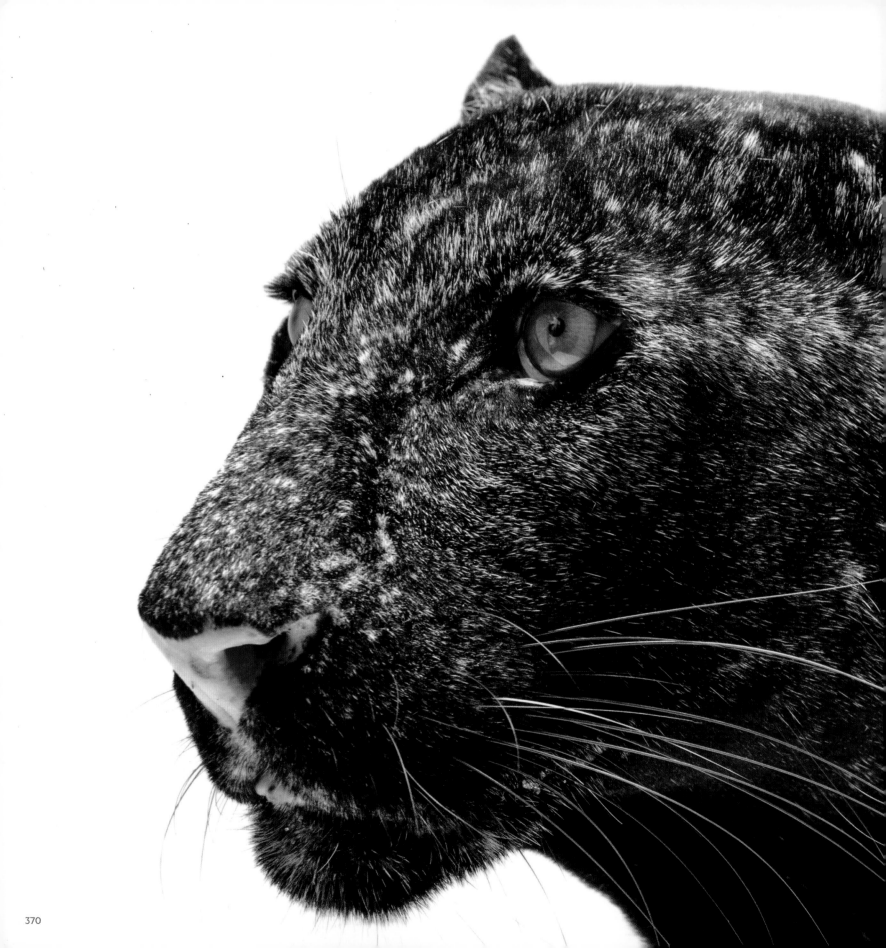

African leopard, *Panthera pardus pardus* (VU)

Coat colors and patterns of African leopards vary from region to region, but the black color phase is relatively rare. The differences in color arise from melanin, the same pigment responsible for human skin tone.

Spectacled bear, *Tremarctos ornatus* (VU)

Spectacled bears are the only known species of bear native to South America. They have been known to build platforms and nests to sleep in the trees of the cloud forests.

Brown woolly monkey, *Lagothrix poeppigii* (VU)

These Amazonian monkeys are larger than most of their arboreal cousins. A bare spot on their prehensile tail helps them improve their grip moving through the trees.

Masai giraffe, *Giraffa tippelskirchi* (VU)

Widespread across southern and eastern Africa, giraffes are nearly as adaptable as they are tall. But recent studies have shown that these iconic animals are at a higher risk than previously realized. From 1985 to 2015, giraffe populations in Africa declined by as much as 40 percent.

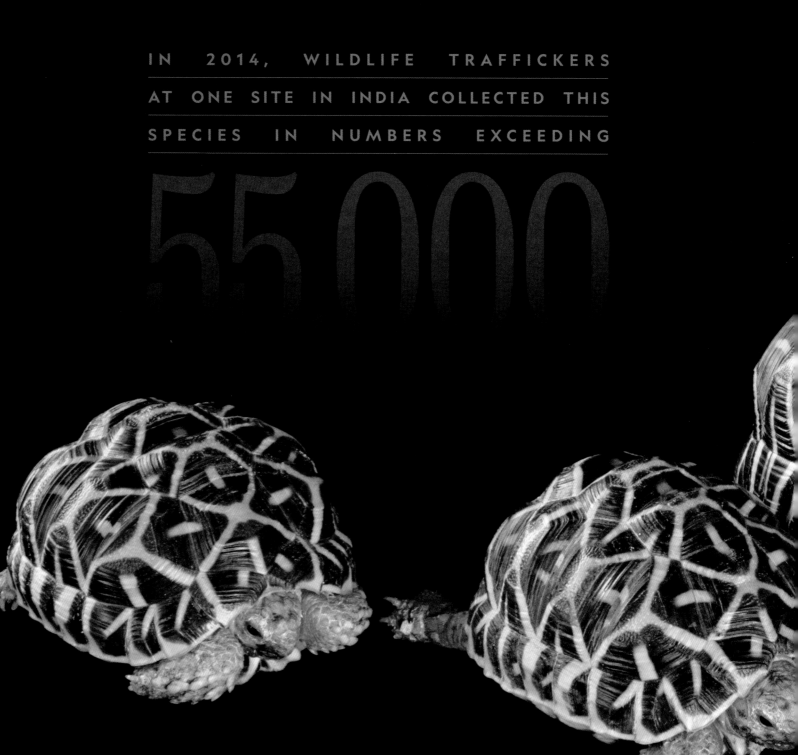

IN 2014, WILDLIFE TRAFFICKERS
AT ONE SITE IN INDIA COLLECTED THIS
SPECIES IN NUMBERS EXCEEDING

55,000

Indian star tortoise, *Geochelone elegans* (VU)

Illegal collection is one of the biggest threats for this tortoise. Some
believe that the tortoises bring good fortune, so they keep them as
house pets. They're often targeted for their ornately patterned shells.

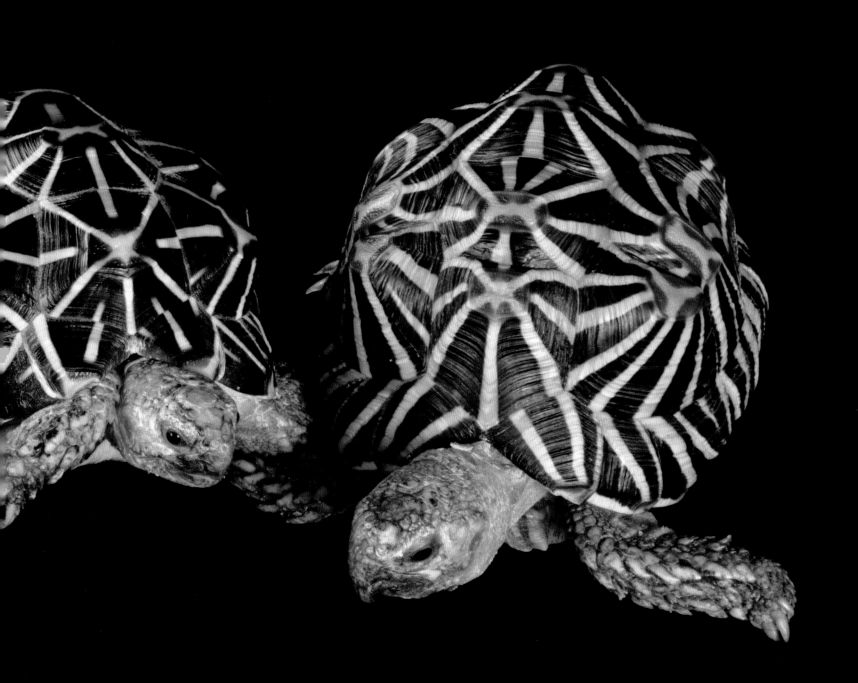

Pacific horned frog, *Ceratophrys stolzmanni* (VU)

These frogs are almost exclusively active during the rainy season in Peru and Ecuador. They breed for a few hours during the season, then spend months buried in the ground in an inactive state.

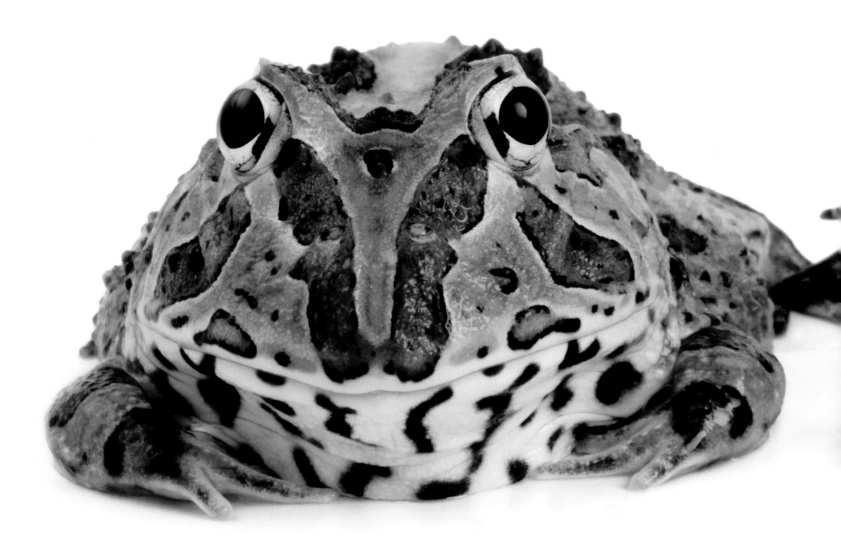

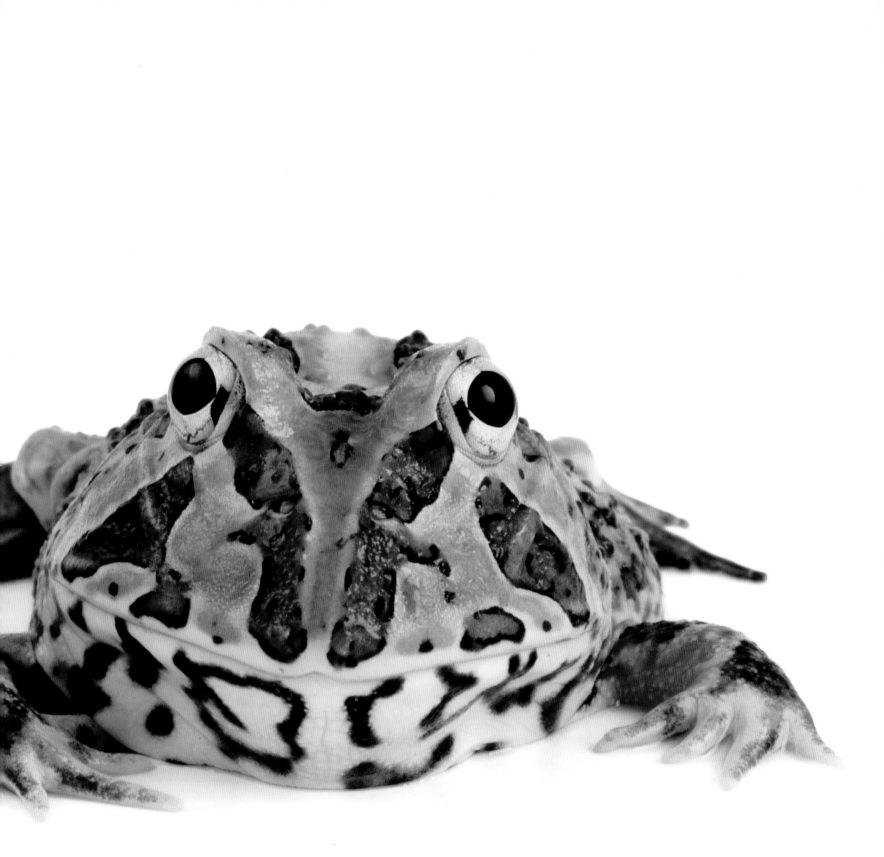

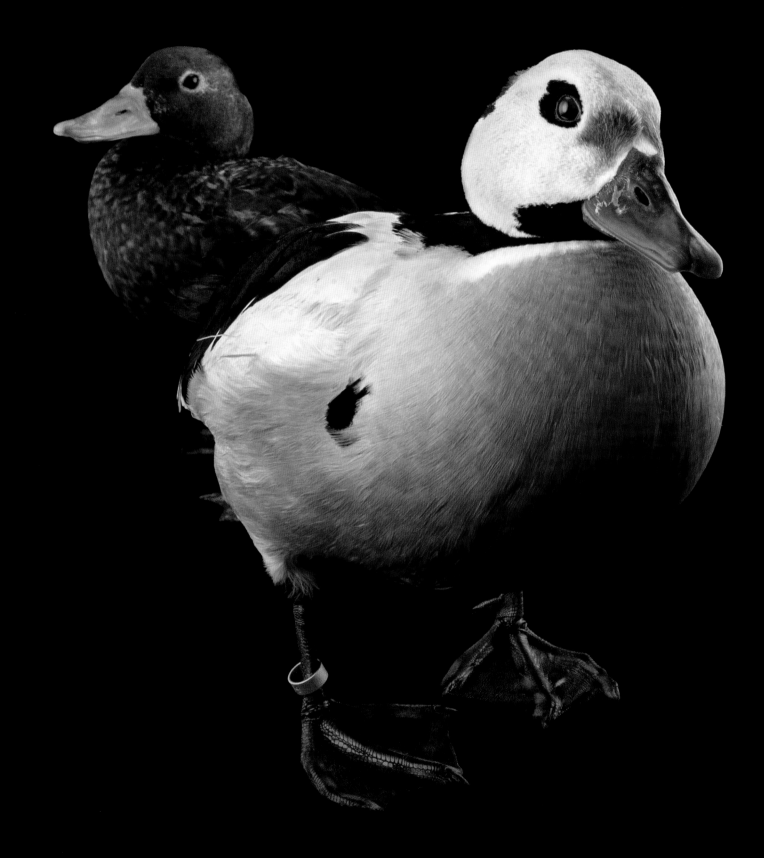

≈140,000

INDIVIDUALS REMAIN IN THE WILD

ARCTIC WATERS ARE FORBIDDING to those who want to learn more about this small, compact duck. But the Steller's eider is perfectly comfortable navigating the rocky shores and open tundras of the planet's coldest climes. During the winter, flocks of Steller's eiders dive in unison beneath the water's surface to forage for food, resurfacing together with a spray. Summer finds the ducks on the tundra near ponds or rivers, tending to their deep, bowl-shaped nests. Though they are hardy in the face of cold, the eider's population is declining, and scientists don't know why. It could be climate change, lead poisoning, increased predation—or something they haven't guessed at yet. The unforgiving terrain makes it hard to carry out research that can yield answers.

Steller's eider, *Polysticta stelleri* (VU)

"ALL ANIMALS, REGARDLESS OF SIZE OR SHAPE, ARE GLORIOUS. EACH IS A LIVING WORK OF ART.

—————

JOEL SARTORE

Clouded leopard, *Neofelis nebulosa* (VU)

This cat's powerful legs and long tail give it excellent balance while roaming its hunting grounds across Asia. Clouded leopards have been targeted by poachers—whether as pets or pelts, they're highly sought after.

ABOUT THE PHOTO ARK

The interaction between animals and their environment is the engine that keeps the planet healthy for all of us. But for many species, time is running out. When you remove one, it affects us all. The National Geographic Photo Ark is using the power of photography to inspire people to help save species at risk before it's too late. Photo Ark founder Joel Sartore has photographed more than 10,000 species around the world as part of a multiyear effort to document every species living in zoos and wildlife sanctuaries, inspire action through education, and help save wildlife by supporting on-the-ground conservation efforts.

Sartore has visited more than 40 countries in his quest to create a photo archive of global biodiversity, which will feature portraits of an estimated 12,000 species of birds, fish, mammals, reptiles, amphibians, and invertebrates. Once completed, the Photo Ark will serve as an important record of each animal's existence and a powerful testament to the importance of saving them.

Photo Ark fans are invited to join the conversation about protecting species and their habitats on social media with the hashtag #SaveTogether and learn about thousands of other species by exploring the Photo Ark at *natgeophotoark.org*.

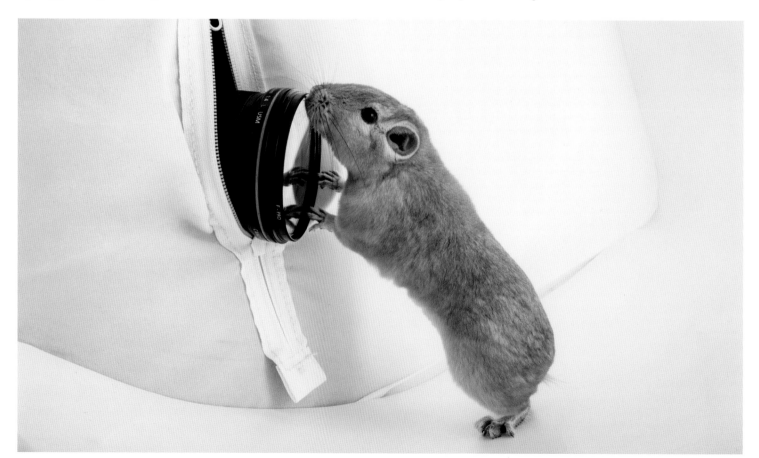

| HOW THE PHOTOS ARE MADE |

So just how do we make these photos? We start with the animal in front of a black or white background, and in nice light. Smaller animals are usually quite easy; they're moved into a space that has black or white on the walls and underfoot. Most often, this means they go into our soft cloth shooting tents. Once inside, they see only the front of my lens. For larger, more skittish animals like zebras, rhinos, and even elephants, we install a background and may use only natural light. We seldom put anything under their feet that could scare them or cause them to slip. In those cases, either we don't photograph the animal's feet or we later use Photoshop to darken the floor to black.

The majority of Photo Ark participants have been around people all their lives and are calm when we work with them. Still, we want the photo shoots to go as quickly as possible so we don't stop to clean up dirt or debris they may deposit on the backgrounds. For that, we later use Photoshop and touch up the final frames. The goal is to end up with a clear, focused portrait of the animal with nothing but pure black or white around them. To eliminate all distractions. To get viewers to care.

OPPOSITE: Common gundi, *Ctenodactylus gundi* (LC)
BELOW: Elegant quail, *Callipepla douglasii* (LC)

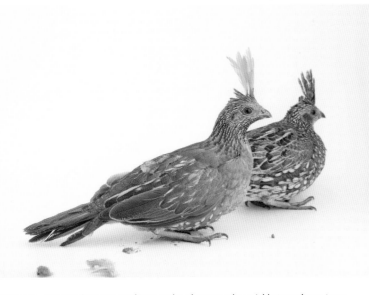

BEFORE: Our number one goal is to make photographs quickly to reduce stress on the animals. This means cleaning up the backgrounds digitally after the shoot.

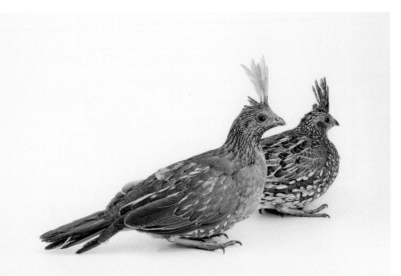

AFTER: The finished product, after dirt and poop have been removed electronically.

ABOUT THE AUTHOR

Joel Sartore is a photographer, an author, a teacher, a conservationist, a National Geographic Fellow, and a regular contributor to *National Geographic* magazine. His hallmarks are a sense of humor and a midwestern work ethic. Sartore specializes in documenting endangered species and landscapes around the world. He is the founder of the Photo Ark, a 25-year documentary project to save species and habitat. In addition to the work he has done for National Geographic, Sartore has contributed to *Audubon* magazine, *Sports Illustrated,* the *New York Times, Smithsonian* magazine, and numerous book projects. He is always happy to return from his travels around the world to his home in Lincoln, Nebraska, where he lives with his wife, Kathy, and their three children.

ACKNOWLEDGMENTS

To me, the mark of a true hero is someone who consistently does the right thing while giving no thought to self. They work for years just to set things right, expecting no recognition or praise. In my world, the heroes are the wildlife rehabbers who drive all night to pick up an injured animal, nurse it back to health, and then months later drive all night to take it back home again. They are the zookeepers, aquarium minders, and captive breeders of the world, keeping healthy populations of animals going until we wise up and preserve enough habitat to allow species to make it on their own. They are the educators, the donors, and the communicators who exalt the natural world with their expertise, their money, and their persistence, knowing we still live in a world worth saving.

As for the Photo Ark project and this book, the support and vast reach of National Geographic is obvious. It continues, and has always been greatly appreciated.

From his office in France, our taxonomist Pierre de Chabannes keeps us well informed, no matter the hour.

Our world headquarters is based in Lincoln, Nebraska, on purpose. Nowhere else could we assemble such a team as Alanna, Bryn, Dakota, Keri, and Tarah, all led by Rebecca. Our brilliant friend Clark DeVries advises on all matters, great and small.

And at home there's Kathy, Cole, Ellen, and Spencer, who may not like it that I'm gone so much, but they understand.

Heroes all.

Bonobo, *Pan paniscus* (EN)

Kanzi, a bonobo, learned to point out lexigrams to convey meaning. Today he not only conveys his own ideas but also tells biologists what other bonobos are saying. He posed for this portrait and then, when asked to press a button to take Joel's picture, he obliged—and took the photo on the opposite page.

| CONSERVATION HEROES |

When we visit a zoo or a wildlife center, our attention goes straight to the animals. But behind those alluring creatures there are dedicated humans hard at work. These are the true heroes of the Photo Ark: the zookeepers, animal caretakers, zoologists, conservationists, researchers, veterinarians, curators, park rangers, and wildlife rehabbers who put their hearts, souls, time, and effort into keeping the species of our planet alive, healthy, breeding, and in some cases even strong enough to return to their native habitats. Throughout this book you heard their voices speaking truths about the challenges we face as we strive to maintain an Earth in balance, rich and complete in its biodiversity, supportive and promising to generations to come. Here we introduce you more fully to the conservation heroes we honor.

JENNY GRAY
Chief Executive Officer, Zoos Victoria

A civil engineer by training, Gray worked as an executive for a major South African bus company and as a banker before coming to the zoo industry. Since she took the helm of Zoos Victoria in 2008, Gray and her staff have intensified the zoos' conservation efforts, focusing on 21 species native to Victoria, including the Leadbeater's possum and the Eastern barred bandicoot. Victoria Zoo scientists and their recovery teams have recently established several freestanding populations of the mainland subspecies of the bandicoot, which is listed as extinct in the wild. Leadbeater's possum numbers (lowland variety) are in dramatic decline, with estimates of less than 40 individuals in the wild. Gray holds a doctorate in ethics from the University of Melbourne and is the author of the 2017 book *Zoo Ethics*. *See page 104.*

MICHAEL MEYERHOFF
Project Manager, Angkor Centre for Conservation of Biodiversity

A trained animal keeper with a special interest in birds and turtles, Meyerhoff has held a number of roles at the Angkor Centre for Conservation of Biodiversity, a nature conservation and wildlife rescue center in Cambodia established by Germany's Allwetterzoo Münster. Meyerhoff's passion for wildlife since childhood has led him to devote his career to saving highly endangered animals from extinction. As Cambodia experiences rapid and widespread development, the center rescues, rehabilitates, and breeds critically endangered animals native to Cambodia and releases them back into the wild. This includes the giant ibis and the white-shouldered ibis, two of the rarest bird species in the world, and the Southern river terrapin, which numbers as few as 500 individuals in the wild. *See page 138.*

STEVE SHURTER
Executive Director, White Oak Conservation

Raised on a dairy farm in western New York, Shurter studied animal science and worked as a zookeeper before coming to species conservation. For more than 30 years he has been involved with efforts in the Democratic Republic of the Congo to conserve the endangered okapi. In 2013, he assumed leadership of White Oak Conservation, a wildlife breeding, education, and training conservation center in Florida. White Oak's breeding programs focus on some of the world's most imperiled animals, including the okapi, Florida panther, and southern black rhinoceros. In 2017 and 2018, White Oak staff successfully bred Florida grasshopper sparrows, a critically endangered subspecies of the more common eastern grasshopper sparrow, and are working with the U.S. Fish and Wildlife Service to reintroduce the sparrows to the wild. *See page 173.*

JAMIE RAPPAPORT CLARK
President and CEO, Defenders of Wildlife

Clark's career in conservation began in college, when she helped to release endangered peregrine falcons back into the wild. In the decades since, she has held the top job at our nation's federal wildlife agency, testified many times before Congress, and currently leads one of the nation's premier conservation advocacy organizations. During Clark's tenure as director of the U.S. Fish and Wildlife Service from 1997 to 2001, she presided over the recovery of the bald eagle and gray wolf and in 1999 removed the peregrine falcon from the endangered species list. She joined Defenders of Wildlife in 2004, became its president and CEO in 2011, and is a tireless advocate in Washington for the Endangered Species Act and other bedrock wildlife and conservation laws. *See page 203.*

ZACHARY LOUGHMAN
Associate Professor of Biology and Zoo Science and Applied Conservation Biology Coordinator, West Liberty University

One of a small group of scientists worldwide who study crayfish, Loughman focuses on the crayfish fauna of central Appalachia.

Assisted by his students at West Virginia's West Liberty University, Loughman in the past decade has completed conservation work across the southeastern United States and described more than 10 species of crayfish new to science. Roughly half required immediate conservation attention, including the Big Sandy crayfish, listed federally as threatened. Loughman also rediscovered the Guyandotte River crayfish, thought to be extinct, which occurs only in a short stretch of two streams in the coalfields of southern West Virginia. Both species are affected by land use practices like mining and development, which cause accumulation of sediment in the crayfish's native waterways. Research by Loughman and his students has helped state and federal wildlife agencies take swift action to recover both of these imperiled crayfish. *See page 239.*

DR. CHENG WEN-HAUR
Deputy Chief Executive Officer/Chief Life Sciences Officer,
Wildlife Reserves Singapore
A veterinarian by training, Cheng held a variety of positions at zoos in China, Australia, and Singapore before returning to Wildlife Reserves Singapore. At WRS, Cheng oversees four wildlife parks' living collections as well as their veterinary services, education, conservation and research, and exhibit design. Roughly five million people experience the parks' 1,000 species each year, but WRS staff are also busy behind the scenes saving rare animals. WRS manages conservation breeding programs to maintain insurance colonies for the Burmese roofed turtle and other highly threatened species, and its veterinarians treat and release critically endangered Sunda pangolins that are injured by vehicles in Singapore. Staff at WRS also serve as first responders to save rare animals such as the big-headed turtle, Philippine forest turtle, and Santa Cruz ground dove in natural disasters and in the mass confiscation of illegally traded wildlife. *See page 284.*

STEVE SHERROD
Executive Director Emeritus, Director of Conservation,
Sutton Avian Research Center
Sherrod's 40-year career in conservation has included key roles in the recovery of two endangered bird species whose rebound was so successful that they were taken off the endangered species list. In the 1980s, Sherrod, a biologist by training, supervised the release of captive-bred peregrine falcons in the eastern United States. And while serving as executive director of the Sutton Center, he initiated a program to raise newly hatched bald eagles behind glass with puppets and reintroduce them in Oklahoma (which at the time

had no nesting pairs and today has 160), Mississippi, Alabama, Georgia, and North Carolina. More recently, he has been instrumental in building a new program at the Sutton Center to breed the highly endangered Attwater's prairie chicken and release it back into Texas. *See page 323.*

KATHY RUSSELL
General Curator, Santa Fe College Teaching Zoo
Russell earned an undergraduate degree in mathematics and worked at a bank before following her interest in animals to Santa Fe College, where she earned a degree in zoo animal technology. For roughly three decades Russell has worked at the 10-acre zoo near Gainesville, Florida, dedicated to training the next generation of zookeepers with a strong emphasis on sustainable practices and conservation. One of only two teaching zoos in the country—and the only one accredited by the Association of Zoos and Aquariums—the zoo has captive-breeding programs for many endangered species, including Matschie's tree kangaroos, Red ruffed lemurs, and Asian small-clawed otters. Since 2007 the zoo has worked with state and federal officials to maintain a captive population of the endangered Perdido Key beach mouse. Down to a handful of mice in 2007, Perdido Key, thanks to conservation efforts by the zoo and other partners, now has mice living throughout the island for the first time in 40 years. *See page 330.*

FRANK RIDGLEY, DVM
Director of Conservation and Research, Zoo Miami
Ridgley is a wildlife veterinarian who leads Zoo Miami's conservation and research department, linking academic and scientific research of Florida's rarest animals with on-the-ground conservation. He's worked with a variety of species in South Florida, including the Florida panther, the American flamingo, and the federally endangered Florida bonneted bat. Despite this urban bat's dwindling numbers, scientists and conservationists still know relatively little about it. Ridgley's team helps wildlife agencies acquire more scientific knowledge about the species by performing acoustic studies and installing artificial roosts for the bats across Dade County. They also treat, rehabilitate, and release injured bats back into the wild. *See page 365.*

CONTRIBUTING WRITERS & CONSULTANTS

ELIZABETH KOLBERT

Kolbert (foreword writer) is a staff writer for the *New Yorker*. Her most recent book, *The Sixth Extinction*, received the Pulitzer Prize for general nonfiction in 2015. She is also the author of *Field Notes From a Catastrophe: Man, Nature, and Climate Change*. A two-time National Magazine Award winner, Kolbert is a visiting fellow at the Center for Environmental Studies at Williams College.

PIERRE DE CHABANNES

Based in France, de Chabannes (researcher) has been the taxonomist for the Photo Ark since 2015. Growing up in a house without television, Pierre was fascinated by nature photo books as a child. Time spent outside at a remote family cabin in the Alps furthered his interest in the natural world. Today he has visited more than 340 zoos in 31 countries and not only identifies the species needed for the Ark but also scouts and produces shoots at zoos, aquariums, and wildlife rehab centers around the world.

LIBBY SANDER

Sander (lead writer) is a writer and editor whose feature writing has appeared in many publications, including the *New York Times,* the *Washington Post,* and the *Chronicle of Higher Education*. A lifelong lover of animals and the natural world, she has focused her recent work on wildlife and conservation. She is a graduate of Bryn Mawr College and Northwestern University and lives in Washington, D.C., with her family.

BRADLEY HAGUE

Hague (caption writer) is a science writer and video producer who has chased stories from the deepest corners of the ocean to the wilds of the African savanna. He has written two books for National Geographic and contributed to several others. His work has also appeared on the Smithsonian Channel, the Discovery Channel, and the National Geographic Channel. When not searching out new scientific discoveries he lives in Washington, D.C., with his wife and son.

PHOTO ARK EDGE FELLOWS

For thousands of creatures living on Earth, time is running out. Although our planet's wildlife and wild places are disappearing at an alarming rate, most threatened species still receive little or no conservation funding. To help save wildlife and sound the alarm for lesser known species at risk, the National Geographic Society and the Zoological Society of London (ZSL) launched a fellowship collaboration. In partnership with ZSL's EDGE of Existence Program, which focuses on the planet's most unusual and endangered species, the National Geographic Photo Ark EDGE Fellowship supports on-the-ground conservation efforts to help save creatures featured in the Photo Ark. The inaugural cohort of fellows, all from Latin America, began their fellowships in 2018, and were followed by a cohort of fellows from Asia in 2019.

ADRIAN LYNGDOH
COUNTRY: India
EDGE SPECIES: Bengal slow loris
(Nycticebus bengalensis) VU
The Bengal slow loris appears on page 269.

ALIFA HAQUE
COUNTRY: Bangladesh
EDGE SPECIES: Largetooth sawfish
(Pristis pristis) CR

ASHISH BASHYAL
COUNTRY: Nepal
EDGE SPECIES: Gharial *(Gavialis gangeticus)* CR
The gharial appears on pages 118-19.

AYUSHI JAIN
COUNTRY: India
EDGE SPECIES: Cantor's giant softshell turtle
(Pelochelys cantorii) EN

DANIEL ARAUZ
COUNTRY: Costa Rica
EDGE SPECIES: Hawksbill turtle
(Eretmochelys imbricata) CR

DAVID QUIMBO
COUNTRY: Philippines
EDGE SPECIES: Rufous-headed hornbill
(Rhabdotorrhinus waldeni) CR
The rufous-headed hornbill appears on pages 70-71.

GINELLE JANE A. GACASAN
COUNTRY: Philippines
EDGE SPECIES: Green turtle *(Chelonia mydas)* EN

HA HOANG
COUNTRY: Vietnam
EDGE SPECIES: Big-headed turtle
(Platysternon megacephalum) CR

JAILABDEEN A
COUNTRY: India
EDGE SPECIES: Gharial *(Gavialis gangeticus)* CR
The gharial appears on pages 118-19.

JAMAL GALVES
COUNTRY: Belize
EDGE SPECIES: Antillean manatee
(Trichechus manatus manatus) EN

JONATHAN PHU JIUN LANG
COUNTRY: Malaysia
EDGE SPECIES: Green turtle *(Chelonia mydas)* EN

MARINA RIVERO
COUNTRY: Mexico
EDGE SPECIES: Baird's tapir *(Tapirus bairdii)* EN

MOUMITA CHAKRABORTY
COUNTRY: India
EDGE SPECIES: Red panda *(Ailurus fulgens)* EN
The red panda appears on page 148.

NGO HANH
COUNTRY: Vietnam
EDGE SPECIES: Crocodile lizard
(Shinisaurus crocodilurus) EN

OTGONTUYA BATSUURI
COUNTRY: Mongolia
EDGE SPECIES: Siberian Crane
(Leucogeranus leucogeranus) CR

RANJANA BHATTA
COUNTRY: Nepal
EDGE SPECIES: Gharial *(Gavialis gangeticus)* CR
The gharial appears on pages 118-19.

SUM PHEARUN
COUNTRY: Cambodia
EDGE SPECIES: Giant ibis
(Thaumatibis gigantea) CR

VINICIUS ALBERICI ROBERTO
COUNTRY: Brazil
EDGE SPECIES: Giant anteater
(Myrmecophaga tridactyla) VU
The giant anteater appears on pages 304-305.

YAJAIRA GARCIA FERIA
COUNTRY: Mexico
EDGE SPECIES: Volcano rabbit
(Romerolagus diazi) EN
The volcano rabbit appears on page 214.

ZSL
LET'S WORK
FOR WILDLIFE

NATIONAL GEOGRAPHIC
PHOTO ARK
JOEL SARTORE

INDEX OF ANIMALS

Here we list, in the order they appear in the book, the common name of each species, the year of its most recent IUCN assessment, the place where the photograph was taken and, when possible, the website of that location.

70-71: Rufous-headed hornbill (2016) | Talarak Foundation, Negros Island, Philippines *talarak.org*

72: Sumatran tigers (2008) | Berlin Tierpark, Berlin, Germany *tierpark-berlin.de*

73: Visayan warty pig (2016) | Negros Forest Park, Negros Island, Philippines *facebook.com/negrosforestandecologicalfoundationinc*

74-5: Bandula barb (1996) | Plzeň Zoo, Plzeň, Czech Republic *zooplzen.cz*

76-7: Sumatran elephant (2011) | Taman Safari Park, South Jakarta, Indonesia *tamansafari.com*

78-9: Bornean orangutan (2016) | Avilon Zoo, Rodriguez, Philippines *avilonzoo.ph*

80: Kurdistan newt (2008) | Wroclaw Zoo, Wroclaw, Poland *zoo.wroclaw.pl*

81: American burying beetle (1996) | Saint Louis Zoo, St. Louis, Missouri *stlzoo.org*

82-3: Philippine eagle (2016) | Philippine Eagle Center, Davao Island, Philippines *philippineeaglefoundation.org*

84: Key Largo cotton mouse (2016) | Crocodile Lake National Wildlife Refuge, Key Largo, Florida *fws.gov/refuge/crocodile_lake/*

84: Key deer (2015) | Zoo Tampa at Lowry Park, Tampa, Florida *zootampa.org*

84: Stock Island tree snail (2000) | Crocodile Lake National Wildlife Refuge, Key Largo, Florida *fws.gov/refuge/crocodile_lake/*

85: Lower Keys marsh rabbit (2008) | Key West, Florida

85: Silver rice rat (2016) | Key West, Florida

85: Schaus swallowtail butterfly (N/A) | Florida Museum of Natural History, Gainesville, Florida *floridamuseum.ufl.edu*

85: Key Largo wood rat (2016) | Disney's Animal Kingdom, Orlando, Florida *disneyworld.disney.go.com/attractions/animal-kingdom/*

86-7: Somali wild ass (2014) | Dallas Zoo, Dallas, Texas *dallaszoo.com*

88-9: Peacock parachute spider (2008) | Sedgwick County Zoo, Wichita, Kansas *scz.org*

90-91: Pygmy hog (2008) | Pygmy Hog Research and Breeding Centre, Assam, India *pygmyhog.org*

92: Cát Bá langur (2008) | Endangered Primate Rescue Center, Cúc Phương National Park, Ninh Bình Province, Vietnam *eprc.asia*

93: Diademed sifaka (2012) | Lemuria Land, Nosy Be, Madagascar *lemurialand.com*

94-5: Titicaca water frog (2004) | Alcide d'Orbigny Natural History Museum, Cochabamba, Bolivia *museodorbigny.org*

96-7: Black bearded saki monkey (2008) | Zoo Brasilia, Brasilia, Brazil *zoo.df.gov.br*

98-9: Madagascar fish-eagle (2016) | Botanical and Zoological Garden of Tsimbazaza, Antananarivo, Madagascar

100-101: Pilalo tree frog (2004) | Balsa de los Sapos, Catholic University, Quito, Ecuador *bioweb.puce.edu.ec*

102: Central American river turtle (2006) | Oklahoma City Zoo, Okalhoma City, Oklahoma *okczoo.org*

103: Javan slow loris (2013) | Night Safari, Singapore *nightsafari.com.sg*

104-105: Leadbeater's possum (2014) | Healesville Sanctuary, Healesville, Australia *zoo.org.au/healesville*

106-107: Malayan tiger (2014) | Omaha's Henry Doorly Zoo and Aquarium, Omaha, Nebraska *omahazoo.com*

108: Javan black-winged starling (2016) | Nature Conservation Agency, Jakarta, Indonesia *bksdadki.com*

108: Ruby-throated bulbul (2016) | Plzeň Zoo, Plzeň, Czech Republic *zooplzen.cz*

108: Greater green leafbird (2016) | Sedgwick County Zoo, Wichita, Kansas *scz.org*

109: Rufous-fronted laughingthrush (2016) | Plzeň Zoo, Plzeň, Czech Republic *zooplzen.cz*

109: Bali myna (2016) | Lisbon Zoo, Lisbon, Portugal *zoo.pt*

109: Sumatran laughingthrush (2016) | Plzeň Zoo, Plzeň, Czech Republic *zooplzen.cz*

109: Javan green magpie (2018) | Taman Safari, South Jakarta, Indonesia *tamansafari.com*

110: Celebes crested macaque (2008) | Omaha's Henry Doorly Zoo and Aquarium, Omaha, Nebraska *omahazoo.com*

111: Northern white-cheeked gibbon (2008) | Gibbon Conservation Center, Santa Clarita, California *gibboncenter.org*

112-13: Addax (2016) | Buffalo Zoo, Buffalo, New York *buffalozoo.org*

114-15: European eel (2013) | Centre for Environmental Education, Miramar, Portugal *cm-gaia.pt*

116: European mink (2015) | Madrid Zoo, Madrid, Spain *zoomadrid.com*

117: Puerto Rican crested toad (2008) | Sedgwick County Zoo, Wichita, Kansas *scz.org*

118-19: Gharial (2007) | Kukrail Gharial and Turtle Rehabilitation Centre, Lucknow, India *uptourism.gov.in/post/kukrail-forest*

120-21: Sumatran rhinoceros (2008) | White Oak Conservation Center, Cincinnati, Ohio *whiteoakwildlife.org*

122-3: Staghorn coral (2008) | Butterfly Pavilion, Westminster, Colorado *butterflies.org*

124-5: Scottish wildcat (2014) | Wildcat Haven, Roy Bridge, Scotland *wildcathaven.com*

126-7: Cross River gorilla (2016) | Limbe Wildlife Centre, Limbe, Cameroon *limbewildlife.org*

128: Siau Island tarsier (2010) | Ragunan Zoo, Jakarta, Indonesia *ragunanzoo.jakarta.go.id*

129: Talaud bear cuscus (2015) | Private Collection

130-31: Citron-crested cockatoo (2018) | Jurong Bird Park, Singapore *birdpark.com.sg*

132-3: Pahrump poolfish (2011) | Desert National Wildlife Refuge, Corn Creek, Nevada *fws.gov/refuge/desert/*

134-5: Blue-eyed black lemur (2012) | Duke Lemur Center, Durham, North Carolina *lemur.duke.edu*

136: Three Forks springsnail (2012) | Phoenix Zoo, Phoenix, Arizona *phoenixzoo.org*

137: Fat threeridge (1996) | USGS Wetland and Aquatic Research Center, Gainesville, Florida *usgs.gov/warc*

FADING

205: Eastern black rhinoceros (2011) | Great Plains Zoo, Sioux Falls, South Dakota *greatzoo.org*

205: Axolotl (2008) | Detroit Zoo, Detroit, Michigan *detroitzoo.org*

206-207: Laos warty newt (2013) | National Mississippi River Museum and Aquarium, Dubuque, Iowa *rivermuseum.com*

208: Southern mountain yellow-legged frog (2008) | San Diego Zoo, San Diego, California *zoo.sandiegozoo.org*

209: Matschie's tree kangaroo (2016) | Lincoln Children's Zoo, Lincoln, Nebraska *lincolnzoo.org*

210-11: March's palm pit viper (2012) | London Zoo, London, England *zsl.org*

212-13: Frégate Island Enid snail (2006) | Exmoor Zoo, Exmoor, England *exmoorzoo.co.uk*

214: Volcano rabbit (2008) | Chapultepec Zoo, Chapultepec, Mexico *data.sedema.cdmx.gob/mx/zoo_chapultepec*

215: Calamian deer (2014) | Los Angeles Zoo, Los Angeles, California *lazoo.org*

216-17: Tasmanian devil (2008) | Australia Zoo, Beerwah, Australia *australiazoo.com.au*

218-19: Madagascar dwarf chameleon (2014) | Madagascar Exotic, Marozevo, Madagascar

220: Annamese langur (2008) | Angkor Centre for Conservation of Biodiversity, Siem Reap, Cambodia *accb-cambodia.org*

221: Grey crowned-crane (2016) | Kansas City Zoo, Kansas City, Missouri *kansascityzoo.org*

222-3: Giant otter (2014) | Dallas World Aquarium, Dallas, Texas *dwazoo.com*

224-5: Saker falcon (2016) | Plzeň Zoo, Plzeň, Czech Republic *zooplzen.cz*

226-7: South Diamond Gila trout (1996) | Mora National Fish Hatchery, Mora, New Mexico *fws.gov/southwest/fisheries/mora*

228-9: Grévy's zebra (2016) | Lee G. Simmons Conservation Park and Wildlife Safari, Ashland, Nebraska *wildlifesafaripark.com*

230: African wild dogs (2012) | Omaha's Henry Doorly Zoo and Aquarium, Omaha, Nebraska *omahazoo.com*

231: Cape vultures (2016) | Cheyenne Mountain Zoo, Colorado Springs, Colorado *cmzoo.org*

232-3: Malagasy giant jumping rat (2016) | Omaha's Henry Doorly Zoo and Aquarium, Omaha, Nebraska *omahazoo.com*

234: Geoffroy's spider monkey (2008) | Chattanooga Zoo, Chattanooga, Tennessee *chattzoo.org*

234: Blue-billed curassow (2016) | Houston Zoo, Houston, Texas *houstonzoo.org*

234: Oncilla (2016) | Jaime Duque Park, Cundinamarca, Colombia *parquejaimeduque.com*

235: Golden-cheeked warbler (2018) | Fort Hood, Texas

235: Margay (2014) | Cincinnati Zoo, Cincinnati, Ohio *cincinnatizoo.org*

235: Golden-capped parakeet (2016) | Jurong Bird Park, Singapore *birdpark.com.sg*

235: Yucatán black howler monkey (2008) | Omaha's Henry Doorly Zoo and Aquarium, Omaha, Nebraska *omahazoo.com*

236: White-fronted capuchin (2008) | Summit Municipal Park, Gamboa, Panama

237: Silvery gibbon (2008) | Bali Safari, Bali, Indonesia *balisafarimarinepark.com*

238-9: Guyandotte River crayfish (2010) | West Liberty, West Virginia *facebook.com/wlucrayfish*

240: Silverstone's poison frog (2017) | Private Collection

241: Golden poison frog (2016) | Rolling Hills Zoo, Salina, Kansas *rollinghillszoo.org*

242-3: Flat-headed cat (2014) | Taiping Zoo, Taiping, Malaysia *zootaiping.gov.my*

244: Lesser chameleon (2009) | Madagascar Exotic, Marozevo, Madagascar

245: Helmeted curassow (2016) | National Aviary of Colombia, Barú, Colombia *acopazoa.org*

246-7: Australian sea lion (2016) | Taronga Zoo, Sydney, Australia *taronga.org.au*

248-9: Green peafowl (2018) | Houston Zoo, Houston, Texas *houstonzoo.org*

250-51: White-naped mangabey (2008) | Rome Zoo, Rome, Italy *bioparco.it*

252-3: Grand Cayman blue iguana (2012) | Sedgwick County Zoo, Wichita, Kansas *scz.org*

DIMMING

254-5: Roanoke logperch (2012) | Conservation Fisheries, Knoxville, Tennessee *conservationfisheries.org*

256: Snowy owl (2017) | New York State Zoo, Watertown *nyszoo.org*

257: Luristan newt (2016) | Conservation Fisheries, Knoxville, Tennessee *conservationfisheries.org*

258-9: Polar bear (2015) | Tulsa Zoo, Tulsa, Oklahoma *tulsazoo.org*

260: Ringed sawback (2010) | National Mississippi River Museum and Aquarium, Dubuque, Iowa *rivermuseum.com*

261: Southern giant clam (1996) | Omaha's Henry Doorly Zoo and Aquarium, Omaha, Nebraska *omahazoo.com*

262-3: Madagascar painted frog (2017) | Private Collection

264-5: African dwarf crocodile (1996) | Lincoln Children's Zoo, Lincoln, Nebraska *lincolnzoo.org*

266-7: Visayan leopard cat (2008) | Avilon Zoo, Rodriguez, Philippines *avilonzoo.ph*

268: Chinese blind cave fish | Berlin Aquarium, Berlin, Germany *aquarium-berlin.de*

269: Bengal slow loris (2008) | Endangered Primate Rescue Center, Cúc Phương National Park, Ninh Bình Province, Vietnam *eprc.asia*

270-71: Arabian oryx (2016) | Phoenix Zoo, Phoenix, Arizona *phoenixzoo.org*

272-3: Barrens topminnow (2012) | Conservation Fisheries, Knoxville, Tennessee *conservationfisheries.org*

274-5: Fossa (2015) | Omaha's Henry Doorly Zoo and Aquarium, Omaha, Nebraska *omahazoo.com*

276: Dakota skipper (1996) | Minnesota Zoo, Apple Valley, Minnesota *mnzoo.org*

277: Gray's monitor (2007) | Los Angeles Zoo, Los Angeles, California *lazoo.org*

278: Wrinkled hornbill (2018) | Houston Zoo, Houston, Texas *houstonzoo.org*

278: Bornean crested fireback (2016) | Houston Zoo, Houston, Texas *houstonzoo.org*

278: Goodfellow's tree kangaroo (2014) | Melbourne Zoo, Melbourne, Australia *zoo.org.au/melbourne*

279: Bornean gibbon (2008) | Miller Park Zoo, Bloomington, Illinois *mpzs.org*

279: Black hornbill (2018) | Jurong Bird Park, Singapore *birdpark.com.sg*

279: Bornean bearded pig (2016) | Gladys Porter Zoo, Brownsville, Texas *gpz.org*

279: Helmeted hornbill (2018) | Penang Bird Park, Perai, Malaysia *penangbirdpark.com.my*

280-81: African elephant (2008) | Cheyenne Mountain Zoo, Colorado Springs, Colorado *cmzoo.org*

282-3: Jamaican boa (1996) | Private Collection

284-5: Greater hog badger (2015) | Night Safari, Singapore *nightsafari.com.sg*

286: Nubian ibex (2008) | Dallas Zoo, Dallas, Texas *dallaszoo.com*

287: Pinyon jay (2016) | University of Nebraska-Lincoln, Lincoln, Nebraska *unl.edu*

288-9: Sarasin's giant gecko (2010) | Saint Louis Zoo, St. Louis, Missouri *stlzoo.org*

290: Nancy Ma's night monkey (2017) | Dallas World Aquarium, Dallas, Texas *dwazoo.com*

291: Sulawesi babirusa (2016) | Los Angeles Zoo, Los Angeles, California *lazoo.org*

292-3: Giant armadillo (2019) | Zoológico de Brasília, Candangolândia, Brazil *www.zoo.df.gov.br*

294-5: Western tragopan (2016) | Himalayan Nature Park, Kufri, India *hnpzookufri.org*

296-7: Mallorcan midwife toad (2008) | London Zoo, London, England *zsl.org*

298-9: Indian rhinoceros (2008) | Fort Worth Zoo, Fort Worth, Texas *fortworthzoo.org*

300-301: Lake Kutubu rainbowfish (1996) | Newport Aquarium, Newport, Kentucky *newportaquarium.com*

302-303: Regal fritillary | Minnesota Zoo, Apple Valley, Minnesota *mnzoo.org*

304-305: Giant anteater (2013) | Caldwell Zoo, Tyler, Texas *caldwellzoo.org*

306: Southern rockhopper penguin (2018) | Omaha's Henry Doorly Zoo and Aquarium, Omaha, Nebraska *omahazoo.com*

307: Okarito kiwi (2017) | West Coast Wildlife Centre, Franz Josef, New Zealand *wildkiwi.co.nz*

308-309: Giant panda (2016) | Zoo Atlanta, Atlanta, Georgia *zooatlanta.org*

310-11: Buckley's glass frog (2008) | Balsa de los Sapos, Catholic University, Quito, Ecuador *bioweb.puce.edu.ec*

312: Mexican caecilian (2008) | Tennessee Aquarium, Chattanooga, Tennessee *tnaqua.org*

313: Spotted seahorse (2012) | Children's Aquarium, Dallas, Texas *childrensaquariumfairpark.com*

314-15: Bilby (2015) | Dreamworld, Coomera, Australia *dreamworld.com.au*

316-17: False gharial (2011) | San Antonio Zoo, San Antonio, Texas *sazoo.org*

318-19: Koalas (2014) | Australia Zoo, Beerwah, Australia *australiazoo.com.au*

320: Kowari (2008) | Plzeň Zoo, Plzeň, Czech Republic *zooplzen.cz*

321: Dusky pademelon (2015) | Plzeň Zoo, Plzeň, Czech Republic *zooplzen.cz*

322-3: Greater prairie-chicken (2016) | San Antonio Zoo, San Antonio, Texas *sazoo.org*

324: Spectacled eider (2018) | Cincinnati Zoo, Cincinnati, Ohio *cincinnatizoo.org*

324: Orca (2017) | SeaWorld, Orlando, Florida *seaworld.com/orlando*

324: Atlantic puffin (2018) | National Aquarium, Baltimore, Maryland *aqua.org*

325: Spotted seal (2015) | Alaska SeaLife Center, Seward, Alaska *alaskasealife.org*

325: Pacific walrus (2014) | Ocean Park Hong Kong, Aberdeen, Hong Kong *oceanpark.com.hk*

325: Arctic fox (2014) | Great Bend-Brit Spaugh Zoo, Great Bend, Kansas *greatbendks.net/84/zoo*

325: Caribou (2015) | Miller Park Zoo, Bloomington, Illinois *mpzs.org*

326-7: Andean flamingo (2016) | Zoo Berlin, Berlin, Germany *zoo-berlin.de*

328: Transcaspian urial (2008) | Berlin Tierpark, Berlin, Germany *tierpark-berlin.de*

329: Mindanao brown deer (2014) | Crocolandia Foundation, Talisay City, Philippines *crocolandia.weebly.com*

330-31: Perdido Key beach mouse (2016) | Kissimmee Prairie Preserve State Park, Okeechobee, Florida *floridastateparks.org*

332-3: Philippine sailfin lizard (2007) | Omaha's Henry Doorly Zoo and Aquarium, Omaha, Nebraska *omahazoo.com*

334-5: Blue leg poso (2011) | Shrimp Fever, Scarborough, Canada *shrimpfever.com*

336-7: Hippopotamus (2016) | San Antonio Zoo, San Antonio, Texas *sazoo.org*

338: Asiatic black bear (2016) | Kamla Nehru Zoological Garden, Kankaria, India *ahmedabadzoo.in*

339: Binturong (2016) | Great Bend-Brit Spaugh Zoo, Great Bend, Kansas *greatbendks.net/84/zoo*

340-41: Red-billed toucan (2016) | Jaime Duque Park, Cundinamarca, Colombia *parquejaimeduque.com*

340-41: Yellow-ridged toucan (2016) | Jaime Duque Park, Cundinamarca, Colombia *parquejaimeduque.com*

342-3: Indochinese gaur (2016) | Phnom Tamao Wildlife Rescue Center, Tro Pang Sap, Cambodia *wildlifealliance.org/wildlife-phnom-tamao*

344: Gray-headed flying fox (2008) | Australian Bat Clinic, Advancetown, Australia *australianbatclinic.com.au*

345: Mandrill (2008) I Gladys Porter Zoo, Brownsville, Texas *gpz.org*

346-7: Eastern barred bandicoot (2014) I Healesville Sanctuary, Healesville, Australia *zoo.org.au/healesville*

348-9: Ashy darter (2011) I Conservation Fisheries, Knoxville, Tennessee *conservationfisheries.org*

350: Cook Strait giant weta (1996) I Zealandia, Wellington, New Zealand *visitzealandia.com*

351: Leatherback (2013) I Bioko Island, Equatorial Guinea

352-3: Horned parakeets (2016) I Loro Parque Foundation, Punta Brava, Spain *loroparque-fundacion.org*

354-5: Snow leopard (2016) I Miller Park Zoo, Bloomington, Illinois *mpzs.org*

356: Javan lutung (2008) I Taman Safari, Indonesia *tamansafari.com*

357: Diana monkey (2008) I Omaha's Henry Doorly Zoo and Aquarium, Omaha, Nebraska *omahazoo.com*

358-9: Southern bald ibis (2016) I Houston Zoo, Houston, Texas *houstonzoo.org*

360: African golden cat (2014) I Park Assango, Libreville, Gabon *facebook.com/parcassango.animalsworld*

360: Lesser flamingo (2018) I Cleveland Metroparks Zoo, Cleveland, Ohio *clevelandmetroparks.com/zoo*

360: Congo peacock (2016) I Saint Louis Zoo, St. Louis, Missouri *stlzoo.org*

361: Bonobo (2016) I Columbus Zoo, Columbus, Ohio *columbuszoo.org*

361: Wattled crane (2018) I Omaha's Henry Doorly Zoo and Aquarium, Omaha, Nebraska *omahazoo.com*

361: Slender-snouted crocodile (2013) I Private Collection

361: Okapi (2015) I White Oak Conservation Center, Cincinnati, Ohio *whiteoakwildlife.org*

362: Yellow-footed tortoise (1996) I Kansas City Zoo, Kansas City, Missouri *kansascityzoo.org*

363: Yellow scroll coral (2008) I Akron Zoo, Akron, Ohio *akronzoo.org*

364-5: Florida bonneted bat (2015) I Private Collection

366: Blue-eyed cockatoo (2018) I Jurong Bird Park, Singapore *birdpark.com.sg*

367: Volcán Alcedo giant tortoise (2015) I Oklahoma City Zoo, Oklahoma City, Oklahoma *okczoo.org*

368-9: Horsfield's tarsier (2008) I Taman Safari, South Jakarta, Indonesia *tamansafari.com*

370-71: African leopard (2015) I Alabama Gulf Coast Zoo, Gulf Shores, Alabama *alabamagulfcoastzoo.org*

372: Spectacled bear (2016) I Jaime Duque Park, Cundinamarca, Colombia *parquejaimeduque.com*

373: Brown woolly monkey (2008) I Piscilago Zoo, Bogotá, Colombia *piscilago.co/zoologico*

374-5: Masai giraffe (2016) I Houston Zoo, Houston, Texas *houstonzoo.org*

376-7: Indian star tortoise (2015) I Taronga Zoo, Sydney, Australia *taronga.org.au*

378-9: Pacific horned frog (2018) I Centro Jambatu, Quito, Ecuador *anfibiosecuador.ec*

380-81: Steller's eider (2018) I Alaska SeaLife Center, Seward, Alaska *alaskasealife.org*

382-3: Clouded leopard (2016) I Houston Zoo, Houston, Texas *houstonzoo.org*

384: Common gundi (2015) I Budapest Zoo & Botanical Garden, Budapest, Hungary *zoobudapest.com/en*

385: Elegant quail (2018) I Omaha's Henry Doorly Zoo and Aquarium, Omaha, Nebraska *omahazoo.com*

387: Bonobo (2016) I Ape Cognition and Conservation Initiative, Des Moines, Iowa *apeinitiative.org*

398: Sumatran rhinoceros (2008) I Cincinnati Zoo, Cincinnati, Ohio *cincinnatizoo.org*

Since 1888, the National Geographic Society has funded more than 13,000 research, exploration, and preservation projects around the world. National Geographic Partners distributes a portion of the funds it receives from your purchase to National Geographic Society to support programs including the conservation of animals and their habitats.

National Geographic Partners
1145 17th Street NW
Washington, DC 20036-4688 USA

Get closer to National Geographic explorers and photographers, and connect with our global community. Join us today at nationalgeographic.com/join

For information about special discounts for bulk purchases, please contact National Geographic Books Special Sales: specialsales@natgeo.com

For rights or permissions inquiries, please contact National Geographic Books Subsidiary Rights: bookrights@natgeo.com

Financially supported by the National Geographic Society.

Library of Congress Cataloging-in-Publication Data
Names: Sartore, Joel, author.
Title: The photo ark vanishing : the world's most vulnerable animals / Joel Sartore ; foreword by Elizabeth Kolbert.
Description: Washington, D.C. : National Geographic, [2019] I Includes index.
Identifiers: LCCN 2019003616 I ISBN 9781426220593 (hardcover)
Subjects: LCSH: Endangered species--Pictorial works. I Wildlife photography. I Photography of animals.
Classification: LCC TR729.W54 S27 2019 I DDC 779/.32--dc23
LC record available at https://lccn.loc.gov/2019003616

Printed in China

19/PPS/1

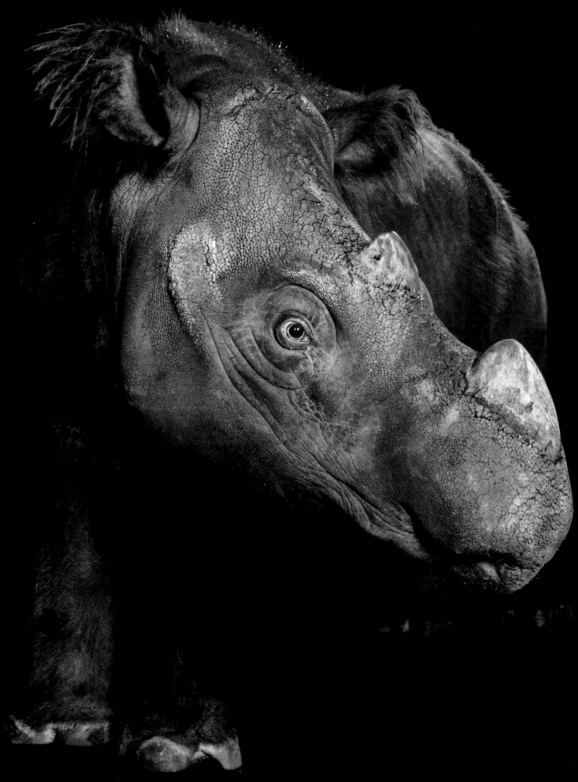

Sumatran rhinoceros,
Dicerorhinus sumatrensis sumatrensis (CR)

For more information, see pages 120–21.

THE NATIONAL GEOGRAPHIC SOCIETY IS

WORKING TO SUPPORT THE PROTECTION

OF 30 PERCENT OF THE PLANET BY 2030

THE PHOTO ARK is a vital component of the National Geographic Society's work to shine a light on threatened species and landscapes around the world.

In the past 50 years alone, we've lost more than 60 percent of wildlife populations, and wild habitats are disappearing at an unprecedented rate. To prevent a global extinction crisis, we must conserve at least half of the planet in its natural state.

As a key milestone, the National Geographic Society is working to support the protection of 30 percent of the planet by 2030. Toward that goal, the Society has partnered with the Wyss Campaign for Nature to raise awareness about the urgent need to protect nature and enable people and wildlife to thrive.

Together we can protect these places—and the species that depend on them—before it's too late.

THE NATIONAL GEOGRAPHIC SOCIETY is an impact-driven global non-profit organization based in Washington, D.C. Since 1888, National Geographic has pushed the boundaries of exploration, investing in bold people and transformative ideas to increase understanding of our world and generate solutions for a healthy, more sustainable future for generations to come. Our ultimate vision: a planet in balance. To learn more, visit *www.nationalgeographic.org.*

NATIONAL
GEOGRAPHIC

PHOTO ARK

JOEL SARTORE

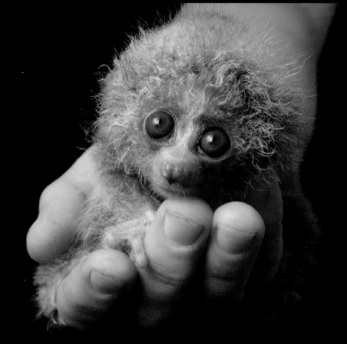

"I WANT PEOPLE TO CARE, TO FALL IN LOVE, AND TO TAKE ACTION."

—**Joel Sartore**

FOR MANY OF EARTH'S CREATURES, TIME IS RUNNING OUT.

Joel Sartore, founder of the Photo Ark, pledged to photograph every animal species in captivity and inspire people to care and take action. Filled with stunning and exquisite photographs, these books gloriously showcase the infinite variety of the animal kingdom and convey a powerful message with humor, poetry, compassion, and art.

AVAILABLE WHEREVER BOOKS ARE SOLD
and at NationalGeographic.com/Books

f NatGeoBooks 🐦 @NatGeoBooks

PHOTO ARK
JOEL SARTORE

NATIONAL GEOGRAPHIC